URBAN QUILTING

Paige Tate & Co.

Copyright 2021 by Wendy Chow

Published by Paige Tate & Co.

Paige Tate & Co. is an imprint of Blue Star Press

PO Box 8835, Bend, OR 97708

contact@bluestarpress.com | www.bluestarpress.com

Design by Rhoda Wong

Photography by Rachel Kuzma

ISBN 978-1950968190

Printed in Colombia

10 9 8 7 6 5 4

Dedication

For Wynne, thanks for being there every step of the way.

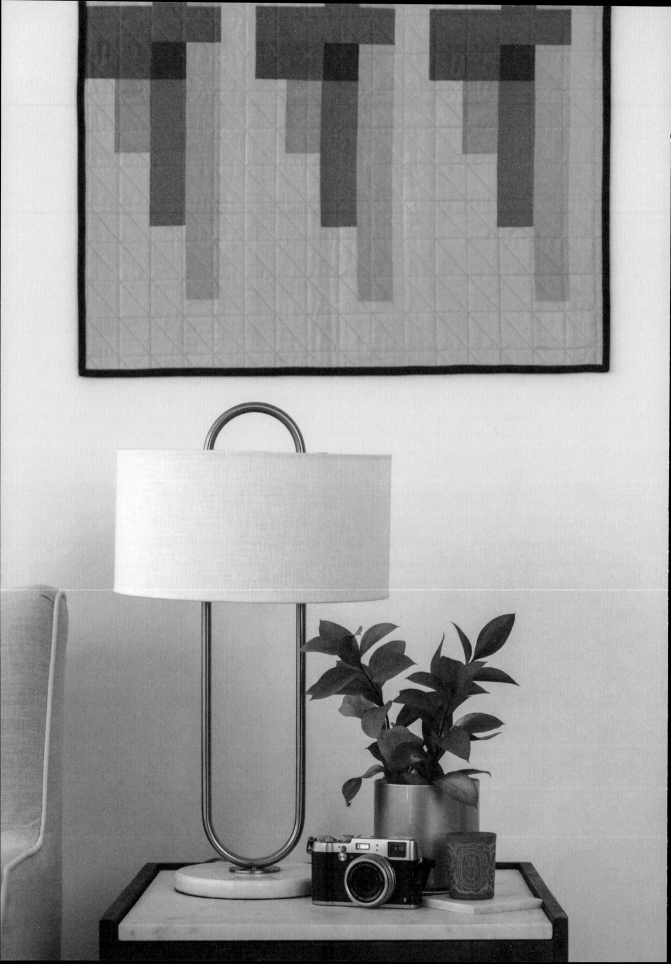

TABLE OF CONTENTS

INTRODUCTION

Welcome to *Urban Quilting*!

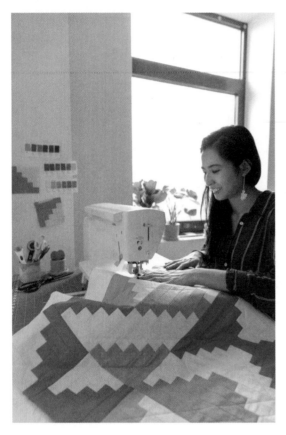

I've always been a city girl. I love the faster pace and the diversity, noise, and hustle and bustle that cities offer. I was born and bred in Perth, the West Coast capital of Australia, which is home to about 2 million people and one of the world's most isolated cities. Growing up, I always dreamed about moving to a bigger city to pursue my career and dreams. Melbourne, Sydney, and Singapore were always on my mind. But never New York City.

Life turned around—in a good way—when I met my husband. My aunt introduced us when I studied abroad in New York City for my postgraduate summer program in 2014. And no, it was never a setup. Prior to the meeting, I thought my aunt was going to introduce me to an older guy in his late 30s or 40s. Surprisingly, the man she introduced me to wasn't much older than me, and we hit it off right away. When I left the United States, we stayed in touch almost every day, but I never intended to take things further.

Six months later, my future husband surprised me with air tickets to Singapore, where he made plans for us to meet up. After that trip, the rest was history. For nearly four years, we dated long distance between Perth and New York City. We traveled back and forth and visited multiple cities together, including Hong Kong, Tokyo, Kyoto, Seoul, Melbourne, Sydney, Montreal, and Washington, D.C. Today, we are happily married and live in New York City.

The designs in *Urban Quilting* were influenced by my travels, urbanscapes, and urban living. This book serves to be a resource for beginners, while also challenging experienced quilters with new techniques and ways of thinking. In addition to offering quilt patterns for various experience levels, the designs explore a variety of methods that help build on your skills. Each pattern also includes a brief insight into quilting history to help you connect the past with the present. Perhaps it will inspire you to write your own story and chapter in the quilt history books. It brings me great honor that you have picked up *Urban Quilting*, and whether or not you choose to make anything from these pages, I hope this book somehow touches you in your quilting journey.

Why I Started Quilting

I used to work for a marketing research and consulting agency. Turning data into business decisions and advice, and seeing the positive changes in my clients' businesses, were things I loved about my job. But working in the industry came with long hours, overlapping deadlines, and never-ending workloads. There were days I was very tempted to sleep on the couch in the office because it was past midnight and I felt too tired to drive home. There were mornings I got into near misses on the freeway and scratched my car at the office garage because I was exhausted from working late the night before.

Quilting was my way to decompress and escape from a hectic corporate job. It was my creative outlet. Thinking about my sewing desk and all the projects waiting on it helped me get through long hours at the office. These thoughts also helped me keep my work life and personal life separate from each other. I did my very best to carve out dedicated time during the week to create by not bringing my laptop home and by not checking work e-mail on my phone (unless I "really" had to). My creative efforts led to the birth of my brand and Instagram account @*the.weekendquilter*. The need to frequently create content and post on Instagram to stay relevant, and the connections I made on the social networking site, kept me accountable to maintaining a work-life balance.

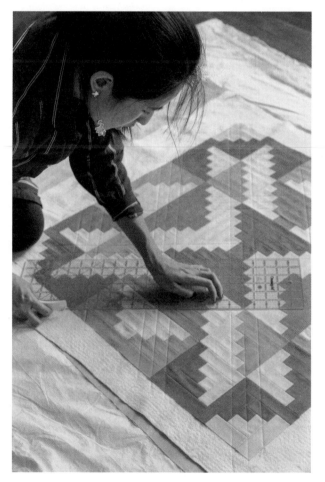

Although my grandmother and mother knew how to sew and make dress patterns, my introduction to quilting did not come from them. My quilting journey started in my parents' dining room, which one of my older sisters turned into a quilting room back in 2010. Watching her turn carefully cut pieces of fabric into elaborate quilts for friends and family—and seeing their faces when they received the quilts—sparked my interest in the craft. At the time, I was still a university student and worked part-time at my corporate job. After covering my school and living expenses (and satisfying my shopping habits and travel bug), I didn't have much money to spend on quilting classes, tools, or fabrics. I only used free online quilting patterns and my sister's tools and scraps. The clearance and fat quarter sections built my fabric stash. And with my basic sewing skills from high school home economics, I taught myself how to quilt.

Why I Wrote This Book

Being a self-taught quilter, I learned things the long and hard way. For example, I once cut more than a thousand triangles for a queen-size quilt instead of using cutting and piecing shortcuts. Before I knew about chain piecing, I stopped and started the sewing machine at the end of each piece. Rather than pressing my seams as I went along, I sent quilt tops to the longarm quilter with my seams looking bulky and all over the place. (For those who have not heard of these quilting terms, don't worry. I'll clue you in when we go over the basics and tips on how to construct a quilt.)

The way I worked really changed when I participated in Sharon Holland and Maureen Cracknell's Sewcial Bee sew-along in 2017. Their comprehensive and creative block patterns introduced me to short-cuts and different construction methods. Learning various ways to make Half-Square Triangles, Flying Geese units, and quilt blocks helped me break down the thought process that goes into quilt design and construction. Sharon and Maureen's weekly quilt block built my confidence, which led me to put my own designs on paper and turn them into quilts—and not just for the bed and the couch. My creations became wall hangings and table runners, as well as pot holders, coasters, and placemats.

Quilts are a timeless part of our homes and heritage, and quilting is an art form that has thrived for centuries and continues to do so today. Whether you work full-time behind a desk, stay up late working the night shift, or are a full-time mom or dad, we are all weekend quilters. We carve out time in our week to dedicate and create for many reasons. People no longer just quilt because it fills a practical material need. Quilting fills personal needs that are unique to each individual.

Quilts are an invitation into the maker's mind and thought process. The simplest decisions, such as design, colors, threads, fabric selection, and placement, are all chosen with intention and reason. Quilts tell stories. They are reflections of us. They commemorate significant life events, such as the union of two families, the birth of a new baby, graduations, retirements, or the passing of a loved one. The act of quilting helps a person clear their mind and engage in creativity, and it's a welcome distraction from what goes on in our hectic lives. The process also helps some of us heal and get through the darkest times.

As a modern quilter and pattern designer, I aim to continue this tradition and pass down a creative legacy through my designs that inspires others to create. Throughout the book, we'll explore detailed instructions for ten different modern quilt patterns inspired by architecture, urban interior design, nature, and traditional quilt designs. I designed the patterns in this book for quilters who are about to embark on their quilting journey, others who have been quilting for several years, and those that just want to flick through pretty photos for quilting decor inspiration for the modern home. As you turn the pages of *Urban Quilting*, I hope the designs get you inspired and excited for your next project. I also hope your quilts bring you and your loved ones a sense of joy and heartwarming memories. Now, let's take a moment to learn a little about quilting's history so that you can appreciate the origins of modern quilting!

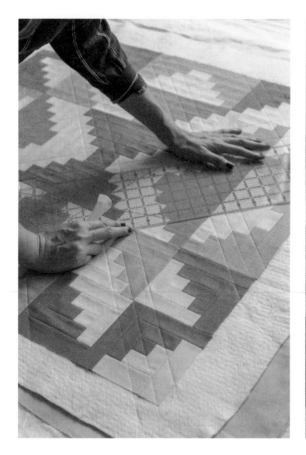
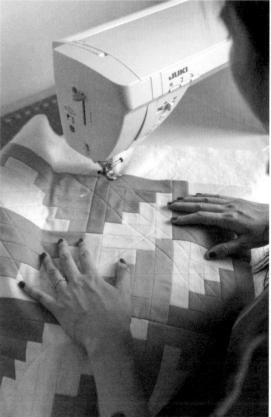

A BRIEF HISTORY OF QUILTS

What is Quilting?

When I tell people I quilt, they often ask me what it is. This question brings me joy and shows that more work is required to share this craft and pass it down as a creative legacy for generations to come.

Quiltmaking can be divided into two main steps. The first step involves gathering and cutting pieces of fabric and sewing them together to form a larger textile called the quilt top. The second step involves layering the quilt top, insulation (or batting), and quilt back and securing the layers with decorative stitching. This decorative stitching is called "quilting" and is what gives this craft its name.

Quilting is one of the oldest forms of needlework and continues to thrive as the world around us evolves. Just as they did for our ancestors, today's quilts do more than fill our practical needs for warmth and protection. They also play a role in adorning the spaces we use every day. Quilting is a creative outlet that gives us a platform with which to tell our stories. The following pages will share a brief insight into quilting's humble beginnings and how it transformed into a global multimillion-dollar industry.

Quilting's Earliest Days

The earliest known evidence of quilting dates back to about 3400 BCE in ancient China and Egypt. In the Western world, quilted garments made their first appearance as garments under knights' armor for comfort, protection, and warmth. It is believed that the armies of the crusaders noted the quilted undergarments in the Middle East and brought the idea back to Europe during the Middle Ages. Quilts gradually made their way onto European beds in the fourteenth century as bed coverings and decorative panels.

Quiltmaking was brought to North America by Dutch and English settlers in the early seventeenth century. At the time, quilts served more practical, utilitarian purposes—keeping people warm—rather than aesthetic ones. They were also a symbol of wealth. Fabrics for quilting were not easy to come by unless you had money and lived in or near an urban area with access to imported goods. Many quilting fabrics were manufactured in India and imported through Europe. Settlers with little money had to be frugal and creative in how they sourced and used fabrics. These resourceful women used fabric scraps from dressmaking, old clothing, and feed sacks to sew their quilts.

Leisure time was another variable that highlighted quilts as a symbol of wealth. Quiltmaking was both time- and labor-intensive. Sewing machines did not exist, and everything was done by hand. In households without helpers, women had limited time for quiltmaking on top of their daily responsibilities, such as tending to the garden, livestock, and children; harvesting crops; cooking; and laundry. To speed up the process, women gathered together to help each other make quilts. Known as quilting bees, these gatherings were also a means of socializing.

A very popular quilting style during this period was wholecloth quilting. Unlike patchwork or pieced quilts, wholecloth quilts were made from one piece of textile, colored with natural dyes. On top of these fabrics, quilting designs often featured intricate and repeating stitches such as clam-shells, feathers, and floral motifs and shapes.

Quilting Advancements in the Nineteenth Century

In the nineteenth century, the industrial revolution helped drive the growth and commercialization of quilting. The introduction of sewing machines made quiltmaking easier and faster. Improvements in spinning, weaving, and printing methods, as well as the expansion of transport and distribution networks, increased access to fabrics and tools for quiltmaking. With these changes, quilting was no longer associated with the affluent. The development of new quilting fabrics and tools meant that quilters could get more creative and generate new elaborate and artistic designs. Quilters gradually drifted away from wholecloth quilts, and assembling several pieces of fabric and blocks became the new trend in quilt design. Although fabrics were widely available and priced at a lower cost, women continued to incorporate scraps from dressmaking projects and old clothes during this period. Consumers also had limited access to sewing machines up until the late nineteenth century.

As ownership of domestic sewing machines increased, so did the demand and establishment of quilt design companies and quilting retailers. In the 1850s, Singer, a sewing machine manufacturer, introduced installment plans to make the ownership of sewing machines even more attainable and affordable. As the popularity of quilting grew, newspapers, farm periodicals, and popular women's magazines published quilt patterns and served as a voice for the quilting industry. These publications shared and promoted quilting services and goods and printed special editions containing patterns, mail-order catalogs, and tips. Mail-order catalogs, quilt kits with patterns and pre-cut fabrics, batting, and quiltmaking tools were also made widely available for consumers.

Quilting in the Aftermath of World War II

The focus on quilting shifted during the Second World War (1939—1945). Quilting lost momentum due to numerous factors. First, women were brought on board to fill in gaps in the workforce while the men were fighting in the trenches. Women also contributed to the war effort by lending their sewing skills, making items for soldiers and victims, and raising funds for the war effort.

These new responsibilities took time away from quilting. Moreover, the perception of quilting changed when readily made bedding and soft home furnishings were inexpensive and widely available for purchase. Quilting began to be seen as outdated, and patching together fabric scraps suggested it was for those who could not afford new bed coverings.

Frugality also brought back memories of the poverty and hardships many experienced during the Great Depression in the 1930s. The desire for new, shiny things was in the eyes of many American consumers in the 1950s. This created a culture of consumerism, particularly in more urban areas. On the contrary, the consumerism culture didn't really take off in rural areas of the country, where the craft carried on as it was.

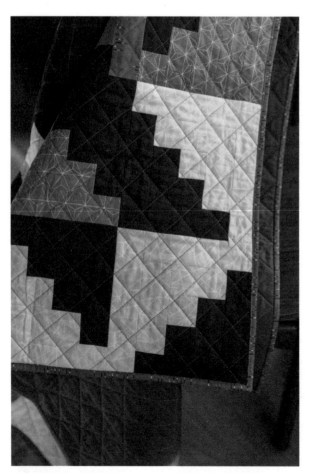

The Revival of Quilting

The year 1976 marked a special moment in American quilting history: America's 200th year of independence from British imperial rule was a platform for the latest quilt revival. In the years surrounding this historical occasion, thousands of people across the country learned and took up quilting. Quilting was no longer associated with poverty and the hardships endured in the depression era, but rather a desire to understand and reconnect with the past. Quilts made during this period documented local history and families and captured the spirit of patriotism, optimism, and new beginnings. New quilters took inspiration from quilts of different eras and what was around them and put their own flair on them. This was also when some of the earliest quilt guilds in the country were established.

Modern quilting also started to emerge around this period. In the 1960s, art quilting made its first appearance. This style features improvisational piecing and the use of solid fabrics. Nancy Crow and Gwen Marston were some of the quilters that pioneered this style and inspired other quilters to go beyond repetitive, traditional quilting blocks.

Amish quilts were also a key influence in the birth of the modern movement. The large-scale piecing, use of negative space, and bright and bold solid fabrics characteristic of these quilts have carried through to today's quilting projects. Further ushering in the era of modern quilting, museum exhibitions and quilt collectors opened their doors to the world of quilting. One notable exhibition took place in the early 2000s at the Museum of Fine Arts in Houston. This exhibition showcased quilts made in Gee's Bend, a small remote African American community in Alabama. These quilts were constructed using improvisational piecing methods, and the designs and use of bold, solid colors made them unique and different.

Quilting Today

Technological advancement in the late 1990s and early 2000s led the way in making modern quilting more mainstream. The introduction of the internet and digital cameras enabled quilters to instantly publish photos and videos of their projects on blogs, forums, and social media sites. These outlets gave quilters a platform for sharing the progress of their work, finding and sharing tips and tutorials, and connecting with other makers across the globe. Fabric manufacturers responded to the increased interest in modern quilting by creating fabrics with a more modern aesthetic. Many introduced and expanded their range of solid colored fabrics and commissioned graphic designers and artists to develop fabric collections incorporating graphic and bold prints. This dramatic change in fabric design also inspired quilters to try new techniques and branch out into different design aesthetics.

Today, the quilting community has never been more connected. The establishment of the Modern Quilt Guild, an international quilting organization, in 2009 has fast-tracked these networks and enabled quilt guilds and quilters across the globe to turn their online connections into monthly in-person meetups and annual conventions. With faster and newer technologies, we can access and exchange information; attend online classes and workshops; participate in virtual quilting bees and quilt-alongs; make new connections; seek inspiration; and buy and sell new quilting designs, materials, and tools at the touch of our fingertips.

Quilting has evolved from a necessity to a multimillion-dollar industry. Year after year, more quilters across the globe join in the conversation, telling their own stories through their work. They are pushing the boundaries and changing the aesthetics of quilting as the world around us evolves, inspiring a new generation of quilters. It brings me great honor and excitement to share the craft of quilting with you on these pages and write my own chapter in the history books.

GETTING STARTED

If you're new to quilting, we'll go over all the basics in the pages that follow. If you have some quilting experience already, you may still find it helpful to review this section before beginning any of the patterns in the book.

To help you decide on your next project, each pattern includes the skill level at the beginning. There are two levels of difficulty:

> **Beginner**: Start here if you are new to quilting. These projects are the easiest and quickest to complete.

> **Advanced Beginner**: Once you're feeling more comfortable and are up for a little challenge, move on to these projects.

The instructions throughout this book are based on the assumption that you have basic knowledge and experience with using a sewing machine. You'll find tips relevant to the project along the way to ensure accurate and successful outcomes.

Before we get started on the exciting stuff, you need to gather the right tools and materials and familiarize yourself with how to assemble your quilt from start to finish. For beginners, I suggest that you read the information on "Tools" *(page 9)*, "Setup" *(page 13)*, and "Quilt Assembly from Start to Finish" *(page 14)* to get an understanding of the basics. Don't stress—you don't have to remember all the ins and outs right away. It takes time and practice. This information will always be here as a reference— even for seasoned and experienced quilters. If you're feeling confident and comfortable, feel free to jump ahead to "General Instructions" *(page 32)* before you get started.

Tools

The following is a list of essential tools to get you started. Over time as you build your confidence, get more comfortable in your workspace, and gain a better feel for how you work, you can invest in other tools, such as smaller and larger rotary cutters and rulers, rotating cutting mats, wool pressing mats, and many more.

Rotary cutter: That pizza cutter-looking thing is a rotary cutter. Although fabric scissors are also on the list of essentials, you'll be using this tool more often. Designed for more accurate and faster fabric cutting and trimming, rotary cutters come in various sizes. The gold standard size is 45mm. This is the perfect size to make all of your basic quilting cuts.

Spare rotary cutting blades: Dull rotary cutting blades slow things down. You know it's dull when you need to run the rotary cutter in the same place more than once to make a clean cut. Imagine having to run your rotary cutter more than once to cut each piece—that's comparable to cutting fabrics for at

least two quilts! This is why it's handy to have spare blades available (in the packaging, of course) and to replace the blade every two to three projects. With a sharp blade, you should be able to cut through six to eight layers of quilting cotton fabric at once.

Fabric scissors: Fabric scissors are convenient for making quick snips without compromising the crisp, fresh cuts you've made with your rotary cutter.

Quilting rulers: Quilting rulers can be used for cutting, measuring, and marking guidelines on fabrics. Quilting rulers come in various sizes and forms, each with its own purpose and ability to make cutting and measuring easier and faster. The three essential sizes I suggest investing in when starting your quilting ruler family are:

1. 6" x 24": With this ruler length, you can cut strips that are as long as the width of the fabric, prepare and trim large pieces, and square up your quilts. If you can only invest in one ruler, this is the one I highly recommend.

2. 6" x 12": This smaller ruler is perfect for cutting and trimming smaller pieces. Compared with the 6" x 24" ruler, the length will not weigh you down, and you'll have better control over your cuts.

3. 12½" x 12½": Cutting squares is a common occurrence in quilting, so it just makes sense to invest in a large ruler for all squares, big and small.

Different ruler sizes come down to personal preference. As you develop your skills, put some thought into investing in specialty rulers to help speed up the cutting and trimming process, and to explore new techniques. For example, you might consider purchasing a 60° triangle ruler for triangle piecing or a Stripology Ruler to cut multiple strips of fabric, squares, and rectangles at a time.

Measuring tape or tape measure: This comes in handy to take measurements that are beyond the size of your quilting ruler (e.g. length of the quilt).

Cutting mat: A cutting mat offers protection against ruining your beautiful surfaces and helps prevent your fabric and ruler from slipping and sliding when cutting and trimming. I also use this tool when pinning pieces of fabric together so I don't scratch my desk.

Cutting mats come in various sizes, and the size you choose depends on the size of your workspace. If you're going to invest in just one cutting mat, ensure there is enough overhang to cover the width of the fabric. The standard width of quilting fabrics is 42", and it generally comes folded in half. You've probably done the math already...you'll need a cutting mat that is at least 21" in length.

Always store your cutting mat flat to prevent warping. Try to keep it clean and restrict its use strictly for fabrics. You don't want your other crafty projects to get stuck on your quilting project!

Pins: These will be your best mates that have your back and prevent your fabrics from shifting when you put them through the machine. Use good-quality fine pins designed for quilting. Big, bulky pins can puncture and damage your project and make it more difficult to align your seams, compromising accurate piecing.

Seam ripper: This is great for those moments when your hands have their own mind and do something that's not outlined in the pattern, or your seams are just slightly off and not aligned. But it's not so great when there's a lot of seam ripping involved, because it means you'll need to go back and redo all that work. Doh!

Sewing machine needles: A dull sewing needle can damage your fabric and cause bad tension, puckering, and skipped stitches. It's also not good for your machine in the long-term because it needs to work twice as hard. Keep spare sewing machine needles available in your tool kit, just in case a boo-boo happens and your needle snaps, or for when they get dull from all the quilting you will be doing.

Thread: You can't go wrong with 50-weight cotton thread for everything on your quilt project, from piecing to quilting to adding the binding. For piecing, you can use a finer thread weight as low as 80-weight. This yields visibly flatter seams and makes it easier to match your seams.

Painter's or masking tape: Yeah, I know. What on Earth is tape doing on the sewing table? Well, it's useful for a number of reasons. For example, the paper-like surface makes it easy to write on when labeling your quilt blocks and pieces.

You can also tape up your quilt blocks on the wall or a surface near your sewing machine as a quick reference when you are unsure how blocks should be assembled, especially with blocks that look really similar.

Tape can also be used to secure two pieces of fabric together. The benefit of using tape instead of pins on some occasions, such as putting together four-in-one Flying Geese units, is you can get a smoother and flatter surface when running your pieces of fabric through the sewing machine. As a result, you can achieve straighter and more accurate piecing. Moreover, you can sew over the tape without worrying about breaking your sewing needle. I'll go over this technique in more detail when we make Flying Geese units in one of the projects.

Iron: Use an iron to smooth out any creases in the fabric before cutting, sewing, or quilting, and to press your seams to achieve accurate and precise piecing.

Fabric markers: These are available in various forms, such as pens, chalk, and pencils, as well as color. I keep a water-soluble blue fabric marker in my tool kit to mark guidelines for sewing. It is always a good idea to test your fabric markers on a scrap piece of fabric from the project you are working on to see how visible the marks appear and if they easily come off. You may want to invest in different colored markers depending on the color of the materials you are working with.

Hera marker or dull knife: This is another useful tool for marking guidelines, particularly quilting guidelines, if you choose not to send your quilt to a longarm quilter.

Walking foot: Newer sewing machines tend to come with this extension. The walking foot provides additional grip and works in unison with the built-in feed dogs under the presser foot on your sewing machine to prevent all three layers of quilting from shifting as your project moves through the sewing machine. This extension also helps reduce puckering and air bubbles in your project. If you plan on sending your quilts to be quilted by a longarm quilter, I would not worry about investing in a walking foot.

Tip: Not sure where to find these tools? At the back of the book, you'll find a list of brick-and-mortar and online retailers where you can purchase tools, fabrics, materials, and more for your quilt projects.

Setup

Before you begin, make sure you are working in a space where you feel comfortable and inspired to create. Start with a clean, large, hard surface for your sewing machine where you can lay your fabrics out for cutting and quilt-sandwich making. You'll learn more about how to put one of these quilt sandwiches together on *page 19*. Make sure the room you're working in is well-lit so you can see what you're doing. Perhaps even put on some music that gets you pumped for quilting fun. I also like to play podcasts, TV shows, and movies that don't require too much of my attention in the background to keep me company while I'm sewing.

Quilt Assembly From Start to Finish

This section walks you through each step of the quilt assembly process, from choosing and preparing your fabrics to cutting, piecing and pressing, quilt-sandwich making, quilting, and binding.

Step 1: Choosing and Preparing Your Fabric

One of the joys of the quilting process is picking out fabrics for your next project. You can mix and match different colors, prints, patterns, and textures to form something special and unique. Quilting fabrics are usually made of 42"-wide woven cotton. Fabric requirements in this book are based on 42" fabric width, though we have built a little bit of extra material into the fabric requirements in case of errors or slight variances in the width.

Quilting is a global craft, and fabrics are sold in different units in different countries. Therefore, I have converted the fabric requirements in each project into centimeters, as well as yards, based on experience. When I first started quilting, I walked into my local fabric store in Australia and none of the staff were able to assist with converting yards into centimeters. I ended up going home with more than enough fabric for three baby quilts, when all I needed was fabric for one throw quilt. I still have these fabrics in my stash to this day!

Sometimes manufacturers skip the prewashing (or preshrinking process) to speed up production time. This is one of the main reasons why the topic of whether or not to prewash your fabrics before cutting comes up fairly frequently in the world of quilting. Quilters prewash their fabrics to avoid the "antique" or crinkled look after washing their finished quilt. The golden rule is: if you choose to prewash your fabrics, prewash everything, unless you are mixing higher-quality cotton fabrics with less-expensive or vintage cotton fabrics. The reason for this is because fabrics of varying quality shrink at different rates, causing the completed quilt to have wonky seams once it has been washed.

Personally, I prewash if I'm not sure or have not used the brand before. However, I often find myself in the non-prewash category because I get too excited about starting a new project. I also don't like how the fabric can get a little limp after washing, making it a little finicky to work with when cutting and piecing.

I intentionally chose the fabrics used in this book so that the quilt designs can easily be replicated. See the "Color Inspiration" page at the start of each quilt pattern for fabric details, including manufacturer, designer, collection, name, and color. All the solids are Robert Kaufman Fabrics' Kona Cotton, which comes in more than 300 colors and is widely available from local and online retailers globally. All the printed and patterned fabrics are from Hawthorne Supply Co., whose in-house designers design their fabrics. These quilting cottons are available print-on-demand from Hawthorne Supply Co.'s online store and can be shipped worldwide.

Note: The fabrics in the book were not sponsored by these companies.

Step 2: Cutting Your Fabric

Before cutting any squares, triangles, or rectangles for your projects, ensure you have done the following to achieve the most accurate piecing:

1. Always iron out all creases in the fabric. Sometimes this may mean ironing both sides of the fabric, depending on how it was stored.

2. Check that the cutting blade on your rotary cutter is sharp.

3. Use a ruler and rotary cutter to trim jagged or uneven edges. To do this, use the folded edge of the fabric as a guide to ensure it is straight and right-angled against the width of the fabric. Remember that no matter how straight fabric appears, the naked eye can play tricks on you.

Note that quilters work in inches. This is why all quilting rulers are in inches. If you grew up using the metric system, this can be a little weird. However, I highly recommended that you do not convert cutting directions into centimeters or millimeters. Designers spend hours calculating how big and how many pieces are required to make a project, so you don't need to do the hard work to figure that out. By converting it into centimeters and millimeters, you run the risk of inaccurate piecing. This is because the individual pieces of fabric and seams will not align with each other. All cutting directions include ¼" seam allowance.

Cut all larger pieces first. Why? It allows you to maximize the fabric, and prevents you from running into a scenario where you have enough fabric but it is not all in one piece. All cutting directions in this book start with the largest piece and work down to the smallest, unless a particular order is otherwise specified.

Finally, just a few more cutting tips and housekeeping rules to keep in mind:

- ✂ Cut away from the body, not toward yourself.

- ✂ Do not cross your arms one over the other while cutting. If you're right-handed, use your left hand to secure the ruler and hold the rotary cutter in your right hand so you can cut your pieces from right to left. For lefties, right hand on the ruler, rotary cutter in the left hand, and cut from left to right.

- ✂ Cutting can turn gruesome if you don't pay attention. Focus on what you're doing, and make sure your fingers are not in the way of the cutting blade.

- ✂ Stand up when you cut. In doing so, you can use your body weight to apply pressure on the ruler to prevent the ruler and fabric from shifting, which allows you to achieve accurate cuts.

- ✂ Measure twice, cut once. Double-check that your ruler is aligned correctly and ensure you have read the cutting directions carefully before cutting. Cutting the wrong size of pieces can stop a project in its tracks.

Step 3: Piecing

A majority of quilting patterns call for a ¼" seam allowance. If seam allowances are off, the individual pieces, corners, and points will not match up when it comes to sewing them together. In other words, the more precise your seams are to the ¼" seam allowance, the more accurate your work will be.

Many sewing machines come with a ¼" seam allowance presser foot extension. If you don't have one, they are widely available at your local sewing/quilting shop or online retailer. However, even with this extension, I still recommend that you check if the machine's needle position is at its true ¼" seam allowance. There are a couple of ways you can do this:

1. Place a quilting ruler between the machine and the presser foot of your machine, imagining the ruler is a piece of fabric. Ensure the quilting ruler is lined up with the right edge of the presser foot and gently lower the presser foot to secure the quilting ruler in place. Then turn the hand wheel to slowly lower the sewing machine needle to touch the ruler. If the needle touches the ¼" mark on the ruler, you're good to start sewing. If not, adjust the needle position left or right accordingly so it matches the ¼" mark on the ruler.

2. If you find that your machine does not allow you to shift your needle position, you could place a quilting ruler between the machine and presser foot and slowly lower the sewing needle with the hand wheel to meet the ¼" mark on the ruler. Gently lower the presser foot to prevent the quilting ruler from shifting. Then stick a 3" piece of masking tape on the throat plate, with the left edge of the tape lined up with the right edge of the ruler to indicate where your fabric edge should sit in order to get a ¼" seam allowance. Remove the ruler.

Once you've made these adjustments, test it out on a 4" square scrap fabric. Cut the fabric in half into two 2" x 4" rectangles. Sew the two pieces together and press the seams open. The new pieces should measure 3½" x 4".

For faster piecing, there are a couple of methods to speed things up:

1. **Chain piecing**: Chain piecing is an efficient and quick technique to sew together pieces of fabric, one after the other. With this technique, you continuously sew your pieces together without cutting the thread between each set. Essentially, all your pieces are linked together with one continuous length of thread. Not only does this save time in stopping and starting the sewing machine at the end of each set, but it also saves thread.

2. **No pins**: Taking the time to pin and remove pins from your fabrics can take up valuable sewing time and potentially damage your fabrics. As you gain more confidence in sewing pieces together, you'll find yourself using fewer pins, or maybe none at all. To take the no-pinning route, carefully align two pieces of fabric together, holding them lightly, but not so lightly that shifting happens as you pass them through the sewing machine.

Step 4: Pressing

Press. Do not iron back and forth like you would a shirt. Ironing can stretch and distort fabrics, especially smaller and thinner pieces. To press, use an up-and-down motion with an iron to flatten your seams. Pressing as you go is essential for creating flatter seams for accurate piecing and reducing seam bulk.

A handy tip before you start pressing to one side or opening your seams is to press the seams as sewn to help the stitches sink into the fabric, reducing seam bulk. Then use either your finger or a hera marker to gently press the seams open or to one side. This makes the pressing portion easier because the seams are somewhat pressed already and you're not fiddling about with a hot iron in your hand. This is an additional step, but so worth it for those flat seams and accurate piecing.

There are a couple of ways to press your seams:

1. Pressing open (pictured at left below): Separate the seams and lay them flat in opposite directions on the wrong side of the quilt block.

2. Pressing to the dark side (pictured at right below): Both seams are shifted toward the darker fabric on the wrong side of the quilt block.

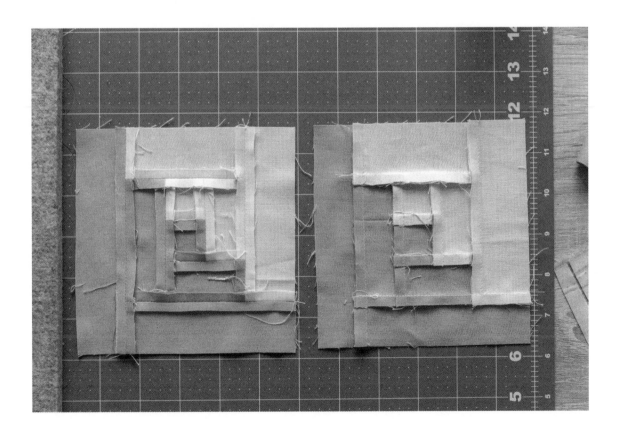

Each method has pros and cons:

Pressing Open	Pressing to the Dark Side
Pros: Quilt tops lay flatter and crisper because seams are evenly distributed. Easier to align seams for more complex blocks when there are multiple points that need to be matched.	Pros: Helps strengthen the quilt long-term. Pressing to one side protects threads from catching on things that may cause pulling, fraying, and stress on the fabric. Seams don't show through on lighter fabric. Pressing is easier and faster. Matching seam intersections is easier and faster, if seams are pressed alternating.
Cons: Quilt is more vulnerable to damage because seams are exposed. Can be more time-intensive and difficult to align seams.	Cons: Bulky seams.

My pressing philosophy is this: you do you. Do what you're more comfortable and familiar with. As long as you stick to your pressing game plan throughout the project for consistency, you're good. If you're not sure, try both ways of pressing in separate projects or test blocks. Personally (and throughout this book), I press my seams open.

Step 5: Quilt-Sandwich Making (Basting)

Once your quilt top is complete, you have two options: assemble all three layers—quilt top, batting, and quilt back—yourself and make it into a "quilt sandwich," or send your quilt to a longarm quilter. You can find longarm quilting services by asking a fellow quilter in your area or searching on Instagram or Google. I have also included a small list of longarm quilters (U.S. only) recommended by the quilting community at the back of the book *(page 152)*. Choosing the longarm quilter route is the easiest option, and you can pick visually effective and decorative finishes. However, this comes with an additional cost, and depending on your longarm quilter's workload, it may take weeks to complete the quilting. This step is about putting together your quilt sandwich (or basting), and the next step explains how to do the quilting yourself. If you're sending your quilt to a longarm quilter, feel free to jump to Step 7, "Binding" *(page 25)*.

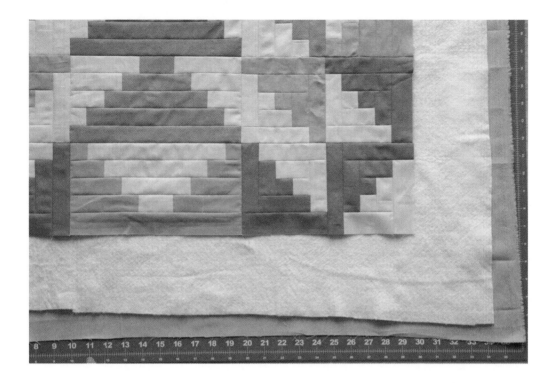

In the quilting world, "basting" is the term used for securing all three layers—quilt top, batting, and quilt back—to prevent shifting during quilting. There are a few methods to baste your quilt sandwich, including pinning, stitching, or spraying. If you're new to quilting or quilt-sandwich making, start on smaller projects to build your skills and confidence. Wall hangings, baby quilts, pillows, and cushions are perfect projects for quilt-sandwich beginners.

Preparing the Quilt Back

Before any quilt-sandwich making takes place, you need to determine if your quilt back (or backing fabric) needs to be pieced together to cover the entire quilt top with approximately 4" overhang on each of the four sides. Depending on the width of the backing fabric, you generally need to join at least two pieces of fabric together for throw-size or larger quilts. To save time and effort, you can purchase backing fabrics in widths greater than the standard 42". For quilts smaller than queen size in this book that require the backing fabric to be pieced together, you will need to cut the yardage in half lengthwise. For queen-size quilts or larger, you will need to cut the required backing fabric yardage into thirds lengthwise. Remove selvedges before sewing backing fabric together.

At this step of the quilting process, this is the only seam-allowance exception, in which you need to increase the seam allowance from ¼" to ½" and press the seams open. Incorporating these two steps in preparing your quilt back will reduce seam bulk, strengthen the quilt long-term, and reduce air bubbles in your quilt sandwich.

Speaking of bubbles, lumps, and bumps, these are a few important steps to follow to achieve a smooth and flat quilt:

1. Ensure your quilt-sandwich making space is big enough to fit your whole quilt, and the surface you're working on is flat and hard, such as hardwood floors or a large worktable.

2. Iron out all creases and wrinkles in your quilt top and back, as well as your batting, since it's been sitting in packaging for a long time. When ironing batting, I recommend using a lower heat setting on your iron, especially if the batting is made with man-made fibers like polyester. [Photo A]

3. Place your quilt back with the right side facing down on your basting surface. Using a large quilting ruler, push out any air bubbles. You may need to do this more than once. To prevent the back from shifting as you work, secure it to your basting surface with painter's tape. [Photo B]

If you are going with the spray basting route, I suggest also lining your basting surface with a layer of newspaper, an old bedsheet, or painter's tarp that is bigger than the quilt sandwich. Doing so prevents your workspace from being covered in sticky basting spray (for the most part).

4. Lay the batting on top of the backing. Start at the center of the quilt and make your way to the edges, pushing out air bubbles with a large quilting ruler. [Photo C]

If you are spray basting, peel back half the batting and spray the quilt back in small portions and then stick the batting to the quilt back. Repeat until the entire surface has been covered.

5. Similar to Step 4, lay the quilt top with the wrong side touching the batting, and smooth out any lumps and bumps with a large quilting ruler. [Photo D]

A

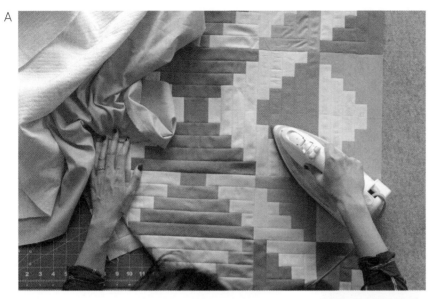

B

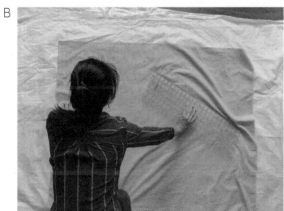

C

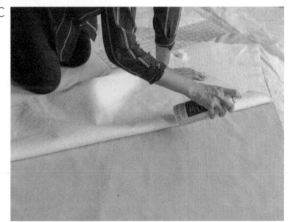

D

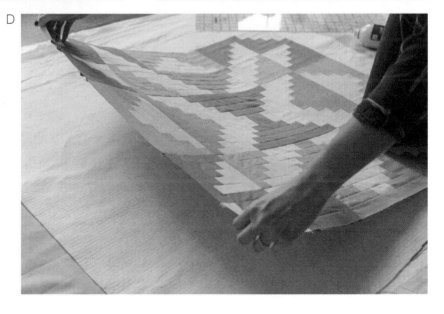

6. *If spray basting:*

When you're done spray basting between each of the three layers, flip your quilt sandwich the other way, so the quilt back is facing up. Use a quilting ruler to push out any air bubbles on the front and back of the quilt again. Take your quilt top to the ironing board and iron the three layers together to activate the glue. This will prevent the layers of the quilt sandwich from peeling off as you work with it. This is also another opportunity to smooth out any lumps in the quilt.

If pin basting:

Place safety pins approximately 2" to 3" apart from each other. Use enough to secure the three quilt layers around your marked quilting guidelines, so they won't get in the way when you're sewing. To speed things up, place all the safety pins in place and then close them all when you're done.

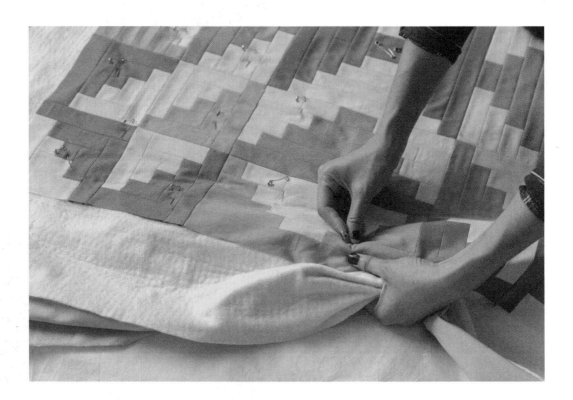

Now your quilt sandwich is ready for quilting!

Step 6: Quilting

The word "quilting" is versatile and can be used to describe different actions throughout the quilting process. For this particular point of the process, "quilting" is sewing together and securing the three layers of the quilt sandwich with straight lines or decorative stitching. This can be done by hand, also known as hand quilting, or by machine.

Quilting stitches and thread colors can accentuate the shapes and colors on your quilt top, as well as add other visual dimension and excitement to the overall look of the quilt. Sometimes stitching can compete with other design elements on the quilt. Therefore before you begin any quilting, whether by hand or machine, use careful planning and consideration when deciding how to quilt your quilt. Coming up with a quilting plan could mean drawing lines on a piece of paper with the quilt design, or you may simply have a general idea in mind.

Once you feel like you have a quilt plan ready, mark your quilting lines with a hera marker or a dull knife. Use a quilting ruler to achieve straight and evenly spaced lines. When using the hera marker or dull knife to mark quilting guidelines, apply a bit of pressure to leave a mark in the fabric. This may mean having to go back and forth on the same area multiple times with pressure.

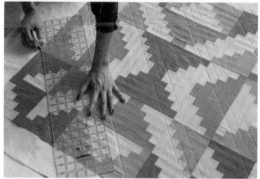

You may need to make a couple adjustments to the sewing machine before quilting. First, attach the walking foot onto the machine for straight-line quilting (free-motion quilting requires a free-motion or darning foot). Adjust the stitch length to anywhere between 2.5 and 3.0 and use 50-weight thread. These suggestions on stitch length and thread weight will showcase the quilting stitches. Your decision with these two variables comes down to preference—how visible you would like the quilting thread to be. If you're not sure, make a scrap quilt sandwich and test different thread weights and stitch lengths to find what you prefer.

When you're done sewing your quilting design, sew a border approximately ⅛"away from the edge of your quilt sandwich to provide additional enforcement to the quilt sandwich before trimming off excess quilt batting and backing fabric and squaring up the quilt to attach the binding.

Step 7: Binding

You're so close to the finish line, and soon you (or some other lucky person) will be snuggling up in the quilt you've made. But before we can cross that finish line, you need to attach the binding to the quilt.

Binding is the strips of fabric that wrap around the outer edges of the quilt sandwich to prevent the raw edges from fraying. It is another design element of a quilt and is attached at the very end of the quiltmaking process. We'll go over how to make binding strips and how to attach the binding to the quilt.

Preparing Binding Strips

1. For the projects in this book, refer to "Binding Fabric" under the "Cutting Directions" in the quilt pattern to identify the number of 2½" strips required for the quilt size you are creating.

2. With the wrong side of the fabric facing up, lay the binding strip horizontally and make a mark 2½" from the left edge. Draw a 45-degree diagonal guideline from the bottom left corner to your mark. [Photo A]

3. Join all the binding strips to form one long binding strip by pinning two 2½" strips at a 90-degree angle, with the right sides together and the marked guideline facing up. Sew along the guidelines. [Photo B]

4. Trim ¼" seam allowance to the outside of the sewn line. Press the seams open at the joints. Do not press seams to the dark side. Pressing the seams open will reduce seam bulk and create an even surface around the quilt. [Photo C]

5. Fold the binding in half lengthwise, with the wrong sides of the fabric facing each other, and press flat. The binding strip will be 1¼" wide. [Photo D]

Attach Binding to Quilt

There are couple of ways to attach binding to a quilt: hand binding and machine binding. For this example, I'll show you how to attach binding with your sewing machine. This method is faster and will hold up better over time compared to hand binding.

1. Start with the quilt back facing up. Align the raw edge of the binding with the raw edge of the quilt sandwich. Start sewing at about 4" from the top of the binding and ¼" from the raw edges. [Photo E]

2. Keep sewing until your needle hits ¼" from the corner. Stop here and backstitch. Then remove the quilt from the sewing machine. [Photo F]

3. Turn the quilt 90 degrees, with the raw edge of the quilt sandwich on the right. Fold the binding at a 45-degree angle and then fold the binding strip back down so the raw edge is aligned with the raw edge of the quilt sandwich. [Photo G]

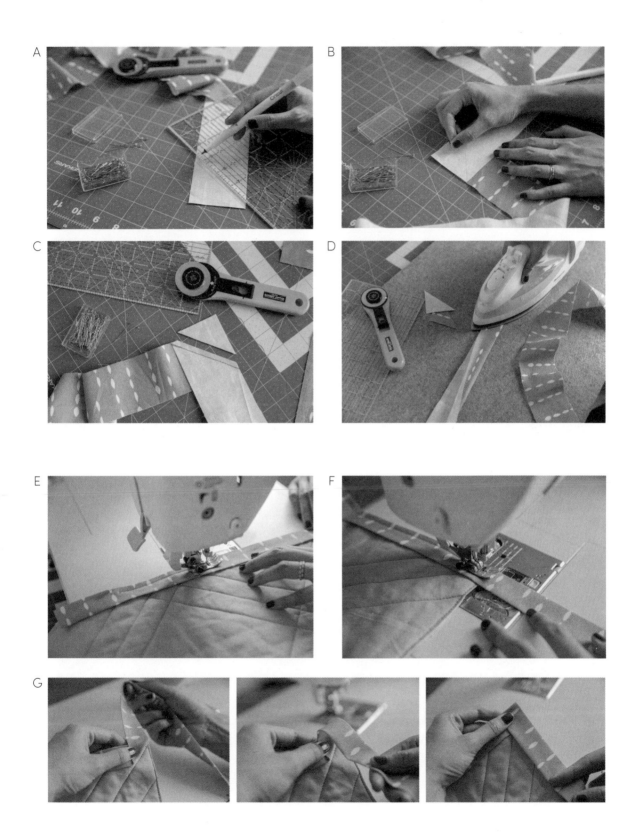

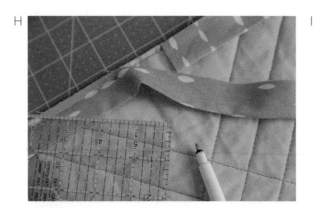

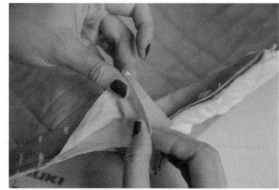

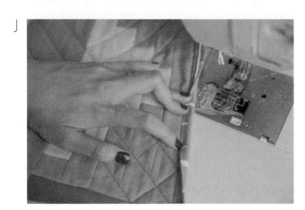

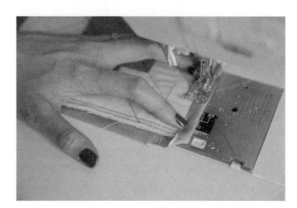

4. Continue attaching the binding as in Steps 1 and 2 until you reach approximately 6" to 8" from the start of the binding. Then remove the quilt from the sewing machine.

5. Lay the quilt flat with the quilt back and the two ends of the binding strip facing up. Place the end of the binding on top of the start of the binding. Use a quilt ruler to mark ½" past the start of the binding, so the two ends overlap each other. Cut on the marked guideline. [Photo H]

6. With the right sides together, sew the two ends of the binding strip together using ¼" seam allowance and press the seams open. [Photo I]

7. Attach the rest of the binding to the back of the quilt.

8. You're now in the home stretch! Fold the finished edge of the binding over to the quilt top and sew to secure it. When you reach approximately 2" from the corner of the quilt, stop and leave the needle and presser foot down. [Photo J]

K 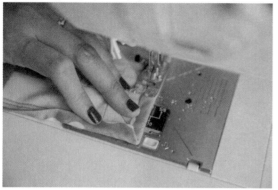 L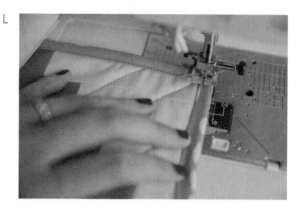

9. Gently fold and hold down the finished edge of the binding on the quilt top so there is a 45-degree angle overhang of binding at the corner of the quilt. Fold the binding perpendicular to the edge you have just attached, toward the center of the quilt, to form the corner of the quilt. You can secure the corner with your hands, pins, or a clip. [Photo K]

10. Continue sewing, and when you get to the tip of the corner fold, leave the needle in. Carefully lift the presser foot to pivot the quilt 90 degrees counterclockwise, and continue sewing the binding to the quilt top. [Photo L]

11. Repeat *Steps 8-10* to complete the quilt.

12. When you reach the start of the binding, don't forget to backstitch to strengthen your binding.

13. Trim any loose threads and enjoy!

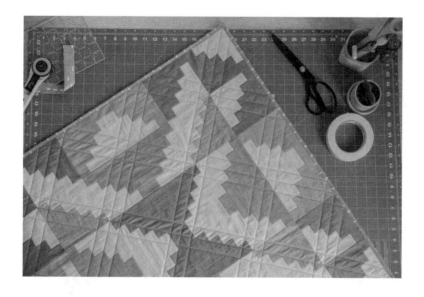

TERMS AND ABBREVIATIONS

As with any other craft, quilters have their own language. Let's go over some quilting terminology that is commonly used in quilt patterns and amongst quilters. You can refer to these pages as a quick reference anytime you feel a little stumped!

Batting: Batting is the insulating layer of the quilt. It is placed between the quilt top and back. Batting is sold by the yard (or in meters), or is readily available in pre-packaged pieces in various bedding sizes. Batting is usually made of cotton, wool, polyester, or bamboo. (Note: Some markets outside of the U.S., such as Australia and the UK, refer to batting as wadding.)

Basting: This step in the quiltmaking process temporarily secures the three layers of the quilt—top, batting, and back—while you incorporate permanent decorative quilting stitches. There are various basting methods, including pinning, spraying, and stitching.

Bind or Binding: Binding is the long strip of fabric around the edge of the quilt that covers the raw edges of the quilt sandwich. It provides strength and longevity to a project. Attaching the binding to the quilt is usually considered the final step in quiltmaking.

Block: Several individual pieces of fabric make up a quilt top. To more easily reference a certain part of a quilt top or how to construct it, a quilt top is divided into different blocks. A quilt block can simply be a square or rectangular piece of fabric cut with a rotary cutter, or it can be several pieces of fabric sewn together to form a larger square or rectangle.

Chain Piecing: In this piecing technique, pieces of fabric are fed through the sewing machine, one after the other, without cutting the thread between each set. Essentially, it is a long chain of quilt block units created on one continuous length of thread.

Fat Eighth (FE): A fat eighth is an eighth of a yard of fabric that measures approximately 9" x 22". It is made by cutting a quarter of a yard in half on the fold.

Fat Quarter (FQ): A fat quarter is a quarter of a yard of fabric. It measures approximately 18" x 22" and is made by cutting a yard of fabric in half lengthwise and vertically. These "fatter" cuts of a quarter of a yard accommodate larger and different cuts compared with the standard quarter yard of fabric that measures approximately 9" x 42".

Finished Size: Finished size refers to the size of the completed block or quilt top, excluding the seam allowance.

Hera Marker: A hera marker is a piece of hard plastic with a thin edge and rounded top. It is designed to create distinctive, creased guidelines without leaving any permanent marks or residue like a marking pen could.

Longarm Quilter or Quilting: Longarm quilting requires a longarm quilting machine. Three layers of the quilt are loaded onto a metal frame, and decorative stitches are sewn on manually or automatically to hold the layers in place permanently. A longarm quilting machine, or sending your project to a longarm quilter, can be very costly. However, it greatly reduces the amount of time and effort in the basting and quilting processes, and there are hundreds of different quilting motifs and designs (also known as pantographs) to select from.

Piecing: Piecing is the process of sewing together multiple pieces of cut fabric to form a quilt block or top.

Pressing: There's a difference between ironing and pressing. Quilters press their seams and do not iron. Ironing is a back-and-forth motion, and this vigorous repeating movement can stretch and distort the fabric, especially smaller and thinner pieces. To press, use an up-and-down motion with an iron to flatten the seams. Pressing seams is a crucial step and should be done throughout the project to help reduce seam bulk and improve the accuracy of your piecing.

Quilt Back or Backing: Backing is the layer or piece of fabric used on the "back" side of a quilt.

Quilt Sandwich: Quilt sandwich refers to the three layers of a quilt combined together: quilt top, batting or wadding, and quilt back.

Quilt Top: The quilt top is where you will put most of your time and effort when making a quilt. It is the top layer of the quilt and features the individually cut pieces of fabric pieced together.

Quilting: Quilting refers to the process of sewing together and securing the three layers of a quilt sandwich with decorative or straight stitches.

Right and Wrong Sides: The right side of the fabric is the side that is visible when a project is completed. This is usually the side with the printed pattern. The wrong side is the "back" or lighter side of the fabric. With solid fabrics, the front and back are often interchangeable.

Seam Allowance: Seam allowance is the distance between the raw edge of the fabric and the sewn seam. The standard seam allowance on quilting projects is ¼", unless otherwise specified in the instructions. For garment sewing, the standard seam allowance is ⅝".

Selvedge: Selvedge (or selvage) is the densely woven edge of a fabric that prevents the length of the fabric from unraveling and fraying before it gets into the hands of the consumer. The selvedge usually contains the manufacturer's name, the name of collection, the fabric designer, and the swatch of colors used in that particular fabric. This part of the fabric needs to be removed before starting your new project, as it could be more difficult to sew through and may shrink in the wash.

Square or Squaring Up: Squaring up, by using a rotary cutter and ruler, ensures all edges of a quilt block or sandwich are straight, and each corner is right-angled. This step helps achieve more accurate piecing and a perfect finish.

Strip Piecing: Strip piecing is a quick and easy piecing method in which multiple strips of fabric are sewn together to create a "strip set." Several vertical cuts are made on the strip set to create multiple segments or units. This replaces the time- and labor-intensive process of cutting and piecing together individual squares and rectangles.

Sub-Cut: Sub-cut means to cut smaller squares or rectangles from a larger piece of fabric that is already cut.

Units: Units refers to the individual pieces or sections that make up a quilt block.

Width of Fabric (WOF): This refers to the distance from selvedge to selvedge. When shopping for quilting fabrics, most often you'll find the WOF is 42" to 44" wide. All fabric requirements in this book assume 42" WOF.

Yardage: In the American market, fabric is sold in yards. Yardage is a term used to refer to fabric requirements or length of a fabric in yards for a project.

GENERAL INSTRUCTIONS

Now that you're ready to start your project, here are a few quick reminders and tips before you get going:

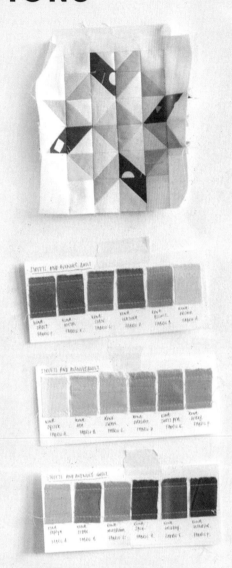

- ✂ Similar to a cooking recipe, a quilt pattern requires that you read through all the instructions before you start a new project. This will help you both identify what supplies you need and give you an understanding of what to expect throughout the project.

- ✂ Remember: all fabric requirements are based on 42" WOF (width of fabric).

- ✂ Remember: cutting dimensions include ¼" seam allowance.

- ✂ Share your *Urban Quilting* moments on social media by using the quilt's unique hashtag, highlighted at the end of each pattern before the quilting directions. And don't forget to tag @*the.weekendquilter* and use #*theweekendquilter* and #*urbanquiltingbook* hashtags as well so I can see your project. It's always exciting seeing your work!

Follow @*the.weekendquilter*** on Instagram and Pinterest for more** *Urban Quilting* **ideas and inspiration.**

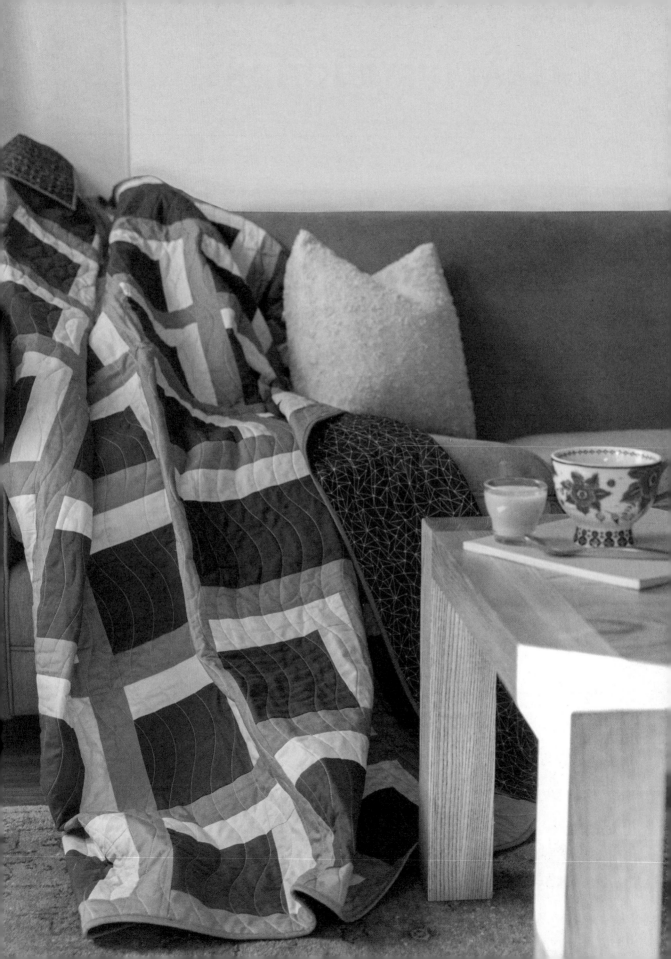

HEY THERE!

(Beginner)

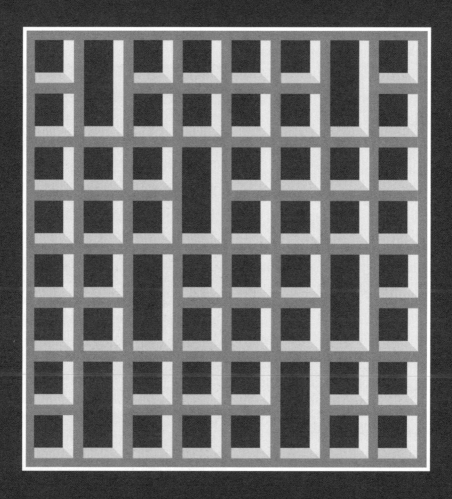

Baby: 42" x 42" (107 cm x 107 cm)

Throw: 62" x 62" (158 cm x 158 cm)

Queen: 82" x 82" (209 cm x 209 cm)

Piecing Methods and Techniques

Strip piecing / 8-in-1 Half-Square Triangles

"Somewhere amongst the millions of people in New York City, there's a friend out there." This is what I kept telling myself when I first moved to the other side of the world. I thought I would have a hard time settling in, meeting new people, and making new friends. I used any and every opportunity possible to start a conversation. I even joined an app for making friends!

Thanks to the online quilting community, some of my initial salutation nerves disappeared, giving me the courage to meet and befriend like-minded people both locally and across the globe. As new friendships formed, it quickly became evident that the internet has changed how the quilting community engages and seeks support, new ideas, and designs. We have never been so connected before. Quilters no longer need to wait for their local monthly or bimonthly guild meet-ups to share project progress, receive feedback, and collaborate with their peers. Friends and complete strangers respond faster than ever online—sometimes in seconds! The online world has also enabled quilters to connect with each other through fabric stores, block and quilt swaps, quilt-alongs, and charity quilt drives.

The Hey There! quilt pattern is an introduction to making Half-Square Triangles—one of the most common motifs in quilt pattern designs. With this quilt design, we're going to get right to it by making 8-in-1 Half-Square Triangles instead of one Half-Square Triangle at a time. The name of the method says it all—it's the fastest method for constructing multiple Half-Square Triangles at a time for your project.

Prior to the digital age, quilting gatherings and groups were largely formed as a means of socializing and staying up-to-date with what was happening in the community. Women met at their local church halls to exchange recipes, news, quilting fabrics, designs, and skills while making quilts to honor significant people or events. These church-based sewing circles go back as far as the early nineteenth century.

In the twentieth century, the purpose of quilting groups shifted. Groups were formed to create a sense of identity within the community, as well as a forum to exchange quilting ideas, support, and education. During the second half of the century, quilting groups existed to keep the craft and traditional female identity alive, as fewer mothers and grandmothers passed on the art of quiltmaking.

Today, myriad quilting groups across the world continue to serve as opportunities for men and women to socialize and share their passion for quilting. The online world has allowed groups to go beyond their local communities and explore different quilting ideas, traditions, and histories outside of their quilting circles.

COLOR INSPIRATION

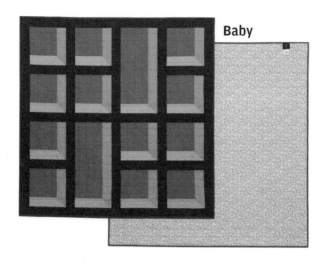

Baby

Fabric A Robert Kaufman, Kona Cotton in Copen

Fabric B Robert Kaufman, Kona Cotton in Blueprint

Fabric C Robert Kaufman, Kona Cotton in Medium Pink

Fabric D Robert Kaufman, Kona Cotton in Aloe

Backing Fabric Hawthorne Supply Co, Erin Anne Designs, Heartbreaker, Cheetah in Cupid

Binding Fabric Robert Kaufman, Kona Cotton in Ultramarine

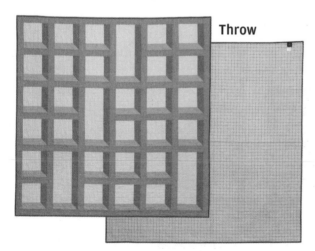

Throw

Fabric A Robert Kaufman, Kona Cotton in Shell

Fabric B Robert Kaufman, Kona Cotton in Persimmon

Fabric C Robert Kaufman, Kona Cotton in Corsage

Fabric D Robert Kaufman, Kona Cotton in Hyacinth

Backing Fabric Hawthorne Supply Co, Mable Tan, In the Countryside, Checkered Fences in Periwinkle Blue

Binding Fabric Robert Kaufman, Kona Cotton in Ultramarine

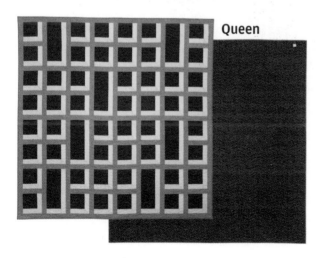

Queen

Fabric A Robert Kaufman, Kona Cotton in Gotham Grey

Fabric B Robert Kaufman, Kona Cotton in Caramel

Fabric C Robert Kaufman, Kona Cotton in Bellini

Fabric D Robert Kaufman, Kona Cotton in Sand

Backing Fabric Hawthorne Supply Co, Hawthorne Essentials, Astral Nights in Onyx and Taupe

Binding Fabric Robert Kaufman, Kona Cotton in Cedar

Fabric Requirements

	Baby	Throw	Queen
Fabric A ●	⅝ yard (58 cm)	1½ yards (138 cm)	2¼ yards (206 cm)
Fabric B ●	⅞ yard (80 cm)	1½ yards (138 cm)	2½ yards (229 cm)
Fabric C ●	½ yard (46 cm)	⅝ yard (58 cm)	1⅛ yard (103 cm)
Fabric D ○	½ yard (46 cm)	¾ yard (69 cm)	1¼ yard (115 cm)
Backing Fabric	2⅞ yard (263 cm)	3⅞ yard (355 cm)	7½ yard (686 cm)
Binding Fabric	⅜ yard (35 cm)	½ yard (46 cm)	¾ yard (69 cm)

Cutting Directions

	Baby	Throw	Queen
Fabric A ●	3 strips, 6½" x WOF (for strip piecing)	7 strips, 6½" x WOF (for strip piecing)	12 strips, 6½" x WOF (for strip piecing)
Fabric B ●	3 strips, 2½" x WOF (for strip piecing) 3 strips, 2½" x WOF (borders) 5 strips, 2½" x WOF, sub-cut: • 14 rectangles, 2½" x 10½" • 14 squares, 2½" x 2½"	7 strips, 2½" x WOF (for strip piecing) 3 strips, 2½" x WOF (borders) 10 strips, 2½" x WOF, sub-cut: • 32 rectangles, 2½" x 10½" • 32 squares, 2½" x 2½"	12 strips, 2½" x WOF (for strip piecing) 4 strips, 2½" x WOF (borders) 18 strips, 2½" x WOF, sub-cut: • 57 rectangles, 2½" x 10½" • 57 squares, 2½" x 2½"
Fabric C ●	1 strip, 6" x WOF, sub-cut: • 2 squares, 6" x 6" 3 strips, 2½" x WOF, sub-cut: • 14 rectangles, 2-½" x 6-½"	1 strip, 6" x WOF, sub-cut: • 4 squares, 6" x 6" 6 strips, 2½" x WOF, sub-cut: • 32 rectangles, 2½" x 6½"	2 strips, 6" x WOF, sub-cut: • 8 squares, 6" x 6" 10 strips, 2½" x WOF, sub-cut: • 57 rectangles, 2½" x 6½"
Fabric D ○	1 strip, 6" x WOF, sub-cut: • 2 squares, 6" x 6" 3 strips, 2½" x WOF (for strip piecing)	1 strip, 6" x WOF, sub-cut: • 4 squares, 6" x 6" 7 strips, 2½" x WOF (for strip piecing)	2 strips, 6" x WOF, sub-cut: • 8 squares, 6" x 6" 12 strips, 2½" x WOF (for strip piecing)
Binding Fabric	5 strips, 2½" x WOF	7 strips, 2½" x WOF	9 strips, 2½" x WOF

Strip Set Units

Step 1

Lay 1 Fabric A 6½" x WOF strip between 1 Fabric B 2½" x WOF and 1 Fabric D 2½" x WOF strip, as shown. With the right sides together, pin two strips together lengthwise and sew. Press the seams open and repeat with the third strip to make **1 Strip Set**. Repeat to create a total of:

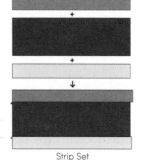

Strip Set

Baby	**3 Strip Set** units
Throw	**7 Strip Set** units
Queen	**12 Strip Set** units

Step 2

Trim the right-hand edge of all Strip Set units to ensure they are straight and right-angled against the length of the strip set.

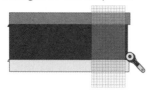

Step 3

Rotate the Strip Set units 180 degrees. Using the straightedge of the left-hand side as a guide, cut a total of:

Baby	2 **16½" Strip Set B** units and 12 **6½" Strip Set A** units
Throw	4 **16½" Strip Set B** units and 28 **6½" Strip Set A** units
Queen	7 **16½" Strip Set B** units and 57 **6½" Strip Set A** units

Strip Set A

Tip: Cut the larger units first, then the smaller units, to maximize yardage on each strip set.

Strip Set B

Set the Strip Set A and Strip Set B units aside for Block Assembly *(page 40)*.

Half-Square Triangle Rows

Step 1

On the wrong side of all Fabric C 6" x 6" squares, draw two diagonal guidelines.

Step 2

With the right sides together, place 1 marked Fabric C 6" x 6" square on top of 1 Fabric D 6" x 6" square and sew a ¼" seam on both sides of the drawn lines.

Step 3

Cut vertically down the center of the 6" x 6" square, using a ruler to align the straightedges of the square and the intersection of the drawn diagonal lines. Without shifting the fabric pieces, make a second cut perpendicular to the first.

Step 4

Separate the fabric pieces. Cut on the drawn guidelines on each of the four squares diagonally, corner to corner.

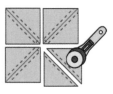

Step 5

Press the seams open and trim each Half-Square Triangle to create **Fabric C/D 2½" x 2½" Half-Square Triangle** units.

Step 6

Repeat **Steps 2 through 5** to create a total of:

Baby	14 Fabric C/D 2½" x 2½" **Half-Square Triangle** units (repeat once)
Throw	32 Fabric C/D 2½" x 2½" **Half-Square Triangle** units (repeat 3 times)
Queen	57 Fabric C/D 2½" x 2½" **Half-Square Triangle** units (repeat 7 times)

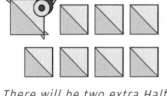

Note: There will be two extra Half-Square Triangle units for the baby-size quilt, and seven extra for the queen-size quilt.

Step 7

As per the diagram shown, sew 1 Fabric B 2½" x 2½" square, 1 Fabric C 2½" x 6½" rectangle, and 1 Fabric C/D 2½" x 2½" Half-Square Triangle unit together to create **1 Half-Square Triangle Row** unit. Press the seams open. Repeat to create a total of:

Baby	14 Half-Square Triangle Rows units
Throw	32 Half-Square Triangle Rows units
Queen	57 Half-Square Triangle Rows units

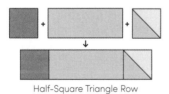

Half-Square Triangle Row

Block Assembly

Step 1

Referring to the diagram shown, combine 2 Fabric B 2½" x 10½" rectangles, 2 Strip Set A units, and 2 Half-Square Triangle Row units to form **1 Block A**, which will be a 10½" x 20½" rectangle. Press the seams open. Repeat to create a total of:

Baby	6 Block A units
Throw	14 Block A units
Queen	25 Block A units

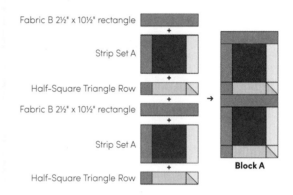

Step 2

Create **1 Block B** (which will be a 10½" x 20½" rectangle) unit by sewing together 1 Fabric B 2½" x 10½" rectangle, 1 Strip Set B unit, and 1 Half-Square Triangle Row unit. Press the seams open. Repeat to create a total of:

Baby	2 Block B units
Throw	4 Block B units
Queen	7 Block B units

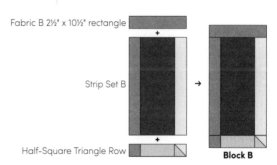

Border Strip Assembly

In this section you will prepare border strips to attach onto the right and bottom edges of the quilt top.

Step 1

For a **baby- or throw-size quilt**, cut 1 Fabric B 2½" x WOF strip in half.

Attach one half of the strip to 1 Fabric B 2½" x WOF strip to create **1 Fabric B 2½" x 62½" Border Strip**. Repeat to create a total of **2 Fabric B 2½" x 62½" Border Strips**.

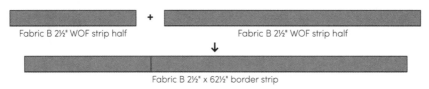

For a **queen-size quilt**, join 2 Fabric B 2½" x WOF strips together. Repeat to create a total of **2 Fabric B 2½" x 83½" Border Strips**.

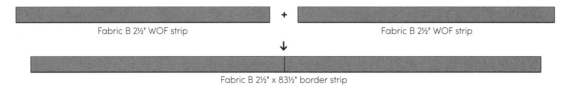

Quilt Assembly

Step 1

To make a **baby-size quilt top**, create two rows as shown, lining the seams up and sewing the rows together.

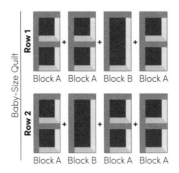

To make a **throw-size quilt top**, create three rows as shown in the diagram, lining the seams up and sewing the rows together.

To make a **queen-size quilt top**, create four rows as shown in the diagram, lining the seams up and sewing the rows together.

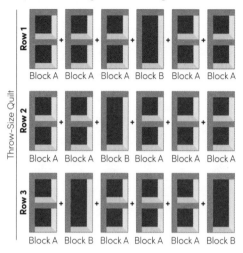

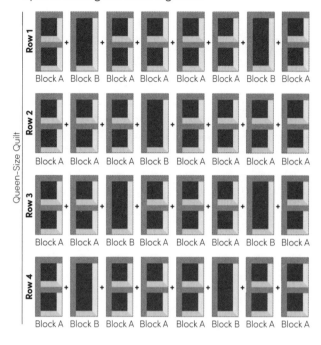

Step 2

For all quilt sizes, attach 1 Fabric B Border Strip on the right of the quilt top, followed by another on the bottom. Press the seams open. Using a ruler and rotary cutter, trim the excess from the ends of each Border Strip.

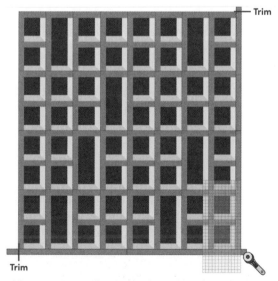

*Queen-size quilt used in this example

Step 3

Press the quilt top and backing fabric. Layer the backing, batting, and quilt top. Baste, quilt, and bind.

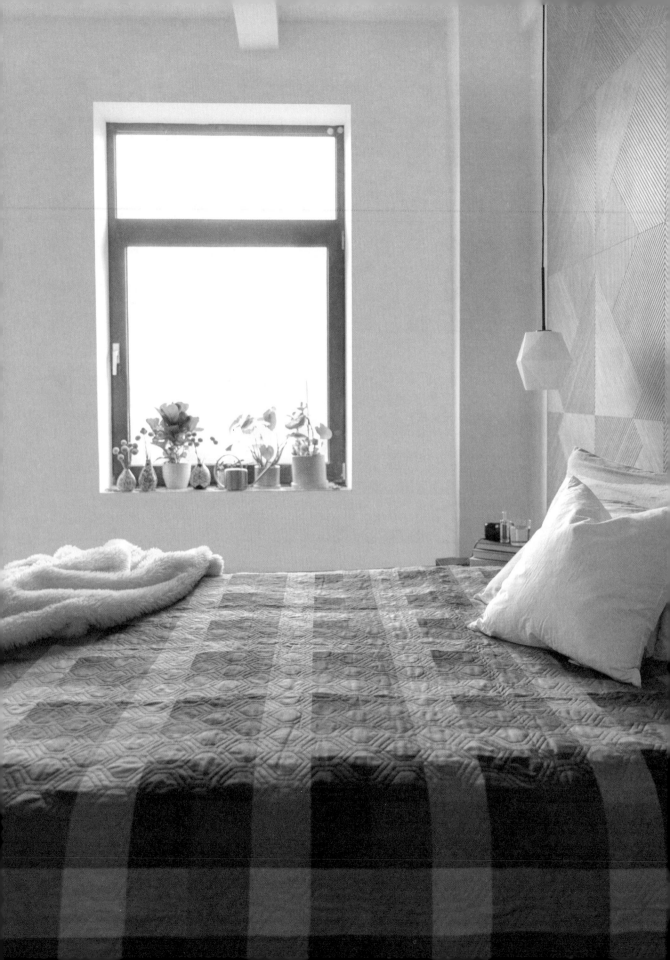

STREETS AND AVENUES

(Advanced Beginner)

Baby: 37½" x 52½" (96 cm x 134 cm)

Throw: 52½" x 52½" (134 cm x 134 cm)

Queen: 84" x 94½" (214 cm x 240 cm)

Piecing Methods and Techniques

Nine-Patch blocks / Strip piecing

The intersecting streets and avenues that make up the grid system in New York City—my new home—inspired the Streets and Avenues quilt. This design takes me back to the summer of 2014 when I first set foot in the city for my master's program. Coming from Perth, Australia, I felt overwhelmed by the busyness in the streets and told myself I would never want to move here—little did I know that on that same trip, I would meet the love of my life!

The Nine-Patch block is made up of nine identical squares that create a larger square. It is one of the most basic quilt blocks. The first Nine-Patch quilts date back to the beginning of the nineteenth century as utilitarian articles, and they continue to be incorporated into modern quilts today. The simple and quick construction methods made it a popular design among pioneer women to keep warm and survive the harsh, cold winters. This pattern also provided them an opportunity to make use of fabric scraps from old clothing and feed sacks.

The Streets and Avenues quilt pattern is a simple and easy introductory project for quilters starting their journey into this beautiful craft. It is also the perfect project for experienced weekend quilters who want to complete a quick project.

There are a couple of ways to construct Nine-Patch blocks, which are the basis of this pattern:

- ✂ The more traditional method is to cut and piece together nine identically sized squares. This method is best when you need to put together a small number of Nine-Patches, or when the colors within the block, or across multiple Nine-Patch blocks, in the quilt vary.

- ✂ The second construction method is strip piecing. With this method, you'll piece together three strips of fabric in the width of each square. Then you'll cut the sewn strips to form one row of three squares at a time, and combine three rows of three squares to form a Nine-Patch block. Strip piecing is the quickest method when it comes to constructing Nine-Patch blocks and is perfect for constructing multiple identical blocks.

COLOR INSPIRATION

Baby

Fabric A ⬤	Robert Kaufman, Kona Cotton in Orchid
Fabric B ⬤	Robert Kaufman, Kona Cotton in Biscuit
Fabric C ⬤	Robert Kaufman, Kona Cotton in Slate
Fabric D ⬤	Robert Kaufman, Kona Cotton in Leather
Fabric E ⬤	Robert Kaufman, Kona Cotton in Metal
Fabric F ⬤	Robert Kaufman, Kona Cotton in Cadet
Backing Fabric	Hawthorne Supply Co, Mable Tan, Modern Farmhouse, Eggshells in Clear Blue Sky
Binding Fabric	Robert Kaufman, Kona Cotton in Windsor

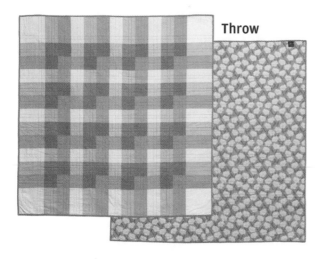

Throw

Fabric A ◯	Robert Kaufman, Kona Cotton in Oyster
Fabric B ⬤	Robert Kaufman, Kona Cotton in Ash
Fabric C ⬤	Robert Kaufman, Kona Cotton in Straw
Fabric D ⬤	Robert Kaufman, Kona Cotton in Overcast
Fabric E ⬤	Robert Kaufman, Kona Cotton in Sweet Pea
Fabric F ⬤	Robert Kaufman, Kona Cotton in Curry
Backing Fabric	Hawthorne Supply Co, Mable Tan, Modern Farmhouse, Primrose in Lemon Zest
Binding Fabric	Robert Kaufman, Kona Cotton in Pickle

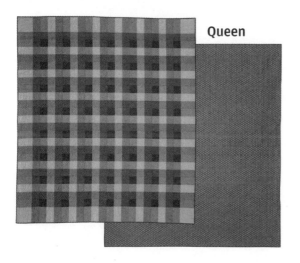

Queen

Fabric A ⬤	Robert Kaufman, Kona Cotton in Papaya
Fabric B ⬤	Robert Kaufman, Kona Cotton in Cedar
Fabric C ⬤	Robert Kaufman, Kona Cotton in Mushroom
Fabric D ⬤	Robert Kaufman, Kona Cotton in Spice
Fabric E ⬤	Robert Kaufman, Kona Cotton in Grizzly
Fabric F ⬤	Robert Kaufman, Kona Cotton in Windsor
Backing Fabric	Hawthorne Supply Co, Shannon McNab, Woodland Autumn, Pathway in River
Binding Fabric	Robert Kaufman, Kona Cotton in Windsor

Fabric Requirements

	Baby	Throw	Queen
Fabric A ●	½ yard (46 cm)	⅞ yards (80 cm)	1½ yards (138 cm)
Fabric B ●	⅝ yard (58 cm)	⅞ yards (80 cm)	2 yards (183 cm)
Fabric C ●	⅝ yard (58 cm)	⅞ yards (80 cm)	2 yards (183 cm)
Fabric D ●	¼ yard (23 cm)	¼ yard (23 cm)	¾ yard (69 cm)
Fabric E ●	⅜ yard (35 cm)	½ yard (46 cm)	1⅜ yards (126 cm)
Fabric F ●	¼ yard (23 cm)	¼ yard (23 cm)	¾ yard (69 cm)
Backing Fabric	2⅝ yards (240 cm)	3⅜ yards (309 cm)	7⅔ yard (701 cm)
Binding Fabric	⅜ yard (35 cm)	½ yard (46 cm)	¾ yard (69 cm)

Cutting Directions

	Baby	Throw	Queen
Fabric A ●	4 squares, 5½" x 5½" 4 strips, 3" x WOF	4 squares, 7½" x 7½" 5 strips, 4" x WOF	4 squares, 7½" x 7½" 11 strips, 4" x WOF
Fabric B ●	6 strips, 3" x WOF	7 strips, 4" x WOF	17 strips, 4" x WOF
Fabric C ●	6 strips, 3" x WOF	7 strips, 4" x WOF	17 strips, 4" x WOF
Fabric D ●	2 strips, 3" x WOF	2 strips, 4" x WOF	6 strips, 4" x WOF
Fabric E ●	4 strips, 3" x WOF	4 strips, 4" x WOF	12 strips, 4" x WOF
Fabric F ●	2 strips, 3" x WOF	2 strips, 4" x WOF	6 strips, 4" x WOF
Binding Fabric	5 strips, 2½" x WOF	6 strips, 2½" x WOF	10 strips, 2½" x WOF

Tip: The colors used in this quilt pattern are very similar in tone and may be difficult to differentiate throughout the project. When working with similar-colored fabrics, cut sample swatches (approximately 1" x 1" in size) before cutting into the fabrics. Then tape or sew the swatches onto a piece on paper and label the fabrics. This will come in handy when you are unsure which fabrics you have picked up throughout the project and will help you avoid those dreaded seam-ripping moments.

Set A Units

Step 1

Lay Fabric A, B, and C strips in sewing order, as shown. With the right sides together, pin two strips together lengthwise and sew. Press the seams open and repeat with the third strip to make **1 Strip Set A**. Repeat to create a total of:

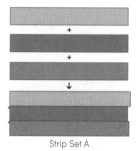

Strip Set A

Tip: Sew the first strip starting at the left edge of the strip set and sew the final seam starting at the right edge of the strip set. This prevents the strip set from bowing.

Baby	**4 Strip Set A** units
Throw	**5 Strip Set A** units
Queen	**11 Strip Set A** units

To ensure that the unit is sewn on straight and not bowed along the edges, lay it flat on a cutting mat. Compare the guidelines on the mat to the edges and seams in the unit.

Step 2

Trim the right-hand edge of all Strip Set A units to ensure they are straight and right-angled against the length of the strip set.

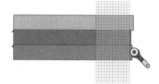

Step 3

Rotate the Strip Set A units 180 degrees. Using the straightedge on the left-hand side as a guide, cut a total of:

Set A1

Baby	15 **5 ½" x 8" Set A1** units
Throw	16 **7 ½" x 11" Set A1** units
Queen	30 **7 ½" x 11" Set A1** units

Step 4

Use a seam ripper to remove Fabric A from four Set A1 units to create **4 Set A2 units**. Set aside the Set A1 and A2 units for the borders.

Set A1 Set A2

Step 5

With the remaining Strip Set A units, cut a total of:

Set A3

Baby	15 **3" x 8" Set A3** units
Throw	9 **4" x 11" Set A3** units
Queen	42 **4" x 11" Set A3** units

Set aside the A3 units. They will be used to create Nine-Patches in Patches, Step 1 *(page 50)*.

Set B Units

Step 1

Lay 1 Fabric B strip, 1 Fabric D strip, and 1 Fabric E strip side by side, as shown. With the right sides together, pin two strips together lengthwise and sew. Press the seams open and repeat with the third strip to make **1 Strip Set B**. Repeat to create a total of:

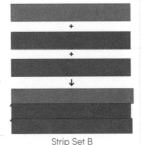

Baby	2 Strip Set B units
Throw	2 Strip Set B units
Queen	6 Strip Set B units

Strip Set B

Step 2

Trim the right-hand edge of all Strip Set B units to ensure they are straight and right-angled against the length of the strip set.

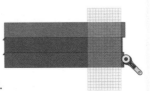

Step 3

Rotate the Strip Set B units 180 degrees. Using the straightedge on the left-hand side as a guide, cut a total of:

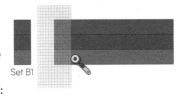

Set B1

Baby	24 3" Set B1 units
Throw	16 4" Set B1 units
Queen	56 4" Set B1 units

Step 4

Use a seam ripper to remove Fabric B from 1 Set B1 unit to form **1 Set B2 unit** (for all quilt sizes).

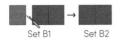

Set B1 Set B2

Set aside the Set B1 and B2 units. These will be used to create Nine-Patches in *Patches, Step 1 (page 50)* and a Four-Patch in *Patches, Step 2 (page 50)*.

Set C Units

Step 1

As per the diagram, sew 1 Fabric C, 1 Fabric E, and 1 Fabric F strip together to create **1 Strip Set C**. Repeat to create a total of:

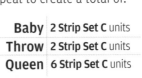
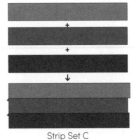

Baby	2 Strip Set C units
Throw	2 Strip Set C units
Queen	6 Strip Set C units

Strip Set C

Step 2

Trim the right-hand edge of all Strip Set C units to ensure they are straight and right-angled against the length of the strip set.

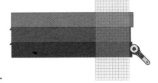

Step 3

Rotate the Strip Set C units 180 degrees. Using the straightedge on the left-hand side as a guide, cut a total of:

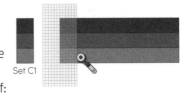

Set C1

Baby	24 3" Set C1 units
Throw	16 4" Set C1 units
Queen	56 4" Set C1 units

These units will be used in *Patches, Step 1 (page 50)* to create Nine-Patches.

Step 4

With a seam ripper, remove Fabric C from 1 Set C1 unit to create **1 Set C2 unit** (for all quilt sizes). This will be used to create a Four-Patch in *Patches, Step 2 (page 50)*.

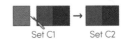

Set C1 Set C2

Patches

Step 1

Arrange and sew 1 Set A3, 1 Set B1, and 1 Set C1 together, as shown, to create **1 Nine-Patch unit**. Press the seams open. Repeat to create a total of:

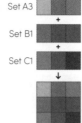

Set A3
+
Set B1
+
Set C1
↓

Nine-Patch

Baby	15 **Nine-Patch** units
Throw	9 **Nine-Patch** units
Queen	42 **Nine-Patch** units

Step 2

Arrange 1 Set B2 and 1 Set C2, as shown, to create **1 Four-Patch** (for all quilt sizes). Press the seams open.

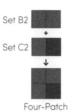

Set B2
+
Set C2
↓

Four-Patch

Step 3

Referring to the diagram shown, sew 1 Set B1 unit and 1 Set C1 unit together to create **1 Six-Patch A**. Repeat to create a total of:

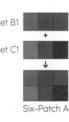

Set B1
+
Set C1
↓

Six-Patch A

Baby	3 **Six-Patch A** units
Throw	3 **Six-Patch A** units
Queen	6 **Six-Patch A** units

Press the seams open.

Step 4

Arrange 1 Set B1 unit and 1 Set C1 unit, as shown, to create **1 Six-Patch B** unit. Press the seams open. Repeat to create a total of:

Baby	5 **Six-Patch B** units
Throw	3 **Six-Patch B** units
Queen	7 **Six-Patch B** units

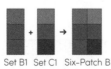

Set B1 Set C1 Six-Patch B

Row Assembly

Step 1

As shown in the diagram, create **Row 1** by arranging and sewing together:

Baby	2 Fabric A 5½" x 5½" squares, 1 Set A2 unit, and 3 Set A1 units
Throw	2 Fabric A 7½" x 7½" squares, 1 Set A2 unit, and 3 Set A1 units
Queen	2 Fabric A 7½" x 7½" squares, 1 Set A2 unit, and 6 Set A1 units

For **baby-size quilt** and **throw-size quilt**:

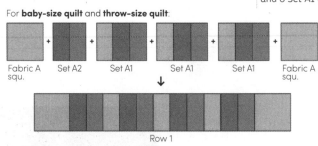

For **queen-size quilt**:

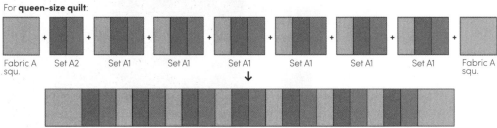

Press the seams open. Repeat to create a total of 2 Row 1 units (for all quilt sizes).

Step 2

Create **1 Row 2** (for all quilt sizes) by arranging and sewing together:

Baby	2 Set A2 units, 1 Four-Patch, and 3 Six-Patch A units
Throw	2 Set A2 units, 1 Four-Patch, and 3 Six-Patch A units
Queen	2 Set A2 units, 1 Four-Patch, and 6 Six-Patch A units

For **baby-size quilt** and **throw-size quilt**:

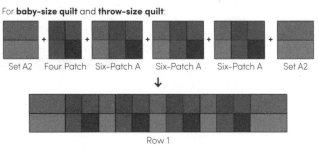

For **queen-size quilt**:

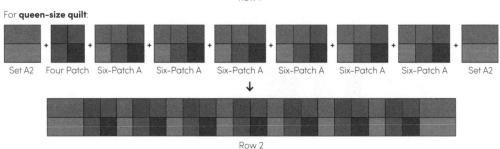

Press the seams open.

Step 3

As shown in the diagram, create **1 Row 3** by arranging and sewing together:

Baby	2 Set A1 units, 1 Six-Patch B unit, and 3 Nine-Patch units
Throw	2 Set A1 units, 1 Six-Patch B unit, and 3 Nine-Patch units
Queen	2 Set A1 units, 1 Six-Patch B unit, and 6 Nine-Patch units

For **baby-size quilt** and **throw-size quilt**:

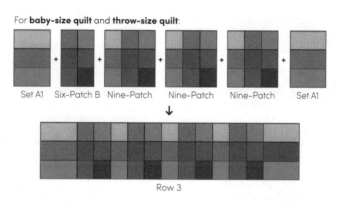

Set A1 Six-Patch B Nine-Patch Nine-Patch Nine-Patch Set A1

↓

Row 3

For **queen-size quilt**:

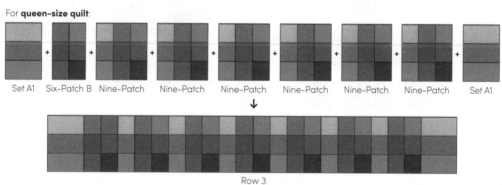

Set A1 Six-Patch B Nine-Patch Nine-Patch Nine-Patch Nine-Patch Nine-Patch Nine-Patch Set A1

↓

Row 3

Press the seams open. Repeat to create a total of:

Baby	**5 Row 3** units
Throw	**3 Row 3** units
Queen	**7 Row 3** units

Quilt Assembly

Step 1

To create a baby-size quilt top, line up the seams and sew 2 Row 1 units, 1 Row 2 unit, and 5 Row 3 units.

To create a throw-size quilt top, line up the seams and sew 2 Row 1 units, 1 Row 2 unit, and 3 Row 3 units.

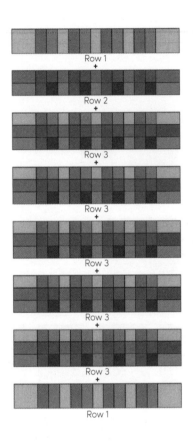

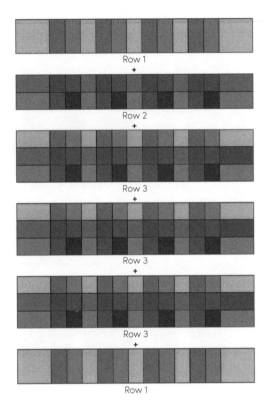

Quilting Directions

To create a queen-size quilt top, line up the seams and sew 2 Row 1 units, 1 Row 2 unit, and 7 Row 3 units.

Step 2

Press the quilt top and backing fabric. Layer the backing, batting, and quilt top. Baste, quilt, and bind.

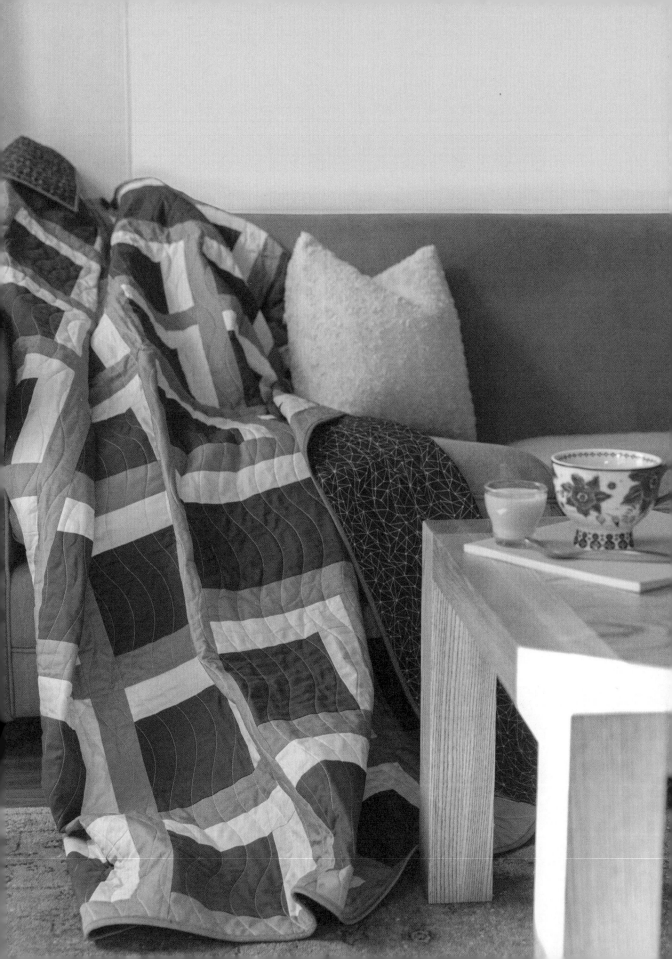

TWIN POLE

(Beginner)

Baby: 48" x 48" (122 cm x 122 cm)

Throw: 72" x 72" (183 cm x 183 cm)

Queen: 81" x 81" (206 cm x 206 cm)

Piecing Methods and Techniques

Strip piecing

Growing up, Toucan and Twin Pole popsicles were a childhood treat. Their bright, colorful, horizontal stripes and two popsicle sticks made them distinctive and popular. You could split the treat in half and share it with a friend—or choose to have the whole thing to yourself!

The most expensive icy treat at the school canteen, at a whopping 90 cents, they were extremely popular during the hot Aussie summer months. At lunch, you tried to befriend someone who would give you their other half or split the cost with you. They were also the go-to treat on family road trips when we stopped to refill at the petrol station, one of many things that made other shoppers stare as I repeatedly begged Mum, "Please. Please. Please," down the freezer aisle. Toucans and Twin Poles also helped mediate several disagreements between my sisters on who got the last popsicle in the box.

Last summer, on a mission to revive my childhood memories, I searched high and low for Toucans, Twin Poles, or something similar at ice cream carts at Central Park and Mister Softee ice cream trucks around the city. Sadly, they have been discontinued, and it's tough missing them during the warmer months.

The Twin Pole quilt pays tribute to my childhood favorites that are no longer with us. Furthering the skills you practiced in the Streets and Avenues quilt, this pattern also incorporates strip piecing and features nine vibrant colors to reflect on how the fabric industry has changed and shaped modern quilting.

Printed quilting fabrics were rare and expensive during the early years of American colonization and were considered a luxury. Only wealthy women in society could afford imported fabrics. Limited options forced women to get creative and resourceful with what they could get their hands on. Essentially, the fabrics incorporated into a quilt could reveal when it was made and the quilter's social and economic status at the time.

Printed fabrics became more readily available and affordable when the number of American fabric manufacturers quickly grew in the first half of the nineteenth century. Increased access to cheaper fabrics enabled women to explore and experiment with original designs and different techniques. Since then, the fabric industry has evolved. Similar to the fashion industry, new quilting fabric designs and collections have short lifespans and are replaced every six months or sooner. Together, this trend and the emergence of modern fabric have played a role in attracting a new generation of quilters who are no longer taught or influenced by their parents or grandparents.

COLOR INSPIRATION

Baby

Fabric A ⬤	Hawthorne Supply Co, Hawthorne Essentials, Stardust in Nectar
Fabric B ⬤	Robert Kaufman, Kona Cotton in Papaya
Fabric C ⬤	Robert Kaufman, Kona Cotton in Marmalade
Fabric D ⬤	Robert Kaufman, Kona Cotton in Pickle
Fabric E ⬤	Robert Kaufman, Kona Cotton in Mango
Fabric F ⬤	Robert Kaufman, Kona Cotton in Malibu
Fabric G ⬤	Robert Kaufman, Kona Cotton in Heliotrope
Fabric H ⬤	Robert Kaufman, Kona Cotton in Orchid Ice
Fabric I ⬤	Robert Kaufman, Kona Cotton in Teal Blue
Backing Fabric	Hawthorne Supply Co, Mable Tan, Urban Jungle. Rainbow Haze in Garden
Binding Fabric	Robert Kaufman, Kona Cotton in Light Parfait

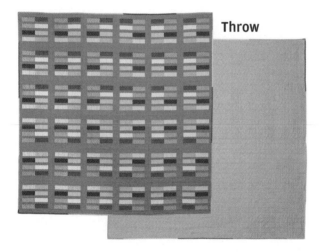

Throw

Fabric A ⬤	Robert Kaufman, Kona Cotton in Nectarine
Fabric B ⬤	Robert Kaufman, Kona Cotton in Artichoke
Fabric C ⬤	Robert Kaufman, Kona Cotton in Oasis
Fabric D ⬤	Robert Kaufman, Kona Cotton in Grapemist
Fabric E ⬤	Robert Kaufman, Kona Cotton in Sea Mist
Fabric F ⬤	Robert Kaufman, Kona Cotton in Geranium
Fabric G ⬤	Robert Kaufman, Kona Cotton in Orchid
Fabric H ⬤	Robert Kaufman, Kona Cotton in Pink
Fabric I ⬤	Robert Kaufman, Kona Cotton in Duckling
Backing Fabric	Hawthorne Supply Co, Hey Miss Designs, Baja Sur, View in Papaya
Binding Fabric	Robert Kaufman, Kona Cotton in Nectarine, Artichoke, Oasis, Grapemist, Sea Mist, Geranium, Pink, Duckling

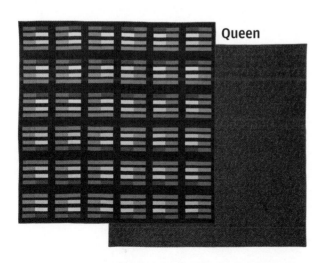

Queen

Fabric A ⬤	Robert Kaufman, Kona Cotton in Pepper
Fabric B ⬤	Robert Kaufman, Kona Cotton in Harbor
Fabric C ⬤	Robert Kaufman, Kona Cotton in Spice
Fabric D ⬤	Robert Kaufman, Kona Cotton in Orangeade
Fabric E ⬤	Robert Kaufman, Kona Cotton in Butter
Fabric F ⬤	Robert Kaufman, Kona Cotton in Curry
Fabric G ⬤	Robert Kaufman, Kona Cotton in Pond
Fabric H ⬤	Robert Kaufman, Kona Cotton in Bluegrass
Fabric I ⬤	Robert Kaufman, Kona Cotton in Torch
Backing Fabric	Hawthorne Supply Co, Hawthorne Essentials, Star Charts in Onyx
Binding Fabric	Robert Kaufman, Kona Cotton in Oasis

Fabric Requirements

	Baby	Throw	Queen
Fabric A ⬤	1¾ yards (161 cm)	3⅔ yards (336 cm)	4⅓ yards (397 cm)
Fabric B to I	¼ yard (23 cm) of each Fabrics B through I	⅜ yard (35 cm) of each Fabrics B through I	⅜ yard (35 cm) of each Fabrics B through I
Backing Fabric	3⅛ yards (286 cm)	4½ yards (414 cm)	7½ yards (686 cm)
Binding Fabric	⅜ yard (35 cm)	⅝ yard (58 cm)	⅔ yard (61 cm)

Cutting Directions

	Baby	Throw	Queen
Fabric A ⬤	8 strips, 1¾" x WOF 11 strips, 2¼" x WOF sub-cut: • 32 rectangles, 2¼" x 12½" • 1 rectangle, 1½" x 12½" 5 strips, 1½" x WOF sub-cut: • 15 rectangles, 1½" x 12½" 11 strips, 1¼" x WOF sub-cut: • 32 rectangles, 1¼" x 12½"	16 strips, 1¾" x WOF 24 strips, 2¼" x WOF sub-cut: • 72 rectangles, 2¼" x 12½" 12 strips, 1½" x WOF sub-cut: • 36 rectangles, 1½" x 12½" 24 strips, 1¼" x WOF sub-cut: • 72 rectangles, 1¼" x 12½"	16 strips, 2" x WOF 24 strips, 2½" x WOF sub-cut: • 72 rectangles, 2½" x 14" 12 strips, 2" x WOF sub-cut: • 36 rectangles, 2" x 14" 24 strips, 1½" x WOF sub-cut: • 72 rectangles, 1½" x 14"
Fabric B to I	1 strip, 5¼" x WOF of each Fabrics B through I	2 strips, 5¼" x WOF of each Fabrics B through I	2 strips, 5¾" x WOF of each Fabrics B through I
Binding Fabric	5 strips, 2½" x WOF	8 strips, 2½" x WOF	9 strips, 2½" x WOF

Twin Pole Units

Step 1

Referring to the table and diagram shown, lay the strips in sewing order:

Baby	2 Fabric A 1¾" x WOF, 1 Fabric B 5¼" x WOF, and 1 Fabric C 5¼" x WOF
Throw	2 Fabric A 1¾" x WOF, 1 Fabric B 5¼" x WOF, and 1 Fabric C 5¼" x WOF
Queen	2 Fabric A 2" x WOF, 1 Fabric B 5¾" x WOF, and 1 Fabric C 5¾" x WOF

With the right sides together, pin two strips together lengthwise and sew. Press the seams open and repeat with the third and fourth strips to make 1 Twin Pole Strip Set B/C. Repeat to create a total of:

Baby	**N/A** (only 1 Twin Pole Strip Set B/C needed)
Throw	**2 Twin Pole Strip Set B/C** units
Queen	**2 Twin Pole Strip Set B/C** units

Twin Pole Strip Set B/C

Set aside unit(s) for *Twin Pole Units, Step 5.*

Tip: Sew the first and fourth strips starting at the left edge of the strip set. Sew the final seam, between the second and third strips, starting at the right edge of the strip set. This prevents the strip set from bowing. To ensure that the unit is sewn on straight and not bowed along the edges, lay it flat on a cutting mat. Compare the guidelines on the mat to the edges and seams in the unit.

Step 2

Create **Twin Pole Strip Set D/E** units by repeating **Step 1** with:

Baby	2 Fabric A 1¾" x WOF, 1 Fabric D 5¼" x WOF, and 1 Fabric E 5¼" x WOF
Throw	2 Fabric A 1¾" x WOF, 1 Fabric D 5¼" x WOF, and 1 Fabric E 5¼" x WOF
Queen	2 Fabric A 2" x WOF, 1 Fabric D 5¾" x WOF, and 1 Fabric E 5¾" x WOF

Repeat to create a total of:

Baby	**N/A** (only 1 Twin Pole Strip Set D/E needed)
Throw	**2 Twin Pole Strip Set D/E** units
Queen	**2 Twin Pole Strip Set D/E** units

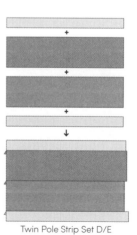

Twin Pole Strip Set D/E

Set aside unit(s) for *Twin Pole Units, Step 5.*

Step 3

Create **Twin Pole Strip Set F/G** units by repeating **Step 1** with:

Baby	2 Fabric A 1¾" x WOF, 1 Fabric F 5¼" x WOF, and 1 Fabric G 5¼" x WOF
Throw	2 Fabric A 1¾" x WOF, 1 Fabric F 5¼" x WOF, and 1 Fabric G 5¼" x WOF
Queen	2 Fabric A 2" x WOF, 1 Fabric F 5¾" x WOF, and 1 Fabric G 5¾" x WOF

Repeat to create a total of:

Baby	**N/A** (only 1 Twin Pole Strip Set F/G needed)
Throw	**2 Twin Pole Strip Set F/G** units
Queen	**2 Twin Pole Strip Set F/G** units

Set aside unit(s) for *Twin Pole Units, Step 5*.

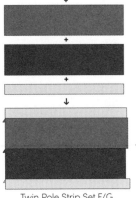

Twin Pole Strip Set F/G

Step 4

Create **Twin Pole Strip Set H/I** units by repeating **Step 1** with:

Baby	2 Fabric A 1¾" x WOF, 1 Fabric H 5¼" x WOF, and 1 Fabric I 5¼" x WOF
Throw	2 Fabric A 1¾" x WOF, 1 Fabric H 5¼" x WOF, and 1 Fabric I 5¼" x WOF
Queen	2 Fabric A 2" x WOF, 1 Fabric H 5¾" x WOF, and 1 Fabric I 5¾" x WOF

Repeat to create a total of:

Baby	**N/A** (only 1 Twin Pole Strip Set H/I needed)
Throw	**2 Twin Pole Strip Set H//I** units
Queen	**2 Twin Pole Strip Set H/I** units

Set aside unit(s) for *Twin Pole Units, Step 5*.

Step 5

Trim the right-hand edge of all Twin Pole Strip Set units from Steps 1 through 4 (for all quilt sizes) to ensure they are straight and right-angled against the length of the strip set.

*Twin Pole Strip Set B/C used in this example

Step 6

Rotate all Twin Pole Strip Set B/C units 180 degrees. Using the straightedge on the left-hand side as a guide, cut a total of:

	Baby	Throw	Queen
2" Twin Pole B/C units	16 units	36 units	36 units
2" Twin Pole D/E units	16 units	36 units	36 units
2" Twin Pole F/G units	16 units	36 units	36 units
2" Twin Pole H/I units	16 units	36 units	36 units

*Twin Pole Strip Set B/C used in this example

Block Units

Step 1

Referring to the diagram shown, sew the following to create **1 Block A**.

Baby	2 Fabric A 2¼" x 12½", 1 Fabric A 1½" x 12½", 2 Fabric A 1¼" x 12½", 1 Twin Pole B/C, 1 Twin Pole D/E, 1 Twin Pole F/G, 1 Twin Pole H/I
Throw	2 Fabric A 2¼" x 12½", 1 Fabric A 1½" x 12½", 2 Fabric A 1¼" x 12½", 1 Twin Pole B/C, 1 Twin Pole D/E, 1 Twin Pole F/G, 1 Twin Pole H/I
Queen	2 Fabric A 2½" x 14", 1 Fabric A 2" x 14", 2 Fabric A 1½" x 14", 1 Twin Pole B/C, 1 Twin Pole D/E, 1 Twin Pole F/G, 1 Twin Pole H/I

Press the seams open. Repeat to create a total of:

Baby	8 12½" **Block A** units
Throw	18 12½" **Block A** units
Queen	18 14" **Block A** units

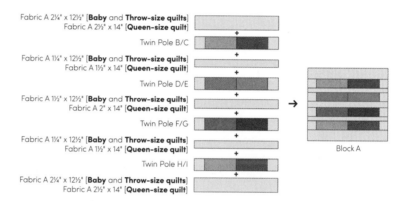

Fabric A 2¼" x 12½" [**Baby** and **Throw**-size quilts]
Fabric A 2½" x 14" [**Queen**-size quilt]
Twin Pole B/C
Fabric A 1¼" x 12½" [**Baby** and **Throw**-size quilts]
Fabric A 1½" x 14" [**Queen**-size quilt]
Twin Pole D/E
Fabric A 1½" x 12½" [**Baby** and **Throw**-size quilts]
Fabric A 2" x 14" [**Queen**-size quilt]
Twin Pole F/G
Fabric A 1¼" x 12½" [**Baby** and **Throw**-size quilts]
Fabric A 1½" x 14" [**Queen**-size quilt]
Twin Pole H/I
Fabric A 2¼" x 12½" [**Baby** and **Throw**-size quilts]
Fabric A 2½" x 14" [**Queen**-size quilt]

Block A

Step 2

Arrange the following and sew, as shown in the diagram, to create **Block B**.

Baby	2 Fabric A 2¼" x 12½", 1 Fabric A 1½" x 12½", 2 Fabric A 1¼" x 12½", 1 Twin Pole B/C, 1 Twin Pole D/E, 1 Twin Pole F/G, 1 Twin Pole H/I
Throw	2 Fabric A 2¼" x 12½", 1 Fabric A 1½" x 12½", 2 Fabric A 1¼" x 12½", 1 Twin Pole B/C, 1 Twin Pole D/E, 1 Twin Pole F/G, 1 Twin Pole H/I
Queen	2 Fabric A 2½" x 14", 1 Fabric A 2" x 14", 2 Fabric A 1½" x 14", 1 Twin Pole B/C, 1 Twin Pole D/E, 1 Twin Pole F/G, 1 Twin Pole H/I

Press the seams open. Repeat to create a total of:

Baby	8 12½" **Block B** units
Throw	18 12½" **Block B** units
Queen	18 14" **Block B** units

Tip: Take care when piecing Block B, as it is similar to Block A. Keep in mind that the two blocks mirror each other. To avoid those frustrating seam-ripping moments, use painters tape to stick the blocks on the wall or a surface near your sewing machine as a reminder of the two fabric placement.

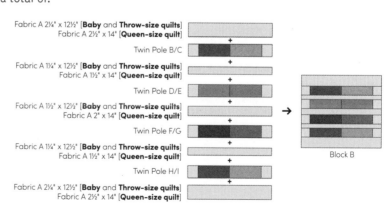

Fabric A 2¼" x 12½" [**Baby** and **Throw**-size quilts]
Fabric A 2½" x 14" [**Queen**-size quilt]
Twin Pole B/C
Fabric A 1¼" x 12½" [**Baby** and **Throw**-size quilts]
Fabric A 1½" x 14" [**Queen**-size quilt]
Twin Pole D/E
Fabric A 1½" x 12½" [**Baby** and **Throw**-size quilts]
Fabric A 2" x 14" [**Queen**-size quilt]
Twin Pole F/G
Fabric A 1¼" x 12½" [**Baby** and **Throw**-size quilts]
Fabric A 1½" x 14" [**Queen**-size quilt]
Twin Pole H/I
Fabric A 2¼" x 12½" [**Baby** and **Throw**-size quilts]
Fabric A 2½" x 14" [**Queen**-size quilt]

Block B

Quilt Assembly

Step 1

As shown in the diagram, create **1 Row** by arranging and sewing together:

Baby	2 Block A units and 2 Block B units
Throw	3 Block A units and 3 Block B units
Queen	3 Block A units and 3 Block B units

Press the seams open. Repeat to create a total of:

Baby	**4 Rows**
Throw	**6 Rows**
Queen	**6 Rows**

Tip: Again, take extra care when putting Rows together. Blocks in each Row mirror each other. Lay blocks on a flat surface in sewing order, and check twice before getting behind the sewing machine.

For **baby-size quilt**:

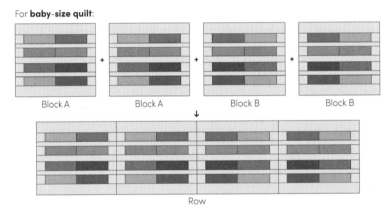

Block A Block A Block B Block B

Row

For **throw-size quilt** and **queen-size quilt**:

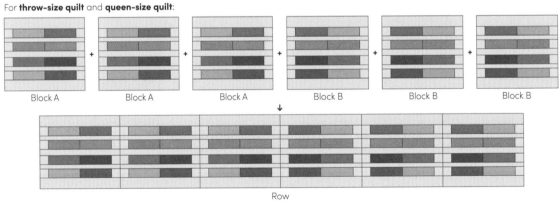

Block A Block A Block A Block B Block B Block B

Row

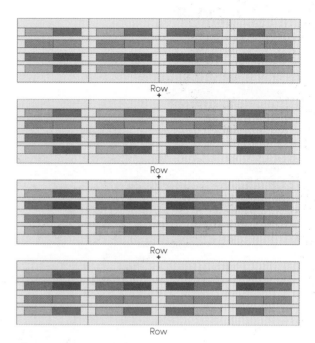

Step 2

To create a **baby-size quilt top**, line up and sew 4 Rows together. Press the seams open.

Note: Turn the bottom 2 Rows 180 degrees before sewing together. The bottom 2 Rows are a reflection of the first 2 Rows.

To create a **throw-size quilt top** or **queen-size quilt top**, line up and sew 6 Rows together. Press the seams open.

Note: Turn the bottom 3 Rows 180 degrees before sewing together. The bottom 3 Rows are a reflection of the first 3 Rows.

Step 3

Press the quilt top and backing fabric. Layer the backing, batting, and quilt top. Baste, quilt, and bind.

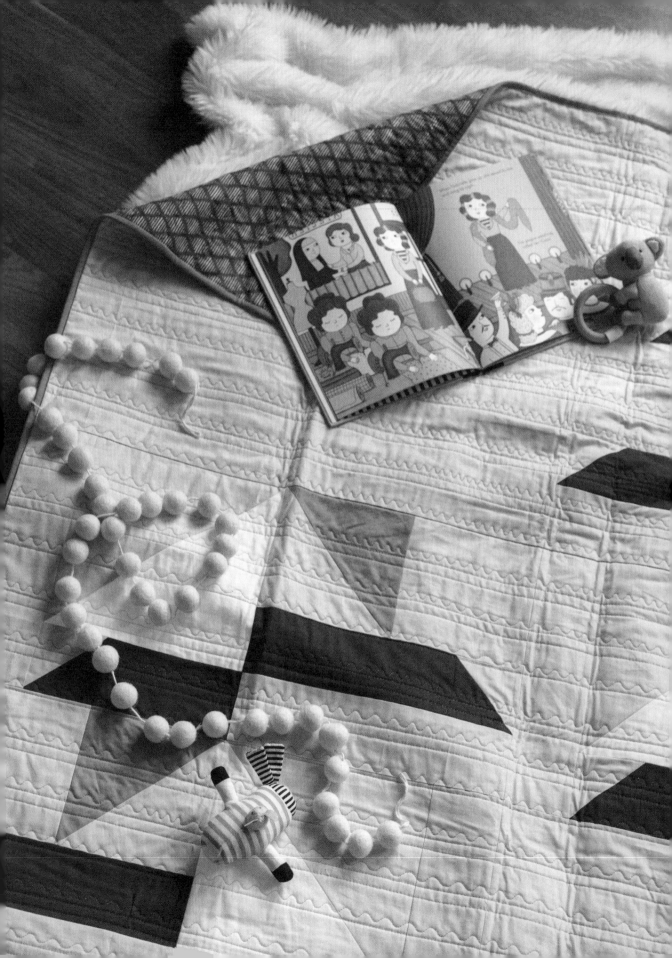

BOAT POND

(Beginner)

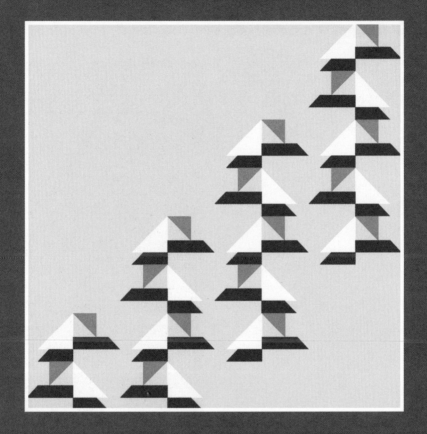

Baby: 48" x 48" (122 cm x 122 cm)

Throw: 72" x 72" (183 cm x 183 cm)

Queen: 96" x 96" (244 cm x 244 cm)

Piecing Methods and Techniques

Half-Square Triangles 8-in-1, 4-in-1, and 2-in-1

The Half-Square Triangle is one of the most commonly used shapes in quilting designs and has continued to make its way in the quilting world, from the very first quilts in history to modern-day designs. Half-Square Triangles consist of two right-angled triangles joined on the longest sides to form a square. This design is popular for its versatility and ability to be used to create various patterns, designs, and well-known quilting blocks—such as Pinwheel and Broken Dishes—by simply rearranging and rotating the squares or playing with different colors. Moreover, Half-Square Triangles are easy and quick to make—if you use shortcuts!

For the first couple of years in my quilting journey, I didn't know Half-Square Triangle shortcuts were a thing. For one of my first quilts, I cut just over 1,000 individual right-angle triangles and pieced them all together! Fortunately, I'm not going to make you do this. Instead, I'll show you all the tricks and shortcuts you need to know when it comes to making Half-Square Triangles.

Living in a bigger city without a car has changed my appreciation for nature and spending time outdoors. Back when my husband and I lived on the Upper East Side, we tried to make the most of warm, sunny weather and get outdoors. We enjoyed stopping by a local bagel store, walking to the park with a quilt, and setting up a picnic on the weekends. The Boat Pond quilt pattern incorporates the 2-in-1, 4-in-1, and 8-in-1 Half-Square Triangle piecing methods and takes you on a journey to a hill that overlooks the boat pond in Central Park, New York City.

The thought of cutting more than 1,000 individual pieces still makes me shudder. But the thought of not having quilting rulers and rotary cutters to help me do that makes me shudder more. The first rotary cutter, by a Japanese company called Olfa, was not introduced to the quilting market until 1979, and acyclic rulers and templates didn't make their way into sewing rooms until the mid-1980s. These innovations have increased quiltmaking efficiency and accuracy, enabling quilters to cut through multiple layers of fabric and pieces at a time, and quickly make straight and precise cuts. Prior to this, quilters used pieces of newspaper or cardboard templates, carefully traced them on their fabrics, and added a ¼" seam allowance around each shape. With a sharp eye, a steady hand, and a pair of dressmaking scissors, they cut each individual piece. As you could imagine, quiltmaking used to be more time-intensive. A project could take weeks, months, or even years to complete!

COLOR INSPIRATION

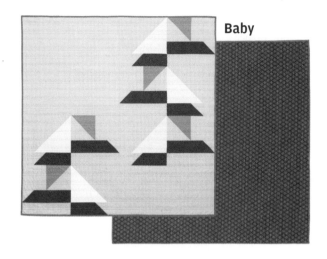

Baby

Fabric A Robert Kaufman, Kona Cotton in Light Parfait

Fabric B Robert Kaufman, Kona Cotton in Celestial

Fabric C Robert Kaufman, Kona Cotton in Natural

Fabric D Robert Kaufman, Kona Cotton in Salmon

Backing Fabric Hawthorne Supply Co, Shannon McNab, Woodland Autumn, Pathway in River

Binding Fabric Robert Kaufman, Kona Cotton in Salmon

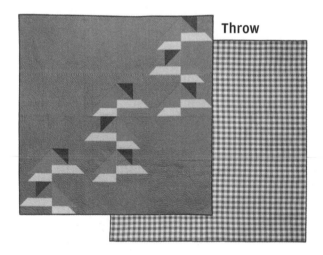

Throw

Fabric A Robert Kaufman, Kona Cotton in Pickle

Fabric B Robert Kaufman, Kona Cotton in Pink

Fabric C Robert Kaufman, Kona Cotton in Orangeade

Fabric D Robert Kaufman, Kona Cotton in Regatta

Backing Fabric Hawthorne Supply Co, Hawthorne Essentials, Buffalo Plaid in Midnight

Binding Fabric Robert Kaufman, Kona Cotton in Nightfall

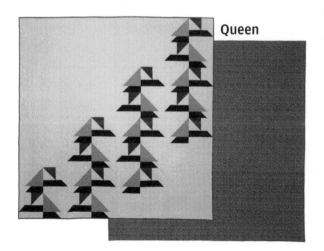

Queen

Fabric A Robert Kaufman, Kona Cotton in Canary

Fabric B Robert Kaufman, Kona Cotton in Navy

Fabric C Robert Kaufman, Kona Cotton in Kumquat

Fabric D Robert Kaufman, Kona Cotton in Cinnamon

Backing Fabric Hawthorne Supply Co, Lisa Clow, Autumn Revival, Soul Burst in Onyx

Binding Fabric Robert Kaufman, Kona Cotton in Prussian

Fabric Requirements

	Baby	Throw	Queen
Fabric A ⬤	2 yard (183 cm)	4 yard (366 cm)	7⅛ yards (652 cm)
Fabric B ⬤	½ yard (46 cm)	¾ yard (69 cm)	1 yards (92 cm)
Fabric C ○	⅜ yard (35 cm)	⅜ yard (35 cm)	⅝ yard (58 cm)
Fabric D ⬤	⅜ yard (35 cm) or 1 fat quarter	⅜ yard (35 cm) or 1 fat quarter	⅜ yard (35 cm)
Backing Fabric	3⅛ yard (286 cm)	4½ yard (412 cm)	8¾ yard (801 cm)
Binding Fabric	½ yard (46 cm)	⅝ yard (58 cm)	¾ yard (69 cm)

Cutting Directions

	Baby	Throw	Queen
Fabric A ⚪	1 strip, 24½" x WOF, sub-cut: • 1 square, 24½" x 24½" • 1 rectangle, 24½" x 12½" 2 strips, 10½" x WOF, sub-cut: • 5 squares, 10½" x 10½" • 2 squares, 8" x 8" 1 strip, 6½" x WOF, sub-cut: • 5 squares, 6½" x 6½" 4 strips, 3½" x WOF, sub-cut: • 10 squares, 3½" x 12½"	4 strips, 24½" x WOF, sub-cut: • 4 squares, 24½" x 24½" • 2 rectangles, 24½" x 12½" • 8 squares, 6½" x 6½" 2 strips, 10½" x WOF, sub-cut: • 6 squares, 10½" x 10½" • 2 squares, 8" x 8" 5 strips, 3½" x WOF, sub-cut: • 16 rectangles, 3½" x 12½"	7 strips, 24½" x WOF, sub-cut: • 7 squares, 24½" x 24½" • 2 rectangles, 24½" x 12½" • 16 squares, 6½" x 6½" 3 strips, 10½" x WOF, sub-cut: • 12 squares, 10½" x 10½" • 1 square, 8" x 8" 11 strips, 3½" x WOF, sub-cut: • 32 rectangles, 3½" x 12½"
Fabric B ⚫	2 strips, 3½" x WOF, sub-cut: • 5 rectangles, 3½" x 9½" • 5 rectangles, 3½" x 6½" 2 squares, 8" x 8"	4 strips, 3½" x WOF, sub-cut: • 8 rectangles, 3½" x 9½" • 8 rectangles, 3½" x 6½" 2 squares, 8" x 8"	7 strips, 3½" x WOF, sub-cut: • 16 rectangles, 3½" x 9½" • 16 rectangles, 3½" x 6½" 4 squares, 8" x 8"
Fabric C ⚪	3 squares, 10½" x 10½"	4 squares, 10½" x 10½"	8 squares, 10½" x 10½"
Fabric D ⚫	2 squares, 10½" x 10½"	2 squares, 10½" x 10½"	4 squares, 10½" x 10½"
Binding Fabric	5 strips, 2½" x WOF	8 strips, 2½" x WOF	10 strips, 2½" x WOF

2-in-1 Half-Square Triangle Units

Step 1

Draw a diagonal guideline on the wrong side of:

Baby	3 Fabric C 10½" x 10½" squares
Throw	4 Fabric C 10½" x 10½" squares
Queen	8 Fabric C 10½" x 10½" squares

Step 2

With the right sides together, place 1 marked Fabric C 10½" x 10½" square on top of 1 Fabric A 10½" x 10½" square, and sew ¼" away from both sides of the marked guideline. Pin as needed to keep the pieces secure as you sew.

Step 3

Cut on the drawn line and press the seams open to create **2 Fabric A/C Half-Square Triangle** units.

Step 4

Repeat *Steps 2 and 3* to create a total of:

Baby	5 Fabric A/C Half-Square Triangle units*
Throw	8 Fabric A/C Half-Square Triangle units
Queen	16 Fabric A/C Half-Square Triangle units

Note: There will be 1 extra Half-Square Triangle unit for a baby-size quilt.

Step 5

Trim each Fabric A/C Half-Square Triangle unit to a 9½" x 9½" square. Set aside units for *Set Units, Step 4 (page 73)*.

Fabric A/C Half-Square Triangles

4-in-1 Half-Square Triangle Units

Step 1

With the right sides facing each other, place 1 Fabric A 10½" x 10½" square on top of 1 Fabric D 10½" x 10½" square, and sew a line ¼" from all four edges to create **1 Fabric A/D Half-Square Triangle Set**. Repeat to create a total of:

Baby	2 Fabric A/D Half-Square Triangle Sets
Throw	2 Fabric A/D Half-Square Triangle Sets
Queen	4 Fabric A/D Half-Square Triangle Sets

Step 2

On the wrong side of all the Fabric A/D Half-Square Triangle Sets, draw two diagonal guidelines.

Step 3

Cut on the marked guidelines and press the seams open to create a total of:

Baby	5 Fabric A/D Half-Square Triangle units*
Throw	8 Fabric A/D Half-Square Triangle units
Queen	16 Fabric A/D Half-Square Triangle units

Note: There will be 3 extra Half-Square Triangle unit for a baby-size quilt.

Step 4

Trim each Fabric A/D Half-Square Triangle unit to a 6½" x 6½" square. Set aside units for *Set Units, Step 5 (page 73)*.

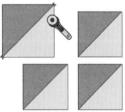

Fabric A/D Half-Square Triangles

8-in-1 Half-Square Triangle Units

Step 1

On the wrong side of all Fabric B 8" x 8" squares, draw two diagonal guidelines.

Step 2

With the right sides together, place 1 marked Fabric B 8" x 8" square on top of 1 Fabric A 8" x 8" square, and sew ¼" on both sides of the guidelines.

Step 3

Cut vertically down the center of the 8" x 8" square, using a ruler to align the straightedges of the square and the intersection of the diagonal guidelines.

Without shifting the fabric pieces, make a second cut perpendicular to the first.

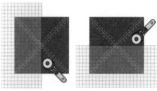

Step 4

Separate the fabric pieces. Cut on the marked guidelines on each of the four squares diagonally, corner to corner. Press the seams open to create **8 Fabric A/B Half-Square Triangle** units.

Step 5

Repeat *Steps 2 through 4* to create a total of:

Note: There will be 6 extra Half-Square Triangle units for a baby-size quilt.

Baby	10 Fabric A/B Half-Square Triangle units*
Throw	16 Fabric A/B Half-Square Triangle units
Queen	32 Fabric A/B Half-Square Triangle units

Step 6

Trim each Fabric A/B Half-Square Triangle unit to a 3½" x 3½" square.

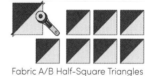

Fabric A/B Half-Square Triangles

Set Units

Step 1

Sew 1 Fabric A/B Half-Square Triangle to the left of 1 Fabric B 3½" x 6½" rectangle to create **1 Set D** unit. Repeat to create a total of:

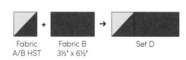

Fabric Fabric B Set D
A/B HST 3½" x 6½"

Baby	3 **Set D** units
Throw	5 **Set D** units
Queen	9 **Set D** units

Press the seams open and set aside for *Set Units, Step 4 (page 73).*

Step 2

Sew 1 Fabric A/B Half-Square Triangle to the right of 1 Fabric B 3½" x 6½" rectangle to create **1 Set E unit**. Repeat to create a total of:

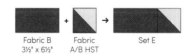

Fabric B Fabric Set E
3½" x 6½" A/B HST

Baby	2 **Set E** units
Throw	3 **Set E** units
Queen	7 **Set E** units

Press the seams open and set aside for *Set Units, Step 4 (page 73).*

Step 3

Similar to in Steps 1 and 2, attach 1 Fabric A/B Half-Square Triangle to the left of 1 Fabric B 3½" x 9½" rectangle to form **1 Set F** unit, and sew together 1 Fabric A/B Half-Square Triangle to the right of 1 Fabric B 3½" x 9½" rectangle to form **1 Set G** unit. Repeat to create a total of:

Baby	2 **Set F** and 3 **Set G** units
Throw	3 **Set F** and 5 **Set G** units
Queen	7 **Set F** and 9 **Set G** units

Press the seams open.

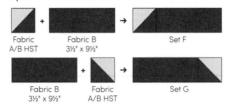

Step 4

As shown in the diagram, combine 1 A/C Half-Square Triangle and 1 Set D unit to create **1 Set H** unit, and combine 1 A/C Half-Square Triangle and 1 Set E unit to create **1 Set I** unit. Repeat to create a total of:

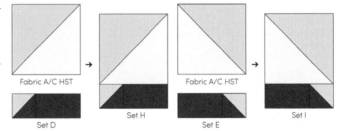

Baby	3 **Set H** and 2 **Set I** units
Throw	5 **Set H** and 3 **Set I** units
Queen	9 **Set H** and 7 **Set I** units

Press the seams open and set aside for Block Assembly, Steps 1 and 2 (page 74).

Step 5

Sew together 1 A/D Half-Square Triangle unit to the left of 1 Fabric A 6½" x 6½" square to create **1 Set J** unit. Repeat to create a total of:

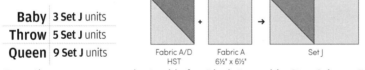

Baby	3 **Set J** units
Throw	5 **Set J** units
Queen	9 **Set J** units

Press the seams open and set aside for *Block Assembly, Step 3 (page 74).*

Step 6

Sew 1 A/D Half-Square Triangle unit to the right of 1 Fabric A 6½" x 6½" square to form **1 Set K** unit. Repeat to create a total of:

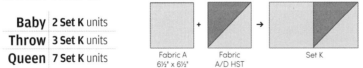

Baby	2 **Set K** units
Throw	3 **Set K** units
Queen	7 **Set K** units

Press the seams open and set aside for *Block Assembly, Step 4 (page 74).*

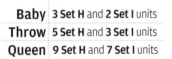

Block Assembly

Step 1

Attach 1 Fabric A 3½" x 12½" rectangle to the left of 1 Set H unit to create **1 Block A** unit. Repeat to create a total of:

Baby	**3 Block A** units
Throw	**5 Block A** units
Queen	**9 Block A** units

Press the seams open and set aside for *Block Assembly, Step 5 (page 75)*.

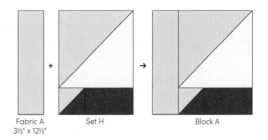

Step 2

Sew 1 Fabric A 3½" x 12½" rectangle to the right of 1 Set I unit to create **1 Block B** unit. Repeat to create a total of:

Baby	**2 Block B** units
Throw	**3 Block B** units
Queen	**7 Block B** units

Press the seams open and set aside for *Block Assembly, Step 5 (page 75)*.

Step 3

Combine 1 Set G, 1 Set J, and 1 Fabric A 3½" x 12½" rectangle to form **1 Block C** unit. Repeat to create a total of:

Baby	**3 Block C** units
Throw	**5 Block C** units
Queen	**9 Block C** units

Press the seams open and set aside for *Block Assembly, Step 5 (page 75)*.

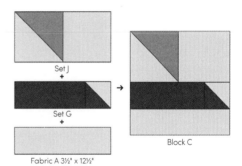

Step 4

As shown in the diagram, sew together 1 Set F, 1 Set K, and 1 Fabric A 3½" x 12½" rectangle to form **1 Block D** unit. Repeat to create a total of:

Baby	**2 Block D** units
Throw	**3 Block D** units
Queen	**7 Block D** units

Press the seams open.

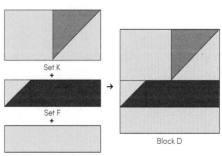

Step 5

Following the diagram, sew together 1 Block A, 1 Block B, 1 Block C, and 1 Block D unit to form **1 Block E** unit. Use pins as needed to align seams and points. Repeat to create a total of:

Baby	**2 Block E** units
Throw	**3 Block E** units
Queen	**7 Block E** units

Press the seams open and set aside for *Quilt Assembly, Step 1 (page 76)*.

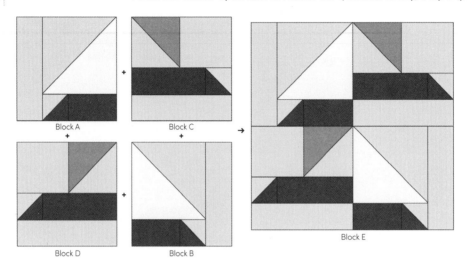

Block A + Block C + Block D + Block B → Block E

Step 6

As shown in the diagram, combine 1 Fabric A 12½" x 24½" rectangle, 1 Block A, and 1 Block C unit to create **1 Block F** unit. Repeat to create a total of:

Baby	**1 Block F** units
Throw	**2 Block F** units
Queen	**2 Block F** units

Press the seams open.

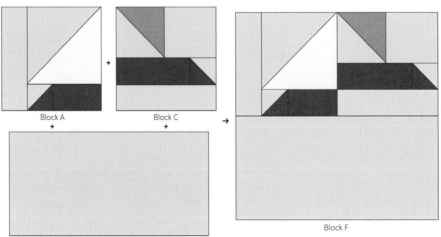

Block A + Block C + Fabric A 12½" x 24½" rectangle → Block F

Quilt Assembly

Step 1

A **baby-size quilt top** is comprised of two rows. Following the diagram, sew together 1 Fabric A 24½" x 24½" square and 1 Block E unit to form **Row 1**. Sew together 1 Block E and 1 Block F unit to create **Row 2**. Line up the seams and join the two rows to form a baby-size quilt top. Press the seams open.

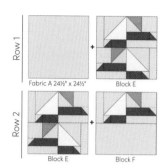

A **throw-size quilt top** is comprised of three rows. For **Row 1** sew together 2 Fabric A 24½" x 24½" squares and 1 Block E unit. For **Row 2** and **Row 3**, refer to the diagram and combine 1 Fabric A 24½" x 24½", 1 Block E, and 1 Block F unit. Line up the seams and join Rows 1 through 3 to create a throw-size quilt top. Press the seams open.

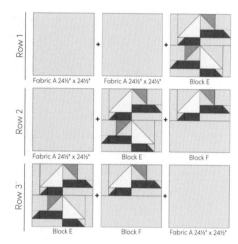

A **queen-size quilt top** is comprised of four rows. As shown in the diagram, sew together 3 Fabric A 24½" x 24½" squares and 1 Block E unit to create **Row 1**. Sew together 2 Fabric A 24½" x 24½" squares and 2 Block E units to create **Row 2**. For **Rows 3** and **4**, sew together 1 Fabric A 24½" x 24½" square, 2 Block E units, and 1 Block F unit. Line up the seams and sew together Rows 1 through 4 to create a queen-size quilt top. Press the seams open.

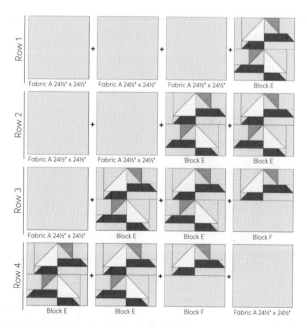

Step 2

Press the quilt top and backing fabric. Layer the backing, batting, and quilt top. Baste, quilt, and bind.

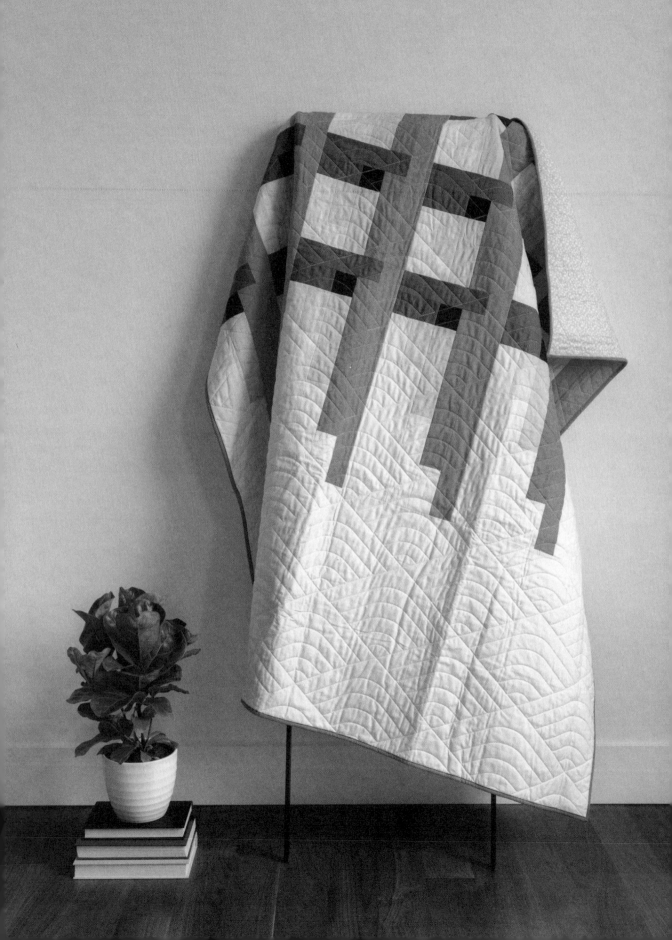

LANDMARK
(Advanced Beginner)

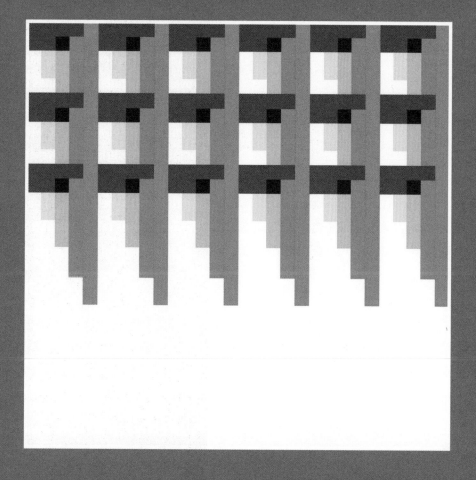

Wall Hanging: 30" x 30" (77 cm x 77 cm)

Baby: 40" x 55" (102 cm x 140 cm)

Throw: 60" x 60" (153 cm x 153 cm)

Piecing Methods and Techniques

Strip piecing / Log Cabin blocks

Different cities across the globe are recognizable by their iconic buildings: The Gherkin in London, the Opera House in Sydney, the Empire State Building in New York City, the pyramids of Giza, Burj Khalifa in Dubai, the Forbidden City in Beijing, and many more. These buildings give character and culture to a city, each with its own unique story and insight into a period in history. Tourists travel far and wide just to see some of these landmarks, and visiting or snapping a picture of the building is often a highlight of a trip.

Perth, Australia, is where I was born and grew up. There are a few iconic buildings that make up the cityscape. I can't imagine Perth's skyline without 108 St Georges Terrace (previously known as the Bankwest Tower or Bond Tower). Occasionally on the way home from work, I used to enjoy dropping by the South Perth Foreshore to go for walks and runs to unwind from a long day. This was one of my favorite spots because I could admire the city's skyline and watch the sunset at the same time.

The Landmark Quilt is a reflection of this iconic building on the Swan River on a warm summer's evening. It's a modern take on Log Cabin blocks, which are made of a square in the middle with strips of fabric added around the square. Traditionally, the middle square is red to represent the fireplace in the home. Sometimes a yellow-colored square is used to suggest the sun shining through a window. Darker strips of fabric on two sides of the quilt block represent the shady side of the house. Lighter strips on the other two sides illustrate the sunny side of the house.

The Log Cabin pattern is believed to date back as far as the ancient Egyptian civilization. In the early nineteenth century, when the British discovered the tombs of deceased Egyptian royalty, they found thousands of small animal mummies wrapped in linen with the pattern on them. Unsure of what to do with the thousands of mummy coverings uncovered from the tombs, British explorers shipped and distributed them to farmers back home. Imagine those farmers' wives taking the patterns and incorporating them into their quilt projects!

In the 1860s, during the Civil War, Log Cabin quilts became popular and widespread in U.S. households. Log Cabin blocks used during this period also appeared in Underground Railway quilts, which are thought to have helped guide slaves escaping from the South. Different colors in the center of the square indicated different messages. Blue meant it was a safe house. Yellow meant to proceed with caution, and red or black meant danger ahead.

Today, there are several variations of Log Cabin blocks, such as Courthouse Steps blocks (we'll explore these in the "Museum Steps" quilt pattern; *page 88*) and Pineapple blocks.

COLOR INSPIRATION

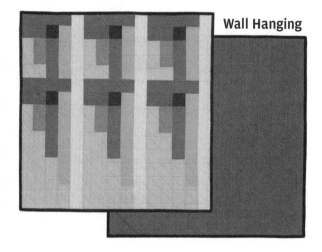

Wall Hanging

Fabric A Robert Kaufman, Kona Cotton in Seafoam
Fabric B Robert Kaufman, Kona Cotton in Curry
Fabric C Robert Kaufman, Kona Cotton in Watermelon
Fabric D Robert Kaufman, Kona Cotton in Bubble Gum
Fabric E Robert Kaufman, Kona Cotton in Daffodil
Fabric F Robert Kaufman, Kona Cotton in Dill
Fabric G Robert Kaufman, Kona Cotton in Velvet
Backing Fabric Robert Kaufman, Kona Cotton in O.D. Green
Binding Fabric Robert Kaufman, Kona Cotton in Hunter Green

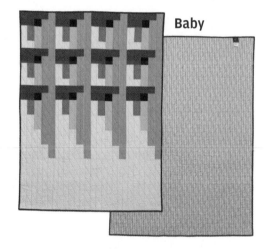

Baby

Fabric A Robert Kaufman, Kona Cotton in Sky
Fabric B Robert Kaufman, Kona Cotton in Turquoise
Fabric C Robert Kaufman, Kona Cotton in Jamaica
Fabric D Robert Kaufman, Kona Cotton in Sage
Fabric E Robert Kaufman, Kona Cotton in Bubble Gum
Fabric F Robert Kaufman, Kona Cotton in Plum
Fabric G Robert Kaufman, Kona Cotton in Pepper
Backing Fabric Hawthorne Supply Co, Hawthorne Supply Co, Bewitched, Rhythmic in Wisteria
Binding Fabric Robert Kaufman, Kona Cotton in Berry

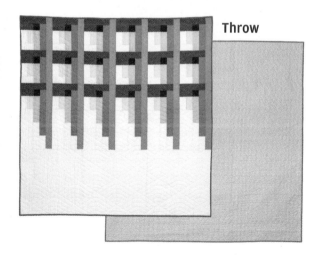

Throw

Fabric A Robert Kaufman, Kona Cotton in Bone
Fabric B Robert Kaufman, Kona Cotton in Pink
Fabric C Robert Kaufman, Kona Cotton in Peach
Fabric D Robert Kaufman, Kona Cotton in Saffron
Fabric E Robert Kaufman, Kona Cotton in Grellow
Fabric F Robert Kaufman, Kona Cotton in Moss
Fabric G Robert Kaufman, Kona Cotton in Black
Backing Fabric Hawthorne Supply Co, Indy Bloom, Dragonfly Dreams, Pebbles in Pink Bloom
Binding Fabric Robert Kaufman, Kona Cotton in Cedar

Fabric Requirements

	Wall Hanging	Baby	Throw
Fabric A ⚪	½ yard (46 cm)	1⅛ yards (104 cm)	1¾ yard (161 cm)
Fabric B ⚪	⅛ yard (12 cm)*	¼ yard (23 cm)*	¼ yard (23 cm)*
Fabric C ⚪	¼ yard (23 cm) or 1 fat quarter	⅜ yard (35 cm)	½ yard (46 cm)
Fabric D ⚫	¼ yard (23 cm) or 1 fat quarter	⅜ yard (35 cm)	½ yard (46 cm)
Fabric E ⚫	¼ yard (23 cm)	⅓ yard (31 cm)	½ yard (46 cm)
Fabric F ⚫	⅓ yard (31 cm)	⅜ yard (35 cm)	⅝ yard (58 cm)
Fabric G ⚫	⅛ yard (12 cm) or 1 fat eighth	⅛ yard (12 cm)	¼ yard (23 cm)
Backing Fabric	1 yard (92 cm)	2¾ yard (252 cm)	3¾ yard (343 cm)
Binding Fabric	⅜ yard (35 cm)	⅜ yard (35 cm)	½ yard (46 cm)

*Do not use fat eighths or fat quarters to fulfill fabric requirement. The length of fat eighths and fat quarters is not long enough for strip piecing.

Cutting Directions

	Wall Hanging	Baby	Throw
Fabric A ⚪	1 strip, 8½" x WOF sub-cut: • 1 square, 8½" x 8½" • 1 rectangle, 2½" x 28" 2 strips, 4½" x WOF sub-cut: • 3 rectangles, 4½" x 12½" • 1 rectangle, 4½" x 8½" • 3 rectangles, 4½" x 2½"	1 strip, 15½" x WOF sub-cut: • 1 rectangle, 15½" x 40½" 1 strip, 8½" x WOF sub-cut: • 2 rectangles, 2½" x 28" • 1 rectangle, 8½" x 11" 3 strips, 4½" x WOF sub-cut: • 4 rectangles, 4½" x 12½" • 1 rectangle, 4½" x 11" • 8 rectangles, 4½" x 2½"	2 strips, 20½" x WOF, sub-cut: • 3 squares, 20½" x 20½" • 1 rectangle, 8½" x 16" 3 strips, 4½" x WOF sub-cut: • 1 rectangle, 4½" x 16" • 6 rectangles, 4½" x 12½" • 12 rectangles, 4½" x 2½" 2 strips, 2½" x WOF

Cutting Directions

Continued...

	Wall Hanging	Baby	Throw
Fabric B ⬤	1 rectangle, 2½" x 28"	2 rectangles, 2½" x 28"	2 strips, 2½" x WOF
Fabric C ⬤	1 strip, 8½" x WOF sub-cut: • 1 square, 8½" x 8½" • 3 rectangles, 2½" x 6½"	1 strip, 11" x WOF sub-cut: • 1 rectangle, 8½" x 11" • 8 rectangles, 2½" x 6½"	1 strip, 16" x WOF sub-cut: • 1 rectangle, 8½" x 16" • 12 rectangles, 2½" x 6½"
Fabric D ⬤	1 strip, 8½" x WOF sub-cut: • 1 rectangle, 8½" x 14½" • 3 rectangles, 8½" x 2½"	1 strip, 11" x WOF sub-cut: • 1 rectangle, 11" x 14½" • 8 rectangles, 8½" x 2½"	1 strip, 16" x WOF sub-cut: • 1 rectangle, 14½" x 16" • 12 rectangles, 8½" x 2½"
Fabric E ⬤	3 strips, 2½" x WOF sub-cut: • 3 rectangles, 2½" x 20½" • 3 rectangles, 2½" x 10½"	4 strips, 2½" x WOF sub-cut: • 4 rectangles, 2½" x 20½" • 8 rectangles, 2½" x 10½"	6 strips, 2½" x WOF sub-cut: • 6 rectangles, 2½" x 20½" • 12 rectangles, 2½" x 10½"
Fabric F ⬤	2 strips, 2½" x WOF sub-cut: • 6 rectangles, 2½" x 8½" 1 rectangle, 4½" x 16"	3 strips, 2½" x WOF sub-cut: • 12 rectangles, 2½" x 8½" 1 rectangle, 4½" x 31"	4 strips, 2½" x WOF sub-cut: • 18 rectangles, 2½" x 8½" 2 rectangle, 4½" x 23½"
Fabric G ⬤	1 rectangle, 2½" x 16"	1 rectangle, 2½" x 31"	6 strips, 2½" x 23½"
Binding Fabric	4 strips, 2½" x WOF	5 strips, 2½" x WOF	7 strips, 2½" x WOF

Strip Set Units

Step 1

Referring to the diagram shown, create **1 Strip Set A/B** unit by combining:

Wall Hanging	1 Fabric A 2½" x 28" rectangle and 1 Fabric B 2½" x 28" rectangle
Baby	1 Fabric A 2½" x 28" rectangle and 1 Fabric B 2½" x 28" rectangle
Throw	1 Fabric A 2½" x WOF and 1 Fabric B 2½" x WOF

Set Strip A/B

Press the seams open. Repeat once to create a total of **2 Strip Set A/B** units for a baby- or throw-size quilt. (Do not repeat for a wall hanging.) Set aside unit(s) for *Strip Set Units, Step 6 (page 84)*.

Step 2

As per the diagram shown, form **1 Strip Set A/C** unit by combining the following:

Wall Hanging	1 Fabric A 8½" x 8½" square and 1 Fabric C 8½" x 8½" square
Baby	1 Fabric A 8½" x 11" rectangle and 1 Fabric C 8½" x 11" rectangle
Throw	1 Fabric A 8½" x 16" rectangle and 1 Fabric C 8½" x 16" rectangle

Set Strip A/C
*Baby-size quilt used in this example

Press the seams open and set aside unit for *Strip Set Units, Step 6 (page 84)*.

Step 3

Form **1 Strip Set A/D** unit by combining the following pieces, as shown in the diagram:

Wall Hanging	1 Fabric A 4½" x 8½" rectangle and 1 Fabric D 8½" x 14½" rectangle
Baby	1 Fabric A 4½" x 11" rectangle and 1 Fabric D 11" x 14½" rectangle
Throw	1 Fabric A 4½" x 16" rectangle and 1 Fabric D 14½" x 16" rectangle

Set Strip A/D
*Baby-size quilt used in this example

Press the seams open and set aside unit for *Strip Set Units, Step 6 (page 84)*.

Step 4

Following the diagram shown, create **1 Strip Set F/G** unit by sewing together:

Wall Hanging	1 Fabric F 4½" x 16" rectangle and 1 Fabric G 2½" x 16" rectangle
Baby	1 Fabric F 4½" x 31" rectangle and 1 Fabric G 2½" x 31" rectangle
Throw	1 Fabric F 4½" x 23½" rectangle and 1 Fabric G 2½" x 23½" rectangle

Set Strip F/G
*Baby-size quilt used in this example

Press the seams open. Repeat once to create a total of **2 Strip Set F/G** units for a throw-size quilt. (Do not repeat for a baby quilt or wall hanging.)

Step 5

Trim the right-hand edge of all Strip Set units created in **Steps 1 through 4** to ensure they are straight and right-angled against the length of the strip set.

*Strip Set A/D used in this example

Step 6

Rotate all Strip Set units 180 degrees. Using the straightedge on the left-hand side as a guide, cut a total of:

*Strip Set A/D used in this example

	Wall Hanging	Baby	Throw
4½" Strip Set A/B	6 units	12 units	18 units
2½" Strip Set A/C	3 units	4 units	6 units
2½" Strip Set A/D	3 units	4 units	6 units
2½" Strip Set F/G	6 units	12 units	18 units

Block Assembly

The composition of Log Cabin blocks in the Landmark quilt pattern is slightly different compared to a traditional block. However, the construction is largely the same, starting with one square or rectangle in the middle and adding strips around the square or rectangle, circling around until you reach the desired block shape and size.

Step 1

Create **1 Block A** unit, in the order shown in the table and diagram, for all quilt sizes. Press the seams open as you go.

Order	Units
1	1 Fabric A 2½" x 4½" rectangle
2	1 Strip Set A/B unit
3	1 Fabric C 2½" x 6½" rectangle
4	1 Strip Set F/G unit
5	1 Fabric D 2½" x 8½" rectangle
6	1 Fabric F 2½" x 8½" rectangle
7	1 Fabric E 2½" x 10½" rectangle

Step 1...

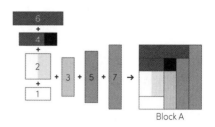

Block A

Repeat to create a total of:

Wall Hanging	**3 Block A** units
Baby	**8 Block A** units
Throw	**12 Block A** units

Step 2

Create **1 Block B** unit, following the diagram and the order shown in the table, for all quilt sizes. Press the seams open as you go.

Order	Units
1	1 Fabric A 4½" x 12½" rectangle
2	1 Strip Set A/B unit
3	1 Strip Set A/C unit
4	1 Strip Set F/G unit
5	1 Strip Set A/D unit
6	1 Fabric F 2½" x 8½" rectangle
7	1 Fabric E 2½" x 20½" rectangle

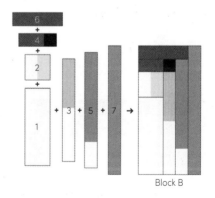

Block B

Repeat to create a total of:

Wall Hanging	**3 Block B** units
Baby	**4 Block B** units
Throw	**6 Block B** units

Quilt Assembly

Step 1

Referring to the diagram shown, form **Row 1** by sewing together:

Wall Hanging	**3 Block A** units
Baby	**4 Block A** units
Throw	**6 Block A** units

Repeat once to create a total of **2 Row 1** units for a baby or throw-size quilt. (Do not repeat for a wall hanging.)

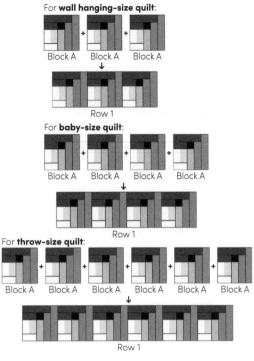

For **wall hanging-size quilt**:

Block A + Block A + Block A

↓

Row 1

For **baby-size quilt**:

Block A + Block A + Block A + Block A

↓

Row 1

For **throw-size quilt**:

Block A + Block A + Block A + Block A + Block A + Block A

↓

Row 1

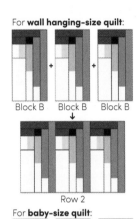

For **wall hanging-size quilt**:

Block B + Block B + Block B

↓

Row 2

Step 2

As per the diagram shown, create **Row 2** by combining:

Wall Hanging	**3 Block A** units
Baby	**4 Block A** units
Throw	**6 Block A** units

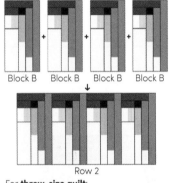

For **baby-size quilt**:

Block B + Block B + Block B + Block B

↓

Row 2

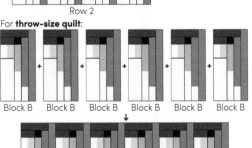

For **throw-size quilt**:

Block B + Block B + Block B + Block B + Block B + Block B

↓

Row 2

Step 3

Create **Row 3** by joining:

Wall Hanging	N/A
Baby	N/A
Throw	3 Fabric A 20½" x 20½" sqaures

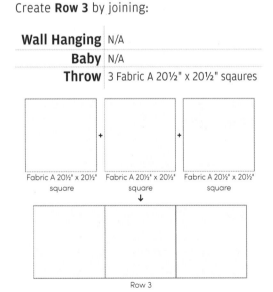

Fabric A 20½" x 20½" square + Fabric A 20½" x 20½" square + Fabric A 20½" x 20½" square

↓

Row 3

Step 4

To create a **wall hanging-size quilt top**, line up the seams and sew together 1 Row 1 unit and 1 Row 2 unit.

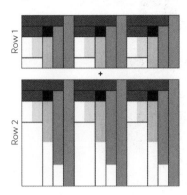

To create a **baby-size quilt top**, line up the seams and sew together 2 Row 1 units, 1 Row 2 unit, and 1 rectangle, 15½" x 40½".

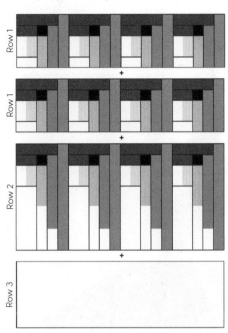

To create a **throw-size quilt top**, line up the seams and sew together 2 Row 1 units, 1 Row 2 unit, and 1 Row 3 unit.

Step 5

Press the quilt top and backing fabric. Layer the backing, batting, and quilt top. Baste, quilt, and bind.

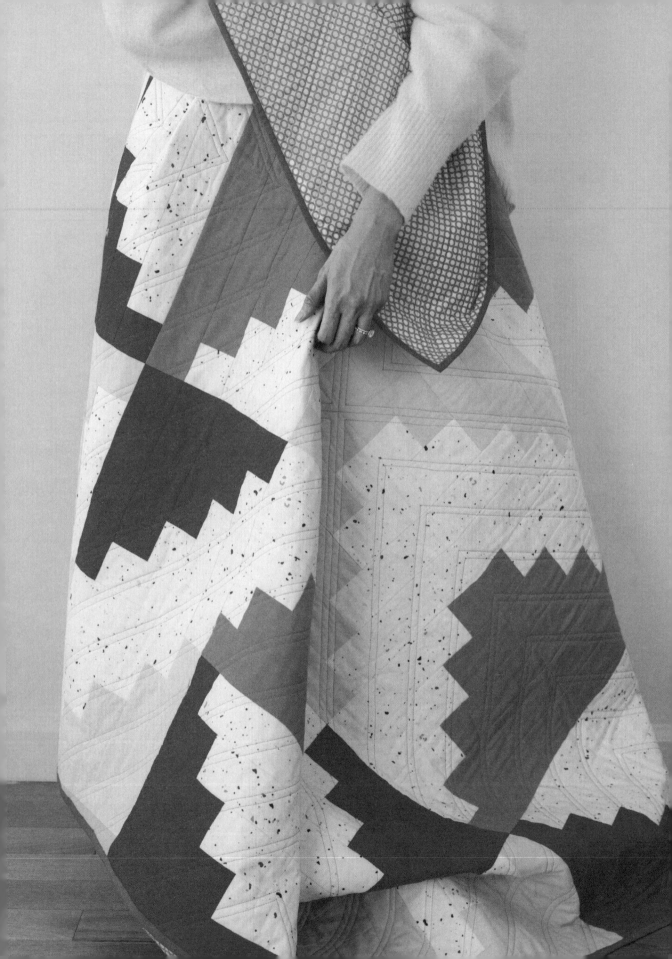

MUSEUM STEPS

(Advanced Beginner)

Wall Hanging: 30" x 30" (77 cm x 77 cm)

Baby: 45" x 45" (115 cm x 115 cm)

Throw: 60" x 60" (153 cm x 153 cm)

Piecing Methods and Techniques

Strip piecing / Log Cabin blocks / Courthouse Steps block

For me, a trip to a new city is not complete without a visit to at least one museum or historical site. This tradition began after an unforgettable family trip to Xi'an, China, when I was fourteen years old. My parents took the family to see the Terracotta Warriors—a historical site with thousands of life-size replicas of China's first emperor's army. Walking through the site, I couldn't help thinking that what stood before me existed centuries ago.

Since that day, visiting a local museum or historical site when I travel goes on the top of my to-do list. These experiences allow me to learn about a country's or city's history and culture in one place, especially if I have limited time on the travel itinerary.

Living in New York City, we are spoiled by some of the best museums in the world. One of my favorites is the Metropolitan Museum of Art, often called The Met. This museum is so large it would take days to see the entire museum. Every time I visit, I am transported to different time periods and discover different cultures. The iconic steps of The Met inspired the Museum Steps quilt. Log Cabin and Courthouse Steps blocks form a star in the design to highlight the fame and glam on the evening of the Met Gala, held the first Monday of every May.

Courthouse Steps blocks (the block in the center of the Museum Steps quilt) date back to the U.S. Civil War period (1861—1865). The name says it all: Courthouse Steps blocks represent the stairs leading up to a courthouse. Like modern-day quilters, quilters back in the day took quilt design inspiration from things they saw in their everyday lives and gave those designs literal names. For example, Bear Paw, Hourglass, and Sawtooth Star blocks.

Courthouse Steps blocks are a variation of the Log Cabin block. Strips of fabric are added around the center square. But instead of wrapping the fabric strips around the center square to form a larger square, like you would for a Log Cabin block, add two identical strips of fabric to the opposite sides of the center square. Add another set of two identical strips to the other two sides, and repeat until the desired size is reached. Traditionally, the center square is black in color to represent the judge that sits in the court. Light and dark colors on opposite ends create contrast and highlight the "steps" leading up to the courthouse.

This quilt pattern also incorporates strip piecing to speed up the process of joining two Log Cabin blocks together. These blocks are referred to as Flying Geese Strip Set Units in this particular pattern.

COLOR INSPIRATION

Wall Hanging

Fabric A ● Robert Kaufman, Kona Cotton in Hunter Green

Fabric B ● Robert Kaufman, Kona Cotton in Pickle

Fabric C ● Robert Kaufman, Kona Cotton in Rose

Fabric D ● Robert Kaufman, Kona Cotton in Amber

Backing Fabric Hawthorne Supply Co, Lisa Clow, Modern Moods, Large Terazzo in Modern

Binding Fabric Robert Kaufman, Kona Cotton in Amber

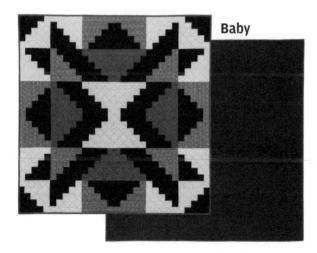

Baby

Fabric A ● Robert Kaufman, Kona Cotton in Nautical

Fabric B ○ Hawthorne Supply Co, Northern Trails, Cracked Ice in Glacier Blue

Fabric C ● Hawthorne Supply Co, Indy Bloom, Desert Rose, Luxe in Clay

Fabric D ● Hawthorne Supply Co, Hawthorne Supply Co, Lynx, Pine Needles in Juniper

Backing Fabric Hawthorne Supply Co, Lisa Clow, Modern Moods, Large Terazzo in Modern

Binding Fabric Robert Kaufman, Kona Cotton in Windsor

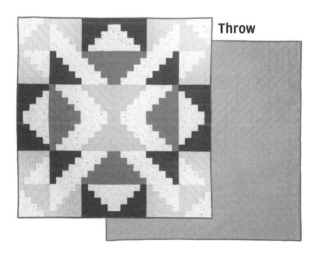

Throw

Fabric A ○ Hawthorne Supply Co, Hey Miss Designs, Chi Town, Large Ninety-Fifth Floor in AM

Fabric B ● Robert Kaufman, Kona Cotton in Orchid

Fabric C ● Robert Kaufman, Kona Cotton in Flame

Fabric D ● Robert Kaufman, Kona Cotton in Nacho Cheese

Backing Fabric Robert Kaufman, Kona Cotton in Nacho Cheese

Binding Fabric Robert Kaufman, Kona Cotton in Saffron

Fabric Requirements

	Wall Hanging	Baby	Throw
Fabric A ○	¾ yard (69 cm)	1 yard (92 cm)	1⅞ yard (172 cm)
Fabric B ◑	⅜ yard (35 cm)	¾ yard (69 cm)	1⅛ yard (103 cm)
Fabric C ●	⅜ yard (35 cm)	⅝ yard (58 cm)	1⅛ yard (103 cm)
Fabric D ◐	¼ yard (23 cm)	⅜ yard (35 cm)	½ yard (46 cm)
Binding Fabric	⅓ yard (31 cm)	⅜ yard (35 cm)	½ yard (46 cm)
Backing Fabric	1 yard (92 cm)	3 yard (275 cm)	3⅞ yard (355 cm)

Cutting Directions

	Wall Hanging	Baby	Throw
Fabric A ○	2 strips, 7" x WOF sub-cut: • 1 rectangle, 7" x 8½" • 1 rectangle, 7" x 6½" • 3 rectangles, 7" x 4½" • 2 rectangles, 7" x 3½" • 3 rectangles, 7" x 2½" • 2 rectangles, 7" x 1½" 6 strips, 1½" x WOF sub-cut: • 2 rectangles, 1½" x 8½" • 2 rectangles, 1½" x 6½" • 18 rectangles, 1½" x 4½" • 16 rectangles, 1½" x 3½" • 18 rectangles, 1½" x 2½" • 16 squares, 1½" x 1½"	2 strips, 9" x WOF sub-cut: • 1 rectangle, 9" x 12½" • 1 rectangle, 9" x 9½" • 3 rectangles, 9" x 6½" • 2 rectangles, 9" x 5" • 3 rectangles, 9" x 3½" • 2 rectangles, 9" x 2" 7 strips, 2" x WOF sub-cut: • 2 rectangles, 2" x 12½" • 2 rectangles, 2" x 9½" • 18 rectangles, 2" x 6½" • 16 rectangles, 2" x 5" • 18 rectangles, 2" x 3½" • 16 squares, 2" x 2"	3 strips, 11" x WOF sub-cut: • 1 rectangle, 11" x 16½" • 3 rectangles, 11" x 8½" • 3 rectangles, 11" x 4½" • 2 rectangles, 11" x 6½" • 1 rectangle, 11" x 12½" • 2 rectangles, 11" x 2½" 12 strips, 2½" x WOF sub-cut in the following order: • 2 rectangles, 2½" x 16½" • 18 rectangles, 2½" x 8½" • 18 rectangles, 2½" x 4½" • 16 squares, 2½" x 2½" • 16 rectangles, 2½" x 6½" • 2 rectangles, 2½" x 12½"
Fabric B ◑	1 square, 2½" x 2½" 7 strips, 1½" x WOF sub-cut in the following order: • 12 rectangles, 1½" x 3½" • 14 rectangles, 1½" x 4½"	1 square, 3½" x 3½" 11 strips, 2" x WOF sub-cut in the following order: • 2 rectangles, 2" x 15½" • 2 rectangles, 2" x 9½"	1 square, 4½" x 4½" 13 strips, 2½" x WOF sub-cut in the following order: • 2 rectangles, 2½" x 20½" • 2 rectangles, 2½" x 16½"

Cutting Directions

Continued...

	Wall Hanging	Baby	Throw
Fabric B ⚪	• 2 rectangles, 1½" x 6½" • 12 rectangles, 1½" x 5½" • 12 squares, 1½" x 1½" • 2 rectangles, 1½" x 8½" • 2 rectangles, 1½" x 10½" • 12 rectangles, 1½" x 2½"	• 2 rectangles, 2" x 12½" • 12 rectangles, 2" x 8" • 14 rectangles, 2" x 6½" • 12 rectangles, 2" x 5" • 12 rectangles, 2" x 3½" • 12 squares, 2" x 2"	• 12 rectangles, 2½" x 4½" • 12 rectangles, 2½" x 6½" • 12 squares, 2½" x 2½" • 2 rectangles, 2½" x 12½" • 14 rectangles, 2½" x 8½" • 12 rectangles, 2½" x 10½"
Fabric C ⚫	1 strip, 7" x WOF sub-cut: • 2 rectangles, 7" x 4½" • 2 rectangles, 7" x 3½" • 2 rectangles, 7" x 2½" • 2 rectangles, 7" x 1½" 3 strips, 1½" x WOF sub-cut: • 4 rectangles, 1½" x 10½" • 4 rectangles, 1½" x 5½" • 4 rectangles, 1½" x 4½" • 4 rectangles, 1½" x 3½" • 4 rectangles, 1½" x 2½" • 4 squares, 1½" x 1½"	1 strip, 9" x WOF sub-cut: • 2 rectangles, 9" x 6½" • 2 rectangles, 9" x 5" • 2 rectangles, 9" x 3½" • 2 rectangles, 9" x 2" 5 strips, 2" x WOF sub-cut: • 4 rectangles, 2" x 8" • 4 rectangles, 2" x 5" • 4 rectangles, 2" x 6½" • 4 rectangles, 2" x 3½" • 4 squares, 2" x 2" • 4 rectangles, 2" x 15½"	2 strips, 11" x WOF sub-cut: • 2 rectangles, 11" x 8½" • 2 rectangles, 11" x 2½" • 2 rectangles, 11" x 4½" • 2 rectangles, 11" x 6½" 6 strips, 2½" x WOF sub-cut in the following order: • 4 rectangles, 2½" x 20½" • 4 rectangles, 2½" x 10½" • 4 rectangles, 2½" x 8½" • 4 squares, 2½" x 2½" • 4 rectangles, 2½" x 6½" • 4 rectangles, 2½" x 4½"
Fabric D ⚫	1 strip, 7" x WOF sub-cut: • 1 rectangle, 7" x 8½" • 1 rectangle, 7" x 6½" • 1 rectangle, 7" x 4½" • 1 rectangle, 7" x 2½" 1 strip, 1½" x WOF sub-cut: • 4 rectangles, 1½" x 10½"	1 strip, 9" x WOF sub-cut: • 1 rectangle, 9" x 12½" • 1 rectangle, 9" x 9½" • 1 rectangle, 9" x 6½" • 1 rectangle, 9" x 3½" 2 strips, 2" x WOF sub-cut: • 4 rectangles, 2" x 15½"	1 strip, 11" x WOF sub-cut: • 1 rectangle, 11" x 16½" • 1 rectangle, 11" x 8½" • 1 rectangle, 11" x 12½" • 1 rectangle, 11" x 4½" 2 strips, 2½" x WOF sub-cut: • 4 rectangles, 2½" x 20½"
Binding Fabric	4 strips, 2½" x WOF	5 strips, 2½" x WOF	7 strips, 2½" x WOF

Courthouse Steps Units

To create Courthouse Steps blocks, start with one square in the middle and work your way outward by adding two rectangles on the opposite sides of the center square. Then add another two rectangles on the remaining sides to make a larger square.

Step 1

Assemble **1 Fabric A/B Courthouse Steps** unit (for all quilt sizes) in the order shown in the table and diagram. Press the seams open as you go to ensure accurate piecing.

Order	Wall Hanging	Baby	Throw
1	1 Fabric B 2½" x 2½" square	1 Fabric B 3½" x 3½" square	1 Fabric B 4½" x 4½" square
2	2 Fabric A 1½" x 2½" rectangles	2 Fabric A 2" x 3½" rectangles	2 Fabric A 2½" x 4½" square
3	2 Fabric B 1½" x 4½" rectangles	2 Fabric B 2" x 6½" rectangles	2 Fabric B 2½" x 8½" rectangles
4	2 Fabric A 1½" x 4½" rectangles	2 Fabric A 2" x 6½" rectangles	2 Fabric A 2½" x 8½" rectangles
5	2 Fabric B 1½" x 6½" rectangles	2 Fabric B 2" x 9½" rectangles	2 Fabric B 2½" x 12½" rectangles
6	2 Fabric A 1½" x 6½" rectangles	2 Fabric A 2" x 9½" rectangles	2 Fabric A 2½" x 12½" rectangles
7	2 Fabric B 1½" x 8½" rectangles	2 Fabric B 2" x 12½" rectangles	2 Fabric B 2½" x 16½" rectangles
8	2 Fabric A 1½" x 8½" rectangles	2 Fabric A 2" x 12½" rectangles	2 Fabric A 2½" x 16½" rectangles
9	2 Fabric B 1½" x 10½" rectangles	2 Fabric B 2" x 15½" rectangles	2 Fabric B 2½" x 20½" rectangles

Fabric A/B
Courthourse Step

Log Cabin Units

Similar to the Courthouse Steps block, Log Cabin blocks start with one square in the middle and you add strips around the square until it becomes a Log Cabin block.

Step 1

Create **12 Fabric A/B Log Cabin** units, following the order shown in the table and diagram for each unit. Press the seams open as you go.

Order	Wall Hanging	Baby	Throw
1	1 Fabric B 1½" x 1½" square	1 Fabric B 2" x 2" square	1 Fabric B 2½" x 2½" square
2	1 Fabric A 1½" x 1½" square	1 Fabric A 2" x 2" rectangles	1 Fabric A 2½" x 2½" square
3	1 Fabric A 1½" x 2½" rectangle	1 Fabric A 2" x 3½" rectangle	1 Fabric A 2½" x 4½" rectangle
4	1 Fabric B 1½" x 2½" rectangle	1 Fabric B 2" x 3½" rectangle	1 Fabric B 2½" x 4½" rectangle
5	1 Fabric B 1½" x 3½" rectangle	1 Fabric B 2" x 5" rectangle	1 Fabric B 2½" x 6½" rectangle
6	1 Fabric A 1½" x 3½" rectangle	1 Fabric A 2" x 5" rectangle	1 Fabric A 2½" x 6½" rectangle
7	1 Fabric A 1½" x 4½" rectangle	1 Fabric A 2" x 6½" rectangle	1 Fabric A 2½" x 8½" rectangle
8	1 Fabric B 1½" x 4½" rectangle	1 Fabric B 2" x 6½" rectangle	1 Fabric B 2½" x 8½" rectangle
9	1 Fabric B 1½" x 5½" rectangle	1 Fabric B 2" x 8" rectangle	1 Fabric B 2½" x 10½" rectangle

Fabric A/B Cabin Log

Step 2

Similar to Step 1, create **4 Fabric A/C Log Cabin** units, following the order shown in the table and diagram for each unit. Press the seams open as you go.

Order	Wall Hanging	Baby	Throw
1	1 Fabric C 1½" x 1½" square	1 Fabric C 2" x 2" square	1 Fabric C 2½" x 2½" square
2	1 Fabric A 1½" x 1½" square	1 Fabric A 2" x 2" square	1 Fabric A 2½" x 2½" square
3	1 Fabric A 1½" x 2½" rectangle	1 Fabric A 2" x 3½" rectangle	1 Fabric A 2½" x 4½" rectangle
4	1 Fabric C 1½" x 2½" rectangle	1 Fabric C 2" x 3½" rectangle	1 Fabric C 2½" x 4½" rectangle
5	1 Fabric C 1½" x 3½" rectangle	1 Fabric C 2" x 5" rectangle	1 Fabric C 2½" x 6½" rectangle
6	1 Fabric A 1½" x 3½" rectangle	1 Fabric A 2" x 5" rectangle	1 Fabric A 2½" x 6½" rectangle
7	1 Fabric A 1½" x 4½" rectangle	1 Fabric A 2" x 6½" rectangle	1 Fabric A 2½" x 8½" rectangle
8	1 Fabric C 1½" x 4½" rectangle	1 Fabric C 2" x 6½" rectangle	1 Fabric C 2½" x 8½" rectangle
9	1 Fabric C 1½" x 5½" rectangle	1 Fabric C 2" x 8" rectangle	1 Fabric C 2½" x 10½" rectangle

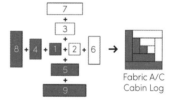

Fabric A/C Cabin Log

Flying Geese Strip Set Units

Step 1

Referring to the diagram shown, form **1 Fabric A/D Flying Geese Strip Set A1** unit by sewing together:

Wall Hanging	2 Fabric A 4½" x 7" rectangles and 1 Fabric D 2½" x 7" rectangle
Baby	2 Fabric A 6½" x 9" rectangles and 1 Fabric D 3½" x 9" rectangle
Throw	2 Fabric A 8½" x 11" rectangles and 1 Fabric D 4½" x 11" rectangle

Fabric A/D Flying Geese Strip Set A1

Press the seams open and set aside for *Step 5*.

Step 2

Create **1 Fabric A/D Flying Geese Strip Set A2** unit by sewing together the following, using the diagram shown.

Wall Hanging	2 Fabric A 3½" x 7" rectangles and 1 Fabric D 4½" x 7" rectangle
Baby	2 Fabric A 5" x 9" rectangles and 1 Fabric D 6½" x 9" rectangle
Throw	2 Fabric A 6½" x 11" rectangles and 1 Fabric D 8½" x 11" rectangle

Fabric A/D Flying Geese Strip Set A2

Press the seams open and set aside for *Step 5*.

Step 3

Create **1 Fabric A/D Flying Geese Strip Set A3** unit by sewing together the following, as shown in the diagram.

Wall Hanging	2 Fabric A 2½" x 7" rectangles and 1 Fabric D 6½" x 7" rectangle
Baby	2 Fabric A 3½" x 9" rectangles and 1 Fabric D 9½" x 9" rectangle
Throw	2 Fabric A 4½" x 11" rectangles and 1 Fabric D 12½" x 11" rectangle

Fabric A/D Flying Geese Strip Set A3

Press the seams open and set aside for *Step 5*.

Step 4

Form **1 Fabric A/D Flying Geese Strip Set A4** unit by joining together:

Wall Hanging	2 Fabric A 1½" x 7" rectangles and 1 Fabric D 8½" x 7" rectangle
Baby	2 Fabric A 2" x 9" rectangles and 1 Fabric D 12½" x 9" rectangle
Throw	2 Fabric A 2½" x 11" rectangles and 1 Fabric D 16½" x 11" rectangle

Fabric A/D Flying Geese Strip Set A4

Press the seams open.

Step 5

Trim the right-hand edge of all Fabric A/D Flying Geese Strip Sets (created in Steps 1 to 4) to ensure they are straight and right-angled against the length of the units.

*Fabric A/D Flying Geese Strip Set A1 used in this example

Step 6

Rotate all Fabric A/D Flying Geese Strip Sets 180 degrees. Using the straightedge of the left-hand side as a guide, cut a total of:

*Fabric A/D Flying Geese Strip Set A1 used in this example

Wall Hanging	4 1½" Fabric A/D Flying Geese A1 units, 4 1½" Fabric A/D Flying Geese A2 units, 4 1½" Fabric A/D Flying Geese A3 units, 4 1½" Fabric A/D Flying Geese A4 units
Baby	4 2" Fabric A/D Flying Geese A1 units, 4 2" Fabric A/D Flying Geese A2 units, 4 2" Fabric A/D Flying Geese A3 units, 4 2" Fabric A/D Flying Geese A4 units
Throw	4 2½" Fabric A/D Flying Geese A1 units, 4 2½" Fabric A/D Flying Geese A2 units, 4 2½" Fabric A/D Flying Geese A3 units, 4 2½" Fabric A/D Flying Geese A4 units

Step 7

Create **4 Fabric A/D Flying Geese** units. For each unit, sew together, from top to bottom in the following order, 1 Fabric A/D Flying Geese A1 unit, 1 Fabric A/D Flying Geese A2 unit, 1 Fabric A/D Flying Geese A3 unit, 1 Fabric A/D Flying Geese A4 unit and:

Wall Hanging	1 Fabric D 1½" x 10½" rectangle
Baby	1 Fabric D 2" x 15½" rectangle
Throw	1 Fabric D 2½" x 20½" rectangle

Press the seams open.

Step 8

As shown in the diagram, sew together the following to form **1 Fabric A/C Flying Geese Strip Set B1**:

Wall Hanging	2 Fabric C 4½" x 7" rectangles and 1 Fabric A 2½" x 7" rectangle
Baby	2 Fabric C 6½" x 9" rectangles and 1 Fabric A 3½" x 9" rectangle
Throw	2 Fabric C 8½" x 11" rectangles and 1 Fabric A 4½" x 11" rectangle

Fabric A/C Flying Geese Strip Set B1

Press the seams open and set aside for *Step 12*.

Step 9

Create **1 Fabric A/C Flying Geese Strip Set B2** by sewing together:

Wall Hanging	2 Fabric C 3½" x 7" rectangles and 1 Fabric A 4½" x 7" rectangle
Baby	2 Fabric C 5" x 9" rectangles and 1 Fabric A 6½" x 9" rectangle
Throw	2 Fabric C 6½" x 11" rectangles and 1 Fabric A 8½" x 11" rectangle

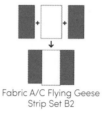

Fabric A/C Flying Geese Strip Set B2

Press the seams open and set aside for *Step 12*.

Step 10

Arrange and sew together the following to create **1 Fabric A/C Flying Geese Strip Set B3**:

Wall Hanging	2 Fabric C 2½" x 7" rectangles and 1 Fabric A 6½" x 7" rectangle
Baby	2 Fabric C 3½" x 9" rectangles and 1 Fabric A 9½" x 9" rectangle
Throw	2 Fabric C 4½" x 11" rectangles and 1 Fabric A 12½" x 11" rectangle

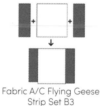

Fabric A/C Flying Geese Strip Set B3

Press the seams open and set aside for *Step 12*.

Step 11

Referring to the diagram shown, form **1 Fabric A/C Flying Geese Strip Set B4** with:

Wall Hanging	2 Fabric C 1½" x 7" rectangles and 1 Fabric A 8½" x 7" rectangle
Baby	2 Fabric C 2" x 9" rectangles and 1 Fabric A 12½" x 9" rectangle
Throw	2 Fabric C 2½" x 11" rectangles and 1 Fabric A 16½" x 11" rectangle

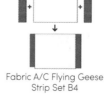

Fabric A/C Flying Geese Strip Set B4

Step 12

Trim the right-hand edge of all Fabric A/C Flying Geese Strip Sets to ensure they are straight and right-angled against the length of the strip set.

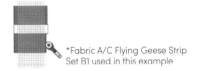

*Fabric A/C Flying Geese Strip Set B1 used in this example

Step 13

Rotate all Fabric A/C Flying Geese Strip Sets 180 degrees. Using the straightedge of the left-hand side as a guide, cut a total of:

*Fabric A/C Flying Geese Strip Set B1 used in this example

Wall Hanging	4 1½" Fabric A/C Flying Geese B1 units, 4 1½" Fabric A/C Flying Geese B2 units, 4 1½" Fabric A/C Flying Geese B3 units, 4 1½" Fabric A/C Flying Geese B4 units
Baby	4 2" Fabric A/C Flying Geese B1 units, 4 2" Fabric A/C Flying Geese B2 units, 4 2" Fabric A/C Flying Geese B3 units, 4 2" Fabric A/C Flying Geese B4 units
Throw	4 2½" Fabric A/C Flying Geese B1 units, 4 2½" Fabric A/C Flying Geese B2 units, 4 2½" Fabric A/C Flying Geese B3 units, 4 2½" Fabric A/C Flying Geese B4 units

Step 14

Create **4 Fabric A/C Flying Geese** units. For each unit, arrange and sew together in the following order, from top to bottom:

Wall Hanging	1 Fabric C 1½" x 10½" rectangle
Baby	1 Fabric C 2" x 15½" rectangle
Throw	1 Fabric C 2½" x 20½" rectangle

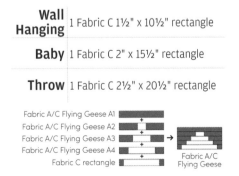

Quilt Assembly

Step 1

For all quilt sizes, combine 4 Fabric A/B Log Cabin units and 1 Fabric A/C Flying Geese unit to create **1 Row 1**. Repeat this step to create a total of **2 Row 1** units.

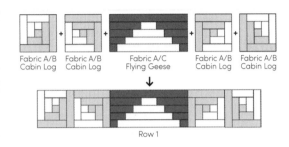

Fabric A/B Cabin Log Fabric A/B Cabin Log Fabric A/C Flying Geese Fabric A/B Cabin Log Fabric A/B Cabin Log

Row 1

Step 2

Create a total of **2 Row 2** units (for all quilt sizes) by sewing together 1 Fabric A/D Flying Geese unit between 2 Fabric A/C Log Cabin units and 2 Fabric A/B Log Cabin units.

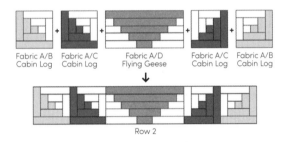

Fabric A/B Cabin Log Fabric A/C Cabin Log Fabric A/D Flying Geese Fabric A/C Cabin Log Fabric A/B Cabin Log

Row 2

Step 3

For all quilt sizes, sew 1 Fabric A/B Courthouse Step unit between 2 Fabric A/D Flying Geese units and 2 Fabric A/C Flying Geese units to form **1 Row 3** unit.

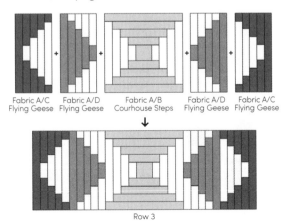

Fabric A/C Flying Geese Fabric A/D Flying Geese Fabric A/B Courhouse Steps Fabric A/D Flying Geese Fabric A/C Flying Geese

Row 3

Step 4

Referring to the diagram shown (for all quilt sizes), arrange and join the rows to complete the quilt top.

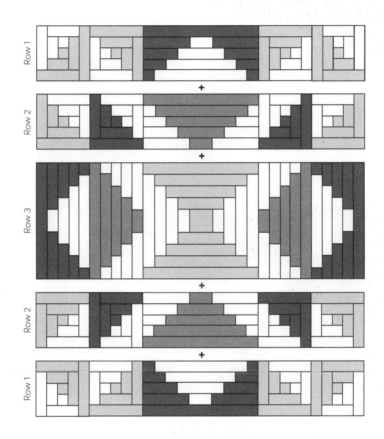

Step 5

Press the quilt top and backing fabric. Layer the backing fabric, batting, and quilt top. Baste, quilt, and bind.

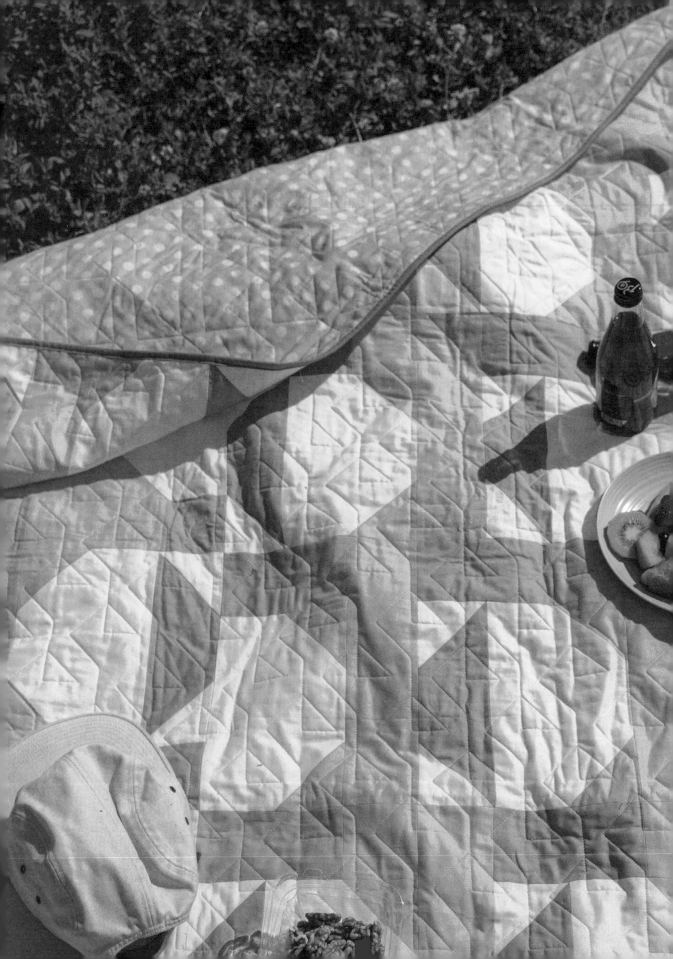

RUSH HOUR
(Advanced Beginner)

Baby: 48" x 48" (122 cm x 122 cm)

Throw: 72" x 72" (183 cm x 183 cm)

Queen: 96" x 96" (244 cm x 244 cm)

Piecing Methods and Techniques

Strip piecing / Snowball blocks / Quick-Corner units

The food truck and cart scenes in New York City and Perth are polar opposites, reflective of the cities' distinct personalities. One is all about the hustle and bustle, and the other is more laid-back and relaxed. Food trucks and carts often bring friends and family together on weekends in Perth. They are places for community building, whereas food trucks and carts in New York City primarily cater to the work crowd, and you often have to make a quick decision because others behind you just want to grab their food and go. No matter the differences in pace and patrons, food trucks and carts across the globe serve as opportunities to experience and share foods from different cultures.

Snowball blocks (octagon shapes) are used throughout the Rush Hour quilt pattern to portray the wheels of food trucks and carts all lined up next to each other. These shapes can also be interpreted as plates of food. The baby Rush Hour quilt consists of 148 pieces, the throw quilt consists of 333 pieces, and the queen quilt consists of 592 pieces. These numbers may sound and look daunting, but it's not as bad as you think. In fact, there are other designs in this book with more pieces! The use of strip and Quick-Corner units techniques to create the Snowball blocks and other elements in this quilt will certainly help you assemble the quilt top in no time.

As mentioned in previous projects, sourcing fabrics for quilts in earlier time periods was not easy and was often expensive. Thus, many quilts were constructed with old clothing, scraps from dressmaking, and feed sacks, unless you were affluent and able to import fabrics from Indian and European merchants. Women in pioneer days took great pride in the number of fabric pieces used in their quilts. The greater the number of pieces incorporated, the more it suggested their thriftiness and the time and patience put into the project.

COLOR INSPIRATION

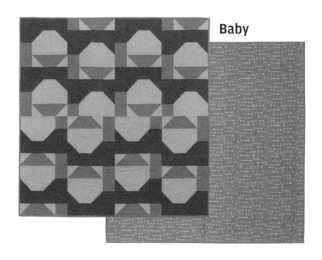

Baby

Fabric A Robert Kaufman, Kona Cotton in Primrose

Fabric B Robert Kaufman, Kona Cotton in Mediterranean

Fabric C Robert Kaufman, Kona Cotton in Pickle

Backing Fabric Hawthorne Supply Co, Hawthorne Supply Co, Botany, Seeds in Gold

Binding Fabric Robert Kaufman, Kona Cotton in Melon

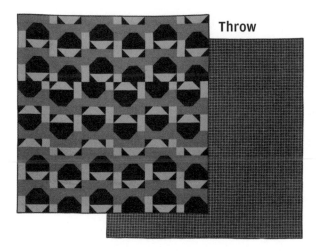

Throw

Fabric A Robert Kaufman, Kona Cotton in Navy

Fabric B Robert Kaufman, Kona Cotton in Marmalade

Fabric C Robert Kaufman, Kona Cotton in Ballerina

Backing Fabric Hawthorne Supply Co, Hawthorne Essentials, Windowpane, Windowpane in Ink

Binding Fabric Robert Kaufman, Kona Cotton in Berry

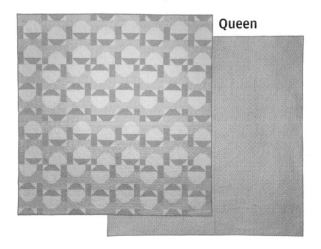

Queen

Fabric A Robert Kaufman, Kona Cotton in Bright Idea

Fabric B Robert Kaufman, Kona Cotton in Corn Yellow

Fabric C Robert Kaufman, Kona Cotton in Corsage

Backing Fabric Hawthorne Supply Co, Mable Tan, Urban Jungle, Pebbles in Orchid

Binding Fabric Robert Kaufman, Kona Cotton in Yarrow

Fabric Requirements

	Baby	Throw	Queen
Fabric A	1⅛ yard (103 cm)	2½ yard (229 cm)	4 yard (366 cm)
Fabric B	1 yard (92)	2⅛ yard (195 cm)	3⅝ yards (332 cm)
Fabric C	⅞ yard (80 cm)	1⅔ yard (153 cm)	2⅔ yards (244 cm)
Backing Fabric	3⅛ yard (286 cm)	4½ yard (412 cm)	8⅔ yards (793 cm)
Binding Fabric	⅜ yard (35 cm)	⅝ yard (58 cm)	¾ yard (69 cm)

Cutting Directions

	Baby	Throw	Queen
Fabric A	3 strips, 6½" x WOF (for strip piecing)	7 strips, 6½" x WOF (for strip piecing)	12 strips, 6½" x WOF (for strip piecing)
	1 strip, 6½" x WOF, sub-cut:	3 strips, 6½" x WOF, sub-cut:	4 strips, 6½" x WOF, sub-cut:
	• 4 squares, 6½" x 9½"	• 9 rectangles, 6½" x 9½"	• 16 rectangles, 6½" x 9½"
	3 strips, 3½" x WOF, sub-cut:	6 strips, 3½" x WOF, sub-cut:	11 strips, 3½" x WOF, sub-cut:
	• 32 rectangles, 3½" x 3½"	• 72 squares, 3½" x 3½"	• 128 rectangles, 3½" x 3½"
Fabric B	1 strip, 3½" x WOF (for strip piecing)	3 strips, 3½" x WOF (for strip piecing)	4 strips, 3½" x WOF (for strip piecing)
	8 strips, 3½" x WOF, sub-cut:	18 strips, 3½" x WOF, sub-cut:	32 strips, 3½" x WOF, sub-cut:
	• 16 rectangles, 3½" x 12½" • 36 squares, 3½" x 3½"	• 36 rectangles, 3½" x 12½" • 81 squares, 3½" x 3½"	• 64 rectangles, 3½" x 12½" • 144 squares, 3½" x 3½"
Fabric C	1 strip, 6½" x WOF (for strip piecing)	3 strips, 6½" x WOF (for strip piecing)	4 strips, 6½" x WOF (for strip piecing)
	3 strips, 3½" x WOF (for strip piecing)	7 strips, 3½" x WOF (for strip piecing)	12 strips, 3½" x WOF (for strip piecing)
	2 strips, 3½" x WOF, sub-cut:	4 strips, 3½" x WOF, sub-cut:	7 strips, 3½" x WOF, sub-cut:
	• 4 rectangles, 3½" x 9½" • 8 squares, 3½" x 3½"	• 9 rectangles, 3½" x 9½" • 18 squares, 3½" x 3½"	• 16 rectangles, 3½" x 9½" • 32 squares, 3½" x 3½"
Binding Fabric	5 strips, 2½" x WOF	8 strips, 2½" x WOF	10 strips, 2½" x WOF

Snowball Units

Step 1

With the right sides together, sew 1 Fabric A 6½" x WOF strip and 1 Fabric C 3½" x WOF strip lengthwise and press the seams open to create **1 Strip Set A** unit. Repeat to create a total of:

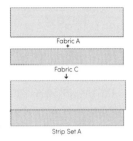

Fabric A
+
Fabric C
↓

Strip Set A

Baby	3 Strip Set A units
Throw	7 Strip Set A units
Queen	12 Strip Set A units

Step 2

Trim the right-hand edge of all Strip Set A units to ensure they are straight and right-angled against the length of the strip set.

Step 3

Rotate the Strip Set A units 180 degrees. Using a straightedge on the left-hand side as a guide, cut a total of:

9½" Set D

Baby	12 9½" Set D units
Throw	27 9½" Set D units
Queen	48 9½" Set D units

Step 4

Draw a diagonal guideline on the wrong side of:

Baby	32 Fabric A 3½" x 3½" squares and 32 Fabric B 3½" x 3½" squares
Throw	72 Fabric A 3½" x 3½" squares and 72 Fabric B 3½" x 3½" squares
Queen	128 Fabric A 3½" x 3½" squares and 128 Fabric B 3½" x 3½" squares

Step 5

As shown in the diagram, with right sides together, place 2 Fabric A 3½" x 3½" squares and 2 Fabric B 3½" x 3½" squares on each corner of Set D, and sew on the marked guidelines.

Step 6

Trim ¼" seam allowance outside of each sewn line. Press the seams open to create **1 Snowball A** unit. Repeat Steps 5 and 6 to create a total of:

Baby	12 Snowball A units
Throw	27 Snowball A units
Queen	48 Snowball A units

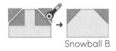

Snowball A

Step 7

Place 2 Fabric B 3½" x 3½" squares on the top 2 corners of 1 Fabric A 6½" x 9½" rectangle with right sides together, as shown, and sew on the marked guidelines.

Step 8

Trim ¼" seam allowance outside of each sewn line. Press the seams open to create **1 Snowball B** unit. Repeat Steps 7 and 8 to create a total of:

Baby	4 Snowball B units
Throw	9 Snowball B units
Queen	16 Snowball B units

Snowball B

Step 9

Arrange 2 Fabric A 3½" x 3½" squares on each end of 1 Fabric C 3½" x 9½" rectangle, as shown in the diagram. Sew on the marked guidelines.

Step 10

Trim ¼" seam allowance outside of each sewn line. Press the seams open to create **1 Snowball C** unit. Repeat Steps 9 and 10 to create a total of:

Baby	4 Snowball C units
Throw	9 Snowball C units
Queen	16 Snowball C units

Snowball C

Strip Set Units

Step 1

With the right sides together, sew 1 Fabric B 3½" x WOF strip and 1 Fabric C 6½" x WOF strip lengthwise and press the seams open to create **1 Strip Set B** unit. Repeat to create a total of:

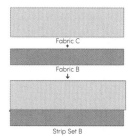

Baby	**N/A** (only 1 Strip Set B unit needed)
Throw	**3 Strip Set B** units
Queen	**4 Strip Set B** units

Step 2

Trim the right-hand edge of all Strip Set B units to ensure they are straight and right-angled against the length of the strip set.

Step 3

Rotate the Strip Set B units 180 degrees. Using the straightedge on the left-hand side as a guide, cut a total of:

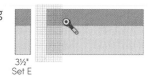

Baby	**12 3½" Set E** units
Throw	**27 3½" Set E** units
Queen	**48 3½" Set E** units

Step 4

Sew 1 Fabric B 3½" x 3½" square and 1 Fabric C 3½" x 3½" square together to create **1 Set F** unit. Press the seams open. Repeat to create a total of:

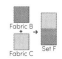

Baby	**4 Set F** units
Throw	**9 Set F** units
Queen	**16 Set F** units

Block Assembly

Step 1

As shown in the diagram, sew together 1 Set E unit and 1 Snowball A unit to create **1 Set G** unit. Press the seams open. Repeat to create a total of:

Baby	**12 Set G** units	
Throw	**27 Set G** units	
Queen	**48 Set G** units	

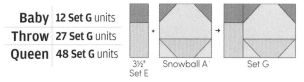

Step 2

Sew 1 Set F unit to the left side of 1 Snowball B unit to create **1 Set H** unit. Press the seams open. Repeat to create a total of:

Baby	**4 Set H** units	
Throw	**9 Set H** units	
Queen	**16 Set H** units	

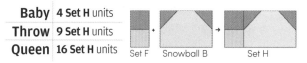

Step 3

Sew 1 Fabric C 3½" x 3½" square to the left side of 1 Snowball C unit to create **1 Set I** unit. Press the seams open. Repeat to create a total of:

Baby	**4 Set I** units	
Throw	**9 Set I** units	
Queen	**16 Set I** units	

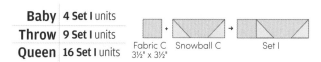

Step 4

Lay 2 Fabric B 3½" x 12½" rectangles and 2 Set G units in the order shown in the diagram and sew to create **1 Block A** unit. Press the seams open. Repeat to create a total of:

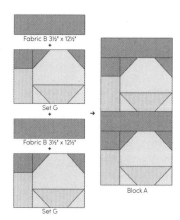

Baby	**4 Set A** units
Throw	**9 Set A** units
Queen	**16 Set A** units

Step 5

Lay 1 Set I unit, 2 Fabric B 3½" x 12½" rectangles, 1 Set G, and 1 Set H unit in the order shown in the diagram to form **1 Block B** unit. Press the seams open. Repeat to create a total of:

Baby	4 Set B units
Throw	9 Set B units
Queen	16 Set B units

Step 6

Combine 1 Block A and 1 Block B unit to create **1 Block C** unit. Press the seams open. Repeat to create a total of:

Baby	4 Set C units
Throw	9 Set C units
Queen	16 Set C units

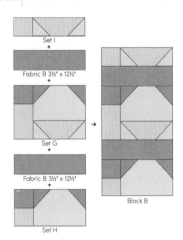

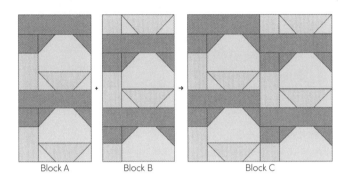

Quilt Assembly

Step 1

For a **baby-size quilt top**, create **2 Rows** of 2 Block C units. Press the seams open.

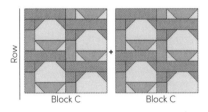

For a **throw-size quilt top**, sew together **3 Rows** of 3 Block C units. Press the seams open.

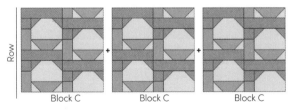

For a **queen-size quilt top**, sew together **4 Rows** of 4 Block C units. Press the seams open.

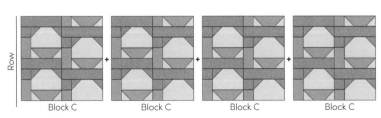

Quilting Directions

Step 2

To create a baby-size quilt top, line up and sew 2 Rows together. Press the seams open.

Note: Turn the second row 180 degrees before sewing together.

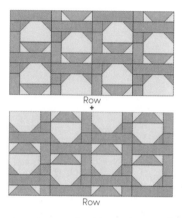

Row
+

Row

To create a throw-size quilt top, line up and sew 3 Rows together. Press the seams open.

Note: Turn the second row 180 degrees before sewing together.

Row
+

Row
+

Row

Row
+

Row
+

Row
+

Row

To form a queen-size quilt top, line up and sew 4 Rows together. Press the seams open.

Note: Turn the second and fourth rows 180 degrees before sewing together.

Step 3

Press the quilt top and backing fabric. Layer the backing, batting, and quilt top. Baste, quilt, and bind.

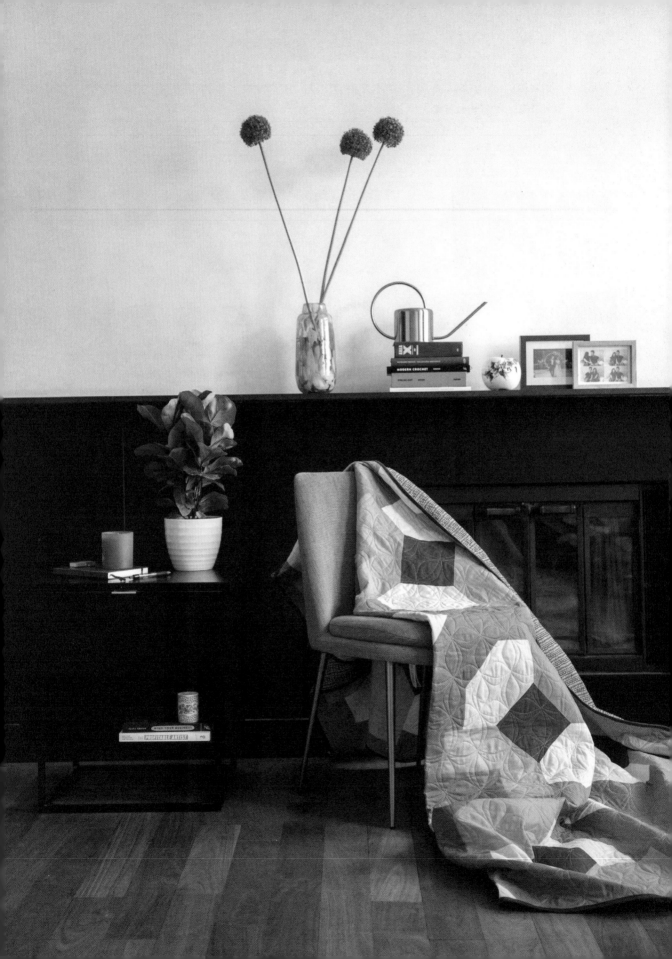

CHINATOWN

(Advanced Beginner)

Baby: 48" x 48" (122 cm x 122 cm)

Throw: 72" x 72" (183 cm x 183 cm)

Queen: 96" x 96" (244 cm x 244 cm)

Piecing Methods and Techniques

Strip piecing / Semi-Snowball blocks / Quick-Corner units

My family migrated to Australia in the early 1990s for a better lifestyle and upbringing. When I was growing up, my parents did their best to connect my sisters and me with our Asian roots, with the hope that we would do the same with our children one day. At least once a year, during the school holidays, they would take us to Hong Kong to visit our relatives and surrounding Chinese cities. Most days of the week, Mum prepared and served Chinese food, and on weekends, after Chinese class or church, my parents took the family to get dim sum and shop at Asian grocers in Chinatown to stock up on Asian condiments, snacks, and ingredients for the week.

Chinatowns are found dotted across the Western world in countries like the United States, Canada, Australia, Spain, France, Germany, and many more. What makes these communities so distinctive within their surroundings is usually the large red arch structures and lion statues that greet shoppers upon arrival. Through these gates, one finds an array of retailers, restaurants, community centers, and groups that enable people to connect with the Asian culture. You can experience traditional and authentic foods, participate in social, cultural, and religious activities and celebrations, and enjoy foreign books and films. Storefronts and businesses are trimmed in red and adorned with lanterns and wall hangings as symbols of good luck and prosperity. For many migrants throughout the decades, Chinatown has been a place that felt like home.

The Chinatown quilt pattern draws inspiration from the architecture and decor in Chinatown businesses. Looking at the overall design from afar, the octangular shapes collectively resemble a room divider used in restaurants. Up close, each octagon is shaped like a lantern. These octagon-like shapes are not entirely pieced together like your standard Snowball block. To create the irregular shape, each octagon is divided into four blocks. Each block is made with strip piecing, and two or three of the corners incorporate the Quick-Corner units method.

Snowball blocks are one of the most recognized Amish quilting blocks and are found in many Amish quilt designs. The octagon shape in the Snowball block creates an optical illusion; from a distance, it appears to be round like a snowball, hence the name. Traditionally, Snowball blocks are assembled by cutting four individual right-angled triangles and sewing them to each corner of a larger octagon to form a large square. Over the years, quilters have altered this construction method and adopted a faster and more accurate way called Quick-Corner units. This involves small squares marked with a diagonal guideliine placed on each corner of a larger square, and sewn in position, trimmed and pressed to be a square (see the Rush Hour quilt pattern on page 100, for example).

COLOR INSPIRATION

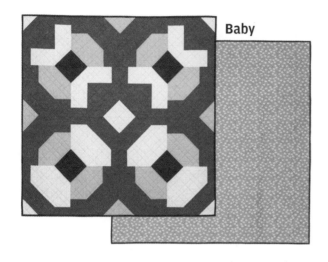

Baby

Fabric A ⬤ Robert Kaufman, Kona Cotton in Pimento

Fabric B ◯ Robert Kaufman, Kona Cotton in Natural

Fabric C ⬤ Robert Kaufman, Kona Cotton in Primrose

Fabric D ⬤ Robert Kaufman, Kona Cotton in Celestial

Backing Fabric Hawthorne Supply Co, Mable Tan, Modern Farmhouse, Eggshells in Clear Blue Sky

Binding Fabric Robert Kaufman, Kona Cotton in Prussian

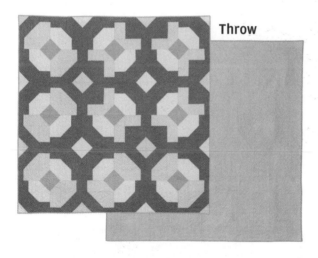

Throw

Fabric A ⬤ Robert Kaufman, Kona Cotton in Cedar

Fabric B ⬤ Robert Kaufman, Kona Cotton in Dusty Blue

Fabric C ⬤ Robert Kaufman, Kona Cotton in Light Parfait

Fabric D ⬤ Robert Kaufman, Kona Cotton in Lupine

Backing Fabric Hawthorne Supply Co, Kasey Free, Desert Magic, Half Moon in Lavender

Binding Fabric Robert Kaufman, Kona Cotton in Wasabi

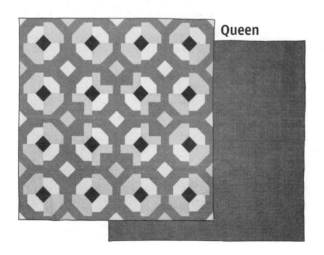

Queen

Fabric A ⬤ Robert Kaufman, Kona Cotton in Pickle

Fabric B ⬤ Robert Kaufman, Kona Cotton in Shadow

Fabric C ◯ Robert Kaufman, Kona Cotton in Natural

Fabric D ⬤ Robert Kaufman, Kona Cotton in Royal

Backing Fabric Hawthorne Supply Co, Hawthorne Essentials, Stitched in Blue Jay

Binding Fabric Robert Kaufman, Kona Cotton in Avocado

Fabric Requirements

	Baby	Throw	Queen
Fabric A ⬤	1⅓ yards (122 cm)	2⅝ yard (240 cm)	4¾ yard (435 cm)
Fabric B ⬤	⅞ yard (80 cm)	1⅝ yard (149 cm)	3¼ yards (298 cm)
Fabric C ◯	⅝ yard (58cm)	1½ yards (138 cm)	2½ yard (229 cm)
Fabric D ⬤	⅜ yard (35 cm)	⅝ yard (58 cm)	1⅛ yard (103 cm)
Backing Fabric	3⅛ yard (286 cm)	4½ yard (412 cm)	8¾ yard (801 cm)
Binding Fabric	⅜ yard (35 cm)	⅝ yard (58 cm)	¾ yard (69 cm)

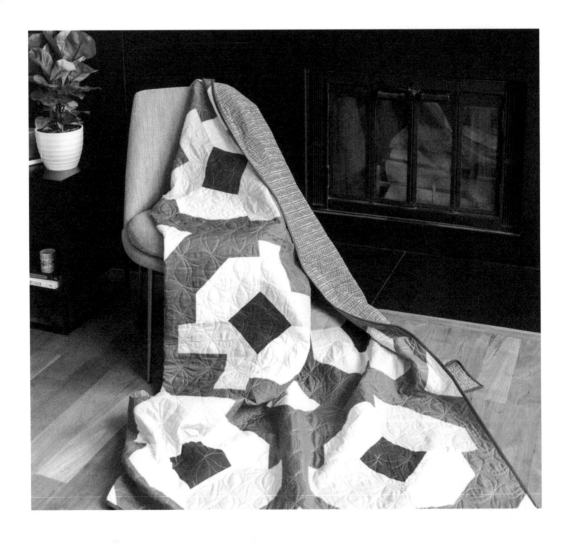

Cutting Directions

	Baby	Throw	Queen
Fabric A ●	2 strips, 8½" x WOF, sub-cut: • 8 squares, 8½" x 8½" 5 strips, 4½" x WOF, sub-cut • 8 rectangles, 4½" x 12½" • 8 rectangles, 4½" x 8½" • 8 squares, 4½" x 4½" 2 strips, 2½" x WOF (for strip piecing)	4 strips, 8½" x WOF, sub-cut: • 18 squares, 8½" x 8½" 11 strips, 4½" x WOF, sub-cut: • 18 rectangles, 4½" x 12½" • 18 rectangles, 4½" x 8½" • 18 squares, 4½" x 4½" 4 strips, 2½" x WOF (for strip piecing)	7 strips, 8½" x WOF, sub-cut: • 32 squares, 8½" x 8½" 20 strips, 4½" x WOF, sub-cut: • 32 rectangles, 4½" x 12½" • 32 rectangles, 4½" x 8½" • 32 squares, 4½" x 4½" 8 strips, 2½" x WOF (for strip piecing)
Fabric B ●	1 strip, 10½" x WOF (for strip piecing) 1 strip, 6½" x WOF, sub-cut: • 4 squares, 6½" x 6½" 1 strip, 6½" x WOF (for strip piecing) 1 strip, 4½" x WOF sub-cut: • 8 squares, 4½" x 4½"	2 strips, 10½" x WOF (for strip piecing) 2 strips, 6½" x WOF, sub-cut: • 10 squares, 6½" x 6½" 2 strips, 6½" x WOF (for strip piecing) 2 strips, 4½" x WOF, sub-cut: • 18 squares, 4½" x 4½"	4 strips, 10½" x WOF (for strip piecing) 4 strips, 6½" x WOF, sub-cut: • 24 squares, 6½" x 6½" 4 strips, 6½" x WOF (for strip piecing) 4 strips, 4½" x WOF, sub-cut: • 32 squares, 4½" x 4½"
Fabric C ○	2 strip, 8½" x WOF, sub-cut: • 8 squares, 8½" x 8½" 1 strip, 4½" x WOF, sub-cut: • 8 squares, 4½" x 4½"	4 strips, 8½" x WOF, sub-cut: • 18 squares, 8½" x 8½" 2 strips, 4½" x WOF, sub-cut: • 18 squares, 4½" x 4½"	7 strips, 8½" x WOF, sub-cut: • 32 squares, 8½" x 8½" 4 strips, 4½" x WOF, sub-cut: • 32 squares, 4½" x 4½"
Fabric D ●	2 strips, 4½" x WOF, sub-cut: • 16 squares, 4½" x 4½"	4 strips, 4½" x WOF, sub-cut: • 32 squares, 4½" x 4½"	7 strips, 4½" x WOF, sub-cut: • 64 squares, 4½" x 4½"
Binding Fabric	5 strips, 2½" x WOF	8 strips, 2½" x WOF	10 strips, 2½" x WOF

Strip Set Units

Step 1

With the right sides together, sew 1 Fabric A 2½" x WOF strip and 1 Fabric B 6½" x WOF strip lengthwise and press the seams open to create **1 Strip Set A/B(i)** unit. Repeat to create a total of:

Baby	N/A (only 1 Strip Set A/B(i) unit needed)
Throw	**2 Strip Set A/B(i) units**
Queen	**4 Strip Set A/B(i)** units

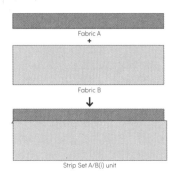

Step 2

Trim the right-hand edge of all Strip Set A/B(i) units to ensure they are straight and right-angled against the length of the strip set.

Step 3

Rotate all Strip Set A/B(i) units 180 degrees. Using the straightedge on the left-hand side as a guide, cut a total of:

Baby	**8 4½" Set A/B(i)** units
Throw	**18 4½" Set A/B(i)** units
Queen	**32 4½" Set A/B(i)** units

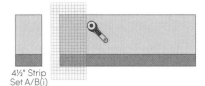

Step 4

Create Strip Set A/B(ii) units by repeating **Steps 1 through 3**, beginning with:

Baby	1 Fabric A 2½" x WOF strip and 1 Fabric B 10½" x WOF strip
Throw	2 Fabric A 2½" x WOF strip and 2 Fabric B 10½" x WOF strip
Queen	4 Fabric A 2½" x WOF strip and 4 Fabric B 10½" x WOF strip

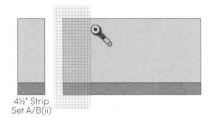

You should have an equal number of Strip Set A/B (i) and Strip Set A/B (ii) units.

Block A Units

Step 1

Mark a diagonal guideline on the wrong side of:

Baby	8 Fabric B 4½" x 4½" squares, 4 Fabric B 6½" x 6½" squares and 16 Fabric D 4½" x 4½" squares
Throw	18 Fabric B 4½" x 4½" squares, 10 Fabric B 6½" x 6½" squares and 36 Fabric D 4½" x 4½" squares
Queen	32 Fabric B 4½" x 4½" squares, 24 Fabric B 6½" x 6½" squares and 64 Fabric D 4½" x 4½" squares

Step 2

With the right sides together, place 1 Fabric D 4½" x 4½" square on the right side of 1 Strip Set A/B(ii) unit, as shown in the diagram, and sew on the guideline.

Tip: Before trimming, sew a second diagonal line ½" away from the drawn guideline. Cut between the two sewn lines to create Half-Square Triangles for another project instead of triangle scraps.

Step 3

Trim ¼" seam allowance outside of the sewn line. Press the seams open to create **1 Fabric A/B/D Quick-Corner** unit. Repeat **Steps 2 and 3** to create a total of:

Baby	**8 Fabric A/B/D Quick-Corner** units. Set aside 4 units for *Block B Units, Step 4 (page 117)*.
Throw	**18 Fabric A/B/D Quick-Corner** units. Set aside 8 units for *Block B Units, Step 4 (page 117)*.
Queen	**32 Fabric A/B/D Quick-Corner** units. Set aside 8 units for *Block B Units, Step 4 (page 117)*.

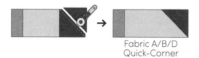

Fabric A/B/D
Quick-Corner

Step 4

With the right sides together, place 1 Fabric B 4½" x 4½" square on the bottom left corner of 1 Fabric A 8½" x 8½" square and sew on the marked guideline.

Step 5

Repeat **Step 4** with 1 Fabric B 6½" x 6½" on the opposite corner of the same Fabric A 8½" x 8½" square, as shown in the diagram.

Step 6

Trim ¼" seam allowance outside of the sewn lines. Press the seams open to create **1 Semi-Snowball A** unit. Repeat **Steps 4 through 6** to create a total of:

Baby	4 **Semi-Snowball A** units
Throw	10 **Semi-Snowball A** units
Queen	24 **Semi-Snowball A** units

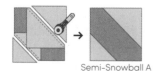

Semi-Snowball A

Step 7

Sew 1 Semi-Snowball A unit to the left of 1 Strip Set A/B(i) unit to create **1 Set A** unit. Repeat to create a total of:

Baby	**4 Set A** units
Throw	**10 Set A** units
Queen	**24 Set A** units

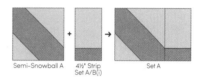

Semi-Snowball A 4½" Strip Set A
 Set A/B(i)

Press the seams open.

Note: Don't panic if your seams don't line up when you place the Semi-Snowball A and Strip Set A/B(i) units on top of each other. The seams will line up when you sew the two pieces together and press the seams.

Step 8

Referring to the diagram shown, sew together 1 Fabric A/B/D Quick-Corner unit and 1 Set A unit to create **1 Block A** unit. Repeat to create a total of:

Baby	**4 Block A** units
Throw	**10 Block A** units
Queen	**24 Block A** units

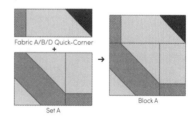

Fabric A/B/D Quick-Corner
+
Set A
Block A

Press the seams open.

Note: Don't panic if your seams don't line up when you place the Set A and Fabric A/B/D Quick-Corner units on top of each other. The seams will line up when you sew the two pieces together and press the seams.

Block B Units

Step 1

As shown in the diagram, with right sides together, place 1 Fabric B 4½" x 4½" square on a corner of 1 Fabric A 8½" x 8½" square. Sew on the marked guidelines.

Step 2

Trim ¼" seam allowance outside of the sewn line. Press the seams open to create a **Semi-Snowball B** unit. Repeat **Steps 1 and 2** to create a total of:

Baby	4 **Semi-Snowball B** units
Throw	8 **Semi-Snowball B** units
Queen	8 **Semi-Snowball B** units

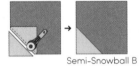

Semi-Snowball B

Step 3

Sew 1 Semi-Snowball B unit to the left of 1 Strip Set A/B(i) unit to create **1 Set B** unit. Repeat to create a total of:

Baby	4 **Set B** units
Throw	8 **Set B** units
Queen	8 **Set B** units

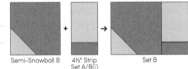

Semi-Snowball B 4½" Strip Set A/B(i) Set B

Press the seams open.

Step 4

To complete a Block B unit, sew together 1 Fabric A/B/D Quick-Corner unit and 1 Set B unit, as shown in the diagram. Repeat to create a total of:

Baby	4 **Block B** units
Throw	8 **Block B** units
Queen	8 **Block B** units

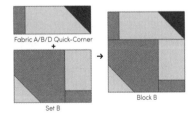

Fabric A/B/D Quick-Corner

Set B

Block B

Press the seams open.

Block C Units

Step 1

Mark a diagonal guideline on the wrong side of:

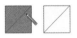

Baby	8 Fabric A 4½" x 4½" squares and 8 Fabric C 4½" x 4½" squares
Throw	18 Fabric A 4½" x 4½" squares and 18 Fabric C 4½" x 4½" squares
Queen	32 Fabric A 4½" x 4½" squares and 32 Fabric C 4½" x 4½" squares

Step 2

With the right sides together, place 1 Fabric C 4½" x 4½" square on 1 Fabric A 4½" x 12½" rectangle as shown in the diagram, and sew on the marked guideline.

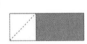

Step 3

Trim ¼" seam allowance outside of the sewn line. Press the seams open to create **1 Fabric A/C Quick-Corner** unit. Repeat **Steps 2 and 3** to create a total of:

Baby	8 **Fabric A/C Quick-Corner** units
Throw	18 **Fabric A/C Quick-Corner** units
Queen	32 **Fabric A/C Quick-Corner** units

Fabric A/C Quick-Corner

Step 4

As shown in the diagram, with the right sides together, place 1 Fabric A 4½" x 4½" square and 1 Fabric D 4½" x 4½" square *(from Block A units, Step 1; page 115)* on opposite corners of 1 Fabric C 8½" x 8½" square. Sew on the marked guidelines.

Step 5

Trim ¼" seam allowance outside of the sewn lines. Press the seams open to create **1 Semi-Snowball C** unit. Repeat Steps 4 and 5 to create a total of:

Baby	8 **Semi-Snowball C** units
Throw	18 **Semi-Snowball C** units
Queen	32 **Semi-Snowball C** units

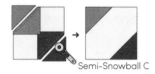

Semi-Snowball C

Step 6

Sew 1 Fabric A 4½" x 8½" rectangle to the left of 1 Semi-Snowball C unit to create **1 Set C** unit. Repeat to create a total of:

Baby	8 **Set C** units
Throw	18 **Set C** units
Queen	32 **Set C** units

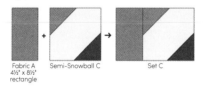

Fabric A
4½" x 8½"
rectangle Semi-Snowball C Set C

Press the seams open.

Step 7

Attach 1 Fabric A/C Quick-Corner unit to 1 Set A unit to create **1 Block C** unit. Repeat to create a total of:

Baby	8 **Block C** units
Throw	18 **Block C** units
Queen	32 **Block C** units

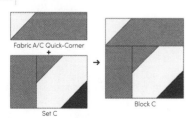

Fabric A/C Quick-Corner
+
Set C Block C

Press the seams open.

Block D Units

Step 1

As shown in the diagram, sew 1 Block C unit to the left of 1 Block A unit and press the seams open to create **1 Set D** unit. Repeat to create a total of:

Baby	4 **Set D** units
Throw	10 **Set D** units
Queen	24 **Set D** units

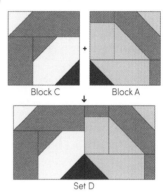

Block C Block A

Set D

Step 2

Line the seams up and combine 2 Set D units, as shown in the diagram, to create **1 Block D** unit. Repeat to create a total of:

Baby	2 **Block D** units
Throw	5 **Block D** units
Queen	12 **Block D** units

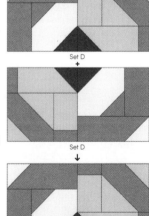

Set D
+
Set D
↓

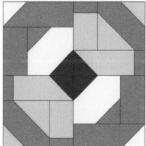

Block D

Block E Units

Step 1

Referring to the diagram, sew 1 Block C unit to the left of 1 Block B unit to form **1 Set E** unit. Repeat to create a total of:

Baby	4 Set E units
Throw	8 Set E units
Queen	8 Set E units

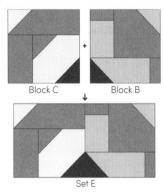

Block C + Block B

Set E

Press the seams open.

Step 2

Sew together 2 Set E units, as shown in the diagram, to create **1 Block E** unit. Repeat to create a total of:

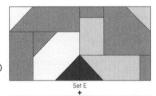

Set E

Set E

Baby	2 Block E units
Throw	4 Block E units
Queen	4 Block E units

Press the seams open.

Block E

Quilt Assembly

Step 1

The **baby-size quilt top** is made up of two rows. Sew together 2 Block E units in the first row, and 2 Block D units in the second row, as shown in the diagram. Line up the seams and join the two rows to form a baby-size quilt top. Press the seam open.

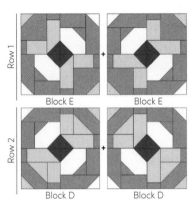

Row 1 — Block E + Block E
Row 2 — Block D + Block D

The **throw-size quilt top** is made up of three rows. For the first and second rows, sew together 1 Block D and 2 Block E units. For the third row, sew together 3 Block D units. Line up the seams and join the three rows to form a throw-size quilt top, as shown in the diagram. Press the seams open.

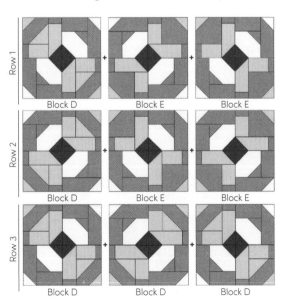

Row 1 — Block D + Block E + Block E
Row 2 — Block D + Block E + Block E
Row 3 — Block D + Block D + Block D

A **queen-size quilt top** is made up of four rows. Sew together 4 Block D units to form the first and fourth rows. Sew together 2 Block D and 2 Block E units to create the second and third rows. Line up the seams and join the four rows to form a queen-size quilt top, as shown in the diagram. Press the seams open.

Step 2

Press the quilt top and backing fabric. Layer the backing, batting, and quilt top. Baste, quilt, and bind.

CROSSTOWN BUZZ

(Advanced Beginner)

Baby: 48" x 48" (122 cm x 122 cm)

Throw: 72" x 72" (183 cm x 183 cm)

Queen: 96" x 96" (244 cm x 244 cm)

Piecing Methods and Techniques

No-Waste Flying Geese / Quick-Corner units

People in New York City are always on the go—uptown, downtown, east side, west side. The Flying Geese units in Crosstown Buzz illustrate the myriad directions people travel in any urban area. Something about this buzz of activity is addictive, and you can't help but walk just as fast, following the beat of the city. Some days the tall buildings, traffic, lights, and crowds can feel overwhelming and claustrophobic, and you need an escape to embrace a slower pace or get a dose of nature. However, once removed from it for awhile, the buzz somehow draws you back in. For me, this feeling has really confirmed New York City is home.

Flying Geese units are made up of three right-angled triangles: a larger triangle (the geese and their flight direction) surrounded by two smaller triangles (the sky). This classic, versatile design has been around for hundreds of years and continues to be widely used in modern quilt designs.

There are two different construction methods for Flying Geese blocks. The traditional method makes one Flying Geese at a time and requires two squares to be sewn on each end of a rectangle. Since there are at least sixty-four Flying Geese units in Crosstown Buzz (depending on the quilt size you choose), the pattern incorporates the second construction method. This no-waste method is the fastest way to grow your flock—five squares and six seams become four Flying Geese. Recreating the same number of Flying Geese using the traditional method would require eight squares, four rectangles, and eight seams—no one has time for this when you're a weekend quilter! The Crosstown Buzz quilt pattern also incorporates Quick-Corner blocks, which are similar to traditional Flying Geese, but with only one sky attached instead of two.

In the late 1700s through the mid-1800s (approximately 1780—1862), a secret network of safe houses and stations was formed by sympathetic white people in the United States to help slaves escape from their owners in the Southern states. This secret route was called the Underground Railroad. Slaveholders had tight control over their slaves. They were forbidden from learning how to read and write, as well as from communicating with each other without white supervision. Attempting to escape or helping slaves make their way to freedom was considered a crime so serious that the death penalty was imposed. However, this did not stop people from escaping.

Legend suggests that shapes and symbols sewn on quilts played an important role in guiding fugitive slaves to freedom in the Northern states and Canada. Safe houses and stations hung these quilts on windowsills and clotheslines, indicating when and in which direction to travel, what was available at the stop to help fugitives throughout their journey, and what potential dangers laid ahead. Flying Geese units were one of many such symbols, used to tell fugitives to follow migrating geese during the spring and summer months and travel north.

COLOR INSPIRATION

Baby

Fabric A ⬤ Robert Kaufman, Kona Cotton in Deep Rose

Fabric B ⬤ Robert Kaufman, Kona Cotton in Brick

Fabric C ⬤ Robert Kaufman, Kona Cotton in Waterfall

Fabric D ⬤ Robert Kaufman, Kona Cotton in Blueprint

Backing Fabric Hawthorne Supply Co, Hawthorne Essentials, Star Charts in Berry

Binding Fabric Robert Kaufman, Kona Cotton in Deep Rose

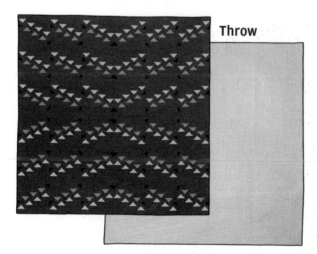

Throw

Fabric A ⬤ Robert Kaufman, Kona Cotton in Celestial

Fabric B ⬤ Robert Kaufman, Kona Cotton in School Bus

Fabric C ⬤ Robert Kaufman, Kona Cotton in Primrose

Fabric D ⬤ Robert Kaufman, Kona Cotton in Black

Backing Fabric Hawthorne Supply Co, Indy Bloom, Smitten, Small Wrapped in Sugar Pink

Binding Fabric Robert Kaufman, Kona Cotton in Black

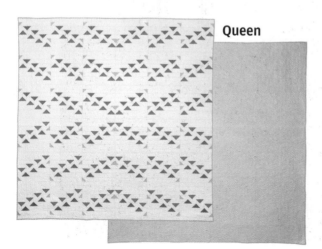

Queen

Fabric A ⬤ Robert Kaufman, Kona Cotton in Bone

Fabric B ⬤ Hawthorne Supply Co, Mable Tan, Modern Farmhouse, Hash in Coral

Fabric C ⬤ Robert Kaufman, Kona Cotton in Hyacinth

Fabric D ⬤ Hawthorne Supply Co, Mable Tan, Modern Farmhouse, Hash in Golden Honey

Backing Fabric Hawthorne Supply Co, Hawthorne Essentials, Astral Nights in Powder Blue

Binding Fabric Robert Kaufman, Kona Cotton in Banana Pepper

Fabric Requirements

	Baby	Throw	Queen
Fabric A ⬤	2⅜ yard (218 cm)	5⅛ yards (469 cm)	8⅓ yards (762 cm)
Fabric B ⬤	¼ yard (23 cm)	⅝ yard (58 cm)	⅞ yard (80 cm)
Fabric C ⬤	⅓ yard (31 cm)	⅝ yard (58 cm)	1 yard (92 cm)
Fabric D ⬤	¼ yard (23 cm)	¼ yard (23 cm)	⅜ yard (35 cm)
Binding Fabric	⅜ yard (35 cm)	⅝ yard (58 cm)	¾ yard (69 cm)
Backing Fabric	3⅛ yard (286 cm)	4½ yard (412 cm)	8⅔ yards (793 cm)

Cutting Directions

	Baby	Throw	Queen
Fabric A ●	8 strips, 3½" x WOF sub-cut: • 32 rectangles, 3½" x 9½" 4 strips, 2⅜" x WOF sub-cut: • 64 squares, 2⅜" x 2⅜" 22 strips, 2" x WOF sub-cut: • 16 rectangles, 2" x 9½" • 32 rectangles, 2" x 6½" • 144 rectangles, 2" x 3½"	18 strips, 3½" x WOF sub-cut: • 72 rectangles, 3½" x 9½" 9 strips, 2⅜" x WOF sub-cut: • 144 squares, 2⅜" x 2⅜" 48 strips, 2" x WOF sub-cut: • 36 rectangles, 2" x 9½" • 72 rectangles, 2" x 6½" • 324 rectangles, 2" x 3½"	24 strips, 4½" x WOF sub-cut: • 72 rectangles, 4½" x 12½" 11 strips, 2⅞" x WOF sub-cut: • 144 rectangles, 2⅞" x 2⅞" 63 strips, 2½" x WOF sub-cut: • 36 rectangles, 2½" x 12½" • 72 rectangles, 2½" x 8½" • 324 rectangles, 2½" x 4½"
Fabric B ●	2 strips, 4¼" x WOF sub-cut: • 16 squares, 4¼" x 4¼"	4 strips, 4¼" x WOF sub-cut: • 36 squares, 4¼" x 4¼"	5 strips, 5¼" x WOF sub-cut: • 36 squares, 5¼" x 5¼"
Fabric C ●	5 strips, 2" x WOF sub-cut: • 96 squares, 2" x 2"	11 strips, 2" x WOF sub-cut: • 216 squares, 2" x 2"	14 strips, 2½" x WOF sub-cut: • 216 squares, 2½" x 2½"
Fabric D ●	2 strips, 2" x WOF sub-cut: • 32 squares, 2" x 2"	4 strips, 2" x WOF sub-cut: • 72 squares, 2" x 2"	5 strips, 2½" x WOF sub-cut: • 72 squares, 2½" x 2½"
Binding Fabric	5 strips, 2½" x WOF	8 strips, 2½" x WOF	10 strips, 2½" x WOF

Flying Geese Units

Step 1

Draw a guideline from one corner to the opposite corner on:

Baby	64 Fabric A 2 ⅜" x 2 ⅜" squares
Throw	144 Fabric A 2 ⅜" x 2 ⅜" squares
Queen	144 Fabric A 2 ⅞" x 2 ⅞" squares

Tip: For lighter- (e.g. white) or darker-colored (e.g. black) fabrics, use an iron to press a diagonal guideline.

Step 2

Referring to the diagram shown, place 2 marked Fabric A squares from Step 1, with the right sides together and diagonal lines lined up, on:

Baby	1 Fabric B 4¼" x 4¼" square
Throw	1 Fabric B 4¼" x 4¼" square
Queen	1 Fabric B 5¼" x 5¼" square

Tip: Use painter's tape instead of pins to secure the Fabric A and Fabric B squares together. This guarantees a smooth, flat surface when you put your pieces through the sewing machine. You can also sew over the tape without worrying about breaking your sewing needle.

If your tape pieces are still sticky, save them for securing pieces of fabric together for other Flying Geese or Quick-Corner units in the next section (page 128).

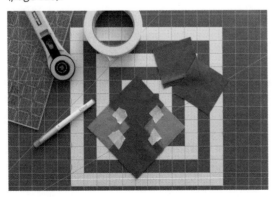

Step 3

Sew ¼" on both sides of the drawn line and cut on the drawn line to create two units.

Step 4

Press the seams to one side, as shown in the diagram.

Step 5

Place 1 marked Fabric A square from Step 1 on each unstitched corner, with the right sides together and the drawn diagonal line running perpendicular to the stitched seam. Sew ¼" on both sides of the drawn line on both units.

Step 6

Cut on the drawn line and press the seams open to create 4 Flying Geese units.

Baby	Fabric A/B 2" x 3½" rectangles
Throw	Fabric A/B 2" x 3½" rectangles
Queen	Fabric A/B 2½" x 4½" rectangles

Step 7

Repeat **Steps 2 through 6** to create a total of:

Baby	**64 Fabric A/B 2" x 3½" Flying Geese units** (repeat 15 times)
Throw	**144 Fabric A/B 2" x 3½" Flying Geese units** (repeat 35 times)
Queen	**144 Fabric A/B 2½" x 4½" Flying Geese units** (repeat 35 times)

Quick-Corner Units

Step 1

On the wrong side of the fabric, draw a guideline from one corner to the opposite corner on:

Baby	32 Fabric D 2" x 2" squares
Throw	72 Fabric D 2" x 2" squares
Queen	72 Fabric D 2 ½" x 2 ½" squares

Step 2

Noting the direction of the marked diagonal line, create 1 Fabric A/D Quick-Corner unit by placing 1 marked Fabric D from Step 1, with right sides together, on the left of:

Baby	1 Fabric A 2" x 3½" rectangle
Throw	1 Fabric A 2" x 3½" rectangle
Queen	1 Fabric A 2½" x 4½" rectangle

Tip: Use painter's tape to secure the Fabric D squares and Fabric A rectangles by sticking one piece of tape in the middle of the Fabric A rectangle to secure the Fabric D square. Then join two ends of tape with the non-sticky side facing each other to create double-sided tape. Place the tape between the two layers of fabric on the corner that does not intersect with the marked guideline.

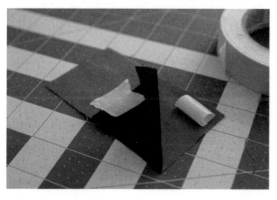

Then sew on the drawn line. Repeat to create a total of:

Baby	16 Fabric A/D Quick-Corner A units
Throw	36 Fabric A/D Quick-Corner A units
Queen	36 Fabric A/D Quick-Corner A units

Set aside units for *Step 11 (page 130)*.

Step 3

Place 1 marked Fabric D from Step 1, with right sides together, noting the direction of the diagonal line next to:

Baby	1 Fabric A 2" x 3½" rectangle
Throw	1 Fabric A 2" x 3½" rectangle
Queen	1 Fabric A 2½" x 4½" rectangle

Then sew on the drawn line. Repeat to create a total of:

Baby	16 Fabric A/D Quick-Corner B units
Throw	36 Fabric A/D Quick-Corner B units
Queen	36 Fabric A/D Quick-Corner B units

Set aside units for *Quick Corner Units, Step 11 (page 130)*.

Step 4

On the wrong side of the fabric, draw a guideline from one corner to the opposite corner on:

Baby	96 Fabric C 2" x 2" squares
Throw	216 Fabric C 2" x 2" squares
Queen	216 Fabric C 2½" x 2½" squares

Step 5

Create 1 Fabric A/C Quick-Corner A unit by arranging and placing 1 Fabric C square (from Step 4), with the drawn guideline running from the bottom left corner to the top right corner, on the left of:

Baby	1 Fabric A 2" x 3½" rectangle
Throw	1 Fabric A 2" x 3½" rectangle
Queen	1 Fabric A 2½" x 4½" rectangle

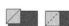

Then sew on the guideline. Repeat to create a total of:

Baby	32 Fabric A/C Quick-Corner A units
Throw	72 Fabric A/C Quick-Corner A units
Queen	72 Fabric A/C Quick-Corner A units

Set aside units for *Quick-Corner units, Step 11 (page 130)*.

Step 6

Referring to the diagram shown, repeat **Step 5** to create **1 Fabric A/C Quick-Corner B** unit by arranging and placing 1 Fabric C square (from Step 4) on the right of:

Baby	1 Fabric A 2" x 3½" rectangle
Throw	1 Fabric A 2" x 3½" rectangle
Queen	1 Fabric A 2½" x 4½" rectangle

Then sew on the guideline. Repeat to create a total of:

Baby	32 Fabric A/C Quick-Corner B units
Throw	72 Fabric A/C Quick-Corner B units
Queen	72 Fabric A/C Quick-Corner B units

Set aside units for *Quick-Corner units, Step 11 (page 130)*.

Step 7

Create **1 Fabric A/C Quick-Corner C** unit by arranging and placing 1 Fabric C square (from Step 4) on the left of:

Baby	1 Fabric A 2" x 6½" rectangle
Throw	1 Fabric A 2" x 6½" rectangle
Queen	1 Fabric A 2½" x 8½" rectangle

Then sew on the guideline. Repeat to create a total of:

Baby	8 Fabric A/C Quick-Corner C units
Throw	18 Fabric A/C Quick-Corner C units
Queen	18 Fabric A/C Quick-Corner C units

Set aside units for *Step 11 (page 130)*.

Step 8

Referring to the diagram shown, create **1 Fabric A/C Quick-Corner D** unit by sewing on the marked line on 1 Fabric C square (from Step 4) to:

Baby	1 Fabric A 2" x 6½" rectangle
Throw	1 Fabric A 2" x 6½" rectangle
Queen	1 Fabric A 2½" x 8½" rectangle

Repeat to create a total of:

Baby	8 Fabric A/C Quick-Corner D units
Throw	18 Fabric A/C Quick-Corner D units
Queen	18 Fabric A/C Quick-Corner D units

Set aside units for *Step 11 (page 130)*.

Step 9

As shown in the diagram, create **1 Fabric A/C Quick-Corner E** unit by placing 1 marked Fabric C square (from Step 4) on the left of:

Baby	1 Fabric A 2" x 9½" rectangle
Throw	1 Fabric A 2" x 9½" rectangle
Queen	1 Fabric A 2½" x 12½" rectangle

Then sew on the guideline. Repeat to create a total of:

Baby	8 Fabric A/C Quick-Corner E units
Throw	18 Fabric A/C Quick-Corner E units
Queen	18 Fabric A/C Quick-Corner E units

Set aside units for *Step 11 (page 130)*.

Step 10

Referring to the diagram shown, create **1 Fabric A/C Quick-Corner F** unit by sewing on the marked line on 1 Fabric C square (from Step 4) to:

Baby	1 Fabric A 2" x 9½" rectangle
Throw	1 Fabric A 2" x 9½" rectangle
Queen	1 Fabric A 2½" x 12½" rectangle

Repeat to create a total of:

Baby	8 Fabric A/C Quick-Corner F units
Throw	18 Fabric A/C Quick-Corner F units
Queen	18 Fabric A/C Quick-Corner F units

Step 11

Trim ¼" seam allowance to the outside of the sewn line on all the Quick-Corner units. Use the helpful reference table to ensure you have created the right number of each type of Quick-Corner unit for your quilt size.

Total Quick-Corner units by quilt size

Quick-Corner unit type	Baby	Throw	Queen
Fabric A/D Quick-Corner A	16 units	36 units	36 units
Fabric A/D Quick-Corner B	16 units	36 units	36 units
Fabric A/C Quick-Corner A	32 units	72 units	72 units
Fabric A/C Quick-Corner B	32 units	72 units	72 units
Fabric A/C Quick-Corner C	8 units	18 units	18 units
Fabric A/C Quick-Corner D	8 units	18 units	18 units
Fabric A/C Quick-Corner E	8 units	18 units	18 units
Fabric A/C Quick-Corner F	8 units	18 units	18 units

Press the seams open.

Block Assembly

The quilt top is made up of two types of blocks, each mirroring the other. All the blocks are made up of six rows. References to rows with the letter A refer to Block A (e.g. Row A1), and rows labeled with the letter B refer to Block B (e.g. Row B1).

Step 1

Create the first half of 1 Row A1 by sewing together 1 Fabric A/D Quick-Corner A unit to:

Baby	1 Fabric A 2" x 3½" rectangle
Throw	1 Fabric A 2" x 3½" rectangle
Queen	1 Fabric A 2½" x 4½" rectangle

Press the seams open. Repeat to create a total of:

Baby	8 Row A1 halves
Throw	18 Row A1 halves
Queen	18 Row A1 halves

Step 2

To build the rest of **Row A1**, attach the first half of Row A1 from Step 1 and 2 to:

Baby	1 Fabric A 3½" x 9½" rectangle
Throw	1 Fabric A 3½" x 9½" rectangle
Queen	1 Fabric A 4½" x 12½" rectangle

Press the seams open. Repeat to create a total of:

Baby	8 Row A1 units
Throw	18 Row A1 units
Queen	18 Row A1 units

Set aside units for *Block Assembly, Step 9 (page 132)*.

Step 3

Referring to the diagram shown, sew together 1 Fabric A/C Quick-Corner B unit and 1 Fabric A/C Quick-Corner E unit to create **1 Row A2**. Press the seams open. Repeat to create a total of:

Baby	8 Row A2 units
Throw	18 Row A2 units
Queen	18 Row A2 units

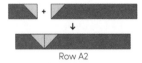

Row A2

Set aside units for *Block Assembly, Step 9 (page 132).*

Step 4

Sew together 1 Fabric A/B Flying Geese unit, 1 Fabric A/C Quick-Corner B unit, and 1 Fabric A/C Quick-Corner C unit to create **1 Row A3**. Press the seams open. Repeat to create a total of:

Baby	8 Row A3 units
Throw	18 Row A3 units
Queen	18 Row A3 units

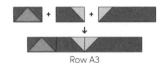

Row A3

Set aside units for *Block Assembly, Step 9 (page 132).*

Step 5

As shown in the diagram, create **1 Row A4** by arranging and sewing together:

Baby	1 Fabric A 2" x 3½" rectangle, 1 Fabric A/B Flying Geese unit, 1 Fabric A/C Quick-Corner B unit, and 1 Fabric A/C Quick-Corner A unit
Throw	1 Fabric A 2" x 3½" rectangle, 1 Fabric A/B Flying Geese unit, 1 Fabric A/C Quick-Corner B unit, and 1 Fabric A/C Quick-Corner A unit
Queen	1 Fabric A 2½" x 4½" rectangle, 1 Fabric A/B Flying Geese unit, 1 Fabric A/C Quick-Corner B unit, and 1 Fabric A/C Quick-Corner A unit

Row A4

Press the seams open. Repeat to create a total of:

Baby	8 Row A4 units
Throw	18 Row A4 units
Queen	18 Row A4 units

Set aside units for *Block Assembly, Step 9 (page 132).*

Step 6

Referring to the diagram shown, create **1 Row A5** by arranging and sewing together:

Baby	1 Fabric A 2" x 6½" rectangle, 1 Fabric A/B Flying Geese unit, and 1 Fabric A/D Quick-Corner B unit
Throw	1 Fabric A 2" x 6½" rectangle, 1 Fabric A/B Flying Geese unit, and 1 Fabric A/D Quick-Corner B unit
Queen	1 Fabric A 2½" x 8½" rectangle, 1 Fabric A/B Flying Geese unit, and 1 Fabric A/D Quick-Corner B unit

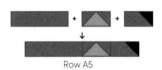

Row A5

Press the seams open. Repeat to create a total of:

Baby	8 Row A5 units
Throw	18 Row A5 units
Queen	18 Row A5 units

Set aside units for *Block Assembly, Step 9 (page 132).*

Step 7

Create the first half of **Row A6** by sewing together 1 Fabric A/B Flying Geese unit and:

Baby	1 Fabric A 2" x 3½" rectangle
Throw	1 Fabric A 2" x 3½" rectangle
Queen	1 Fabric A 2½" x 4½" rectangle

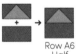

Row A6 Half

Press the seams open. Repeat to create a total of:

Baby	8 Row A6 halves
Throw	18 Row A6 halves
Queen	18 Row A6 halves

Step 8

To build the rest of **Row A6**, attach the left side of the Row A6 half created in Step 7 to:

Baby	1 Fabric A 3½" x 9½" rectangle
Throw	1 Fabric A 3½" x 9½" rectangle
Queen	1 Fabric A 4½" x 12½" rectangle

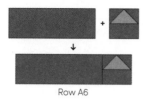

Row A6

Press the seams open. Repeat to create a total of:

Baby	8 Row A6 units
Throw	18 Row A6 units
Queen	18 Row A6 units

Step 9

Arrange Rows A1 through A6 as shown in the diagram to create **1 Block A**. Press the seams open. Repeat to create a total of:

Baby	8 Block A units
Throw	18 Block A units
Queen	18 Block A units

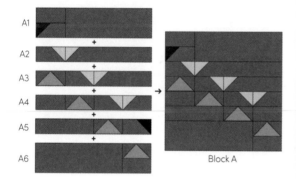

Set aside Block A units for *Quilt Assembly, Step 1 (page 134)*.

Step 10

Create the first half of **Row B1** by sewing together 1 Fabric A/D Quick-Corner B to:

Baby	1 Fabric A 2" x 3½" rectangle
Throw	1 Fabric A 2" x 3½" rectangle
Queen	1 Fabric A 2½" x 4½" rectangle

Row A1 Half

Press the seams open. Repeat to create a total of:

Baby	8 Row B1 halves
Throw	18 Row B1 halves
Queen	18 Row B1 halves

Step 11

To complete **Row B1**, attach the left side of the Row B1 half created in Step 10 to:

Baby	1 Fabric A 3½" x 9½" rectangle
Throw	1 Fabric A 3½" x 9½" rectangle
Queen	1 Fabric A 4½" x 12½" rectangle

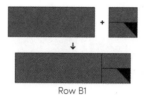

Row B1

Press the seams open. Repeat to create a total of:

Baby	8 Row B1 units
Throw	18 Row B1 units
Queen	18 Row B1 units

Set aside units for *Step 18 (page 133)*.

Step 12

For all quilt sizes, arrange and sew together 1 Fabric A/C Quick-Corner F unit and 1 Fabric A/C Quick-Corner A unit together to create **1 Row B2**. Press the seams open. Repeat to create a total of:

Baby	8 Row B2 units
Throw	18 Row B2 units
Queen	18 Row B2 units

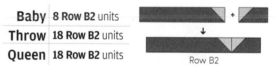

Row B2

Set aside units for *Step 18 (page 133)*.

Step 13

Combine 1 Fabric A/C Quick-Corner D unit, 1 Fabric A/C Quick-Corner A unit, and 1 Fabric A/B Flying Geese unit to create **1 Row B3**. Press the seams open. Repeat to create a total of:

Baby	8 Row B3 units
Throw	18 Row B3 units
Queen	18 Row B3 units

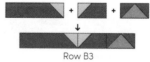

Row B3

Set aside units for *Step 18 (page 133)*.

Step 14

Noting the placement and direction of Row B4, create **1 Row B4** by sewing together 1 Fabric A/C Quick-Corner B unit, 1 Fabric A/C Quick-Corner A unit, 1 Fabric A/B Flying Geese unit, and:

Baby	1 Fabric A 2" x 3½" rectangle
Throw	1 Fabric A 2" x 3½" rectangle
Queen	1 Fabric A 2½" x 4½" rectangle

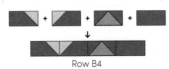

Row B4

Press the seams open. Repeat to create a total of:

Baby	**8 Row B4** units	
Throw	**18 Row B4** units	Set aside units for
Queen	**18 Row B4** units	*Step 18 (page 133).*

Step 15

Following the diagram, create **1 Row B5** unit by sewing together 1 Fabric A/D Quick-Corner A unit, 1 Fabric A/B Flying Geese unit, and:

Baby	1 Fabric A 2" x 6½" rectangle
Throw	1 Fabric A 2" x 6½" rectangle
Queen	1 Fabric A 2½" x 8½" rectangle

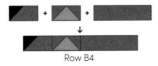

Row B4

Press the seams open. Repeat to create a total of:

Baby	**8 Row B5** units	
Throw	**18 Row B5** units	Set aside units for
Queen	**18 Row B5** units	*Step 18 (page 133).*

Step 16

Create the first half of **Row B6** by sewing together 1 Fabric A/B Flying Geese unit and:

Baby	1 Fabric A 2" x 3½" rectangle
Throw	1 Fabric A 2" x 3½" rectangle
Queen	1 Fabric A 2½" x 4½" rectangle

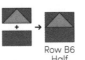

Row B6 Half

Press the seams open. Repeat to create a total of:

Baby	**8 Row B6** halves
Throw	**18 Row B6** halves
Queen	**18 Row B6** halves

Step 17

To complete **Row B6**, attach the right side of the Row A6 half created in Step 16 to:

Baby	1 Fabric A 3½" x 9½" rectangle
Throw	1 Fabric A 3½" x 9½" rectangle
Queen	1 Fabric A 4½" x 12½" rectangle

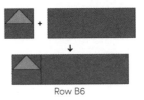

Row B6

Press the seams open. Repeat to create a total of:

Baby	**8 Row B6** units
Throw	**18 Row B6** units
Queen	**18 Row B6** units

Step 18

Line up the seams and join Rows B1 through B6 to create **1 Block B** and press the seams open. Repeat to create a total of:

Baby	**8 Block B** units
Throw	**18 Block B** units
Queen	**18 Block B** units

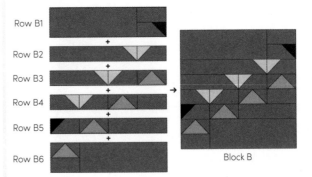

Block B

Quilt Assembly

Step 1

As shown in the diagram, create **1 Row** by arranging and sewing together:

Baby	2 Block A units followed by 2 Block B units
Throw	3 Block A units followed by 3 Block B units
Queen	3 Block A units followed by 3 Block B units

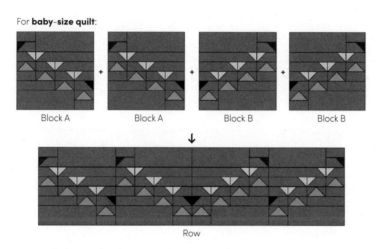

For **baby-size quilt**:

Block A + Block A + Block B + Block B

↓

Row

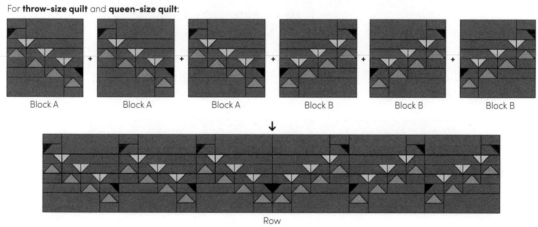

For **throw-size quilt** and **queen-size quilt**:

Block A + Block A + Block A + Block B + Block B + Block B

↓

Row

Press the seams open. Repeat to create a total of:

Baby	**4 Rows**
Throw	**6 Rows**
Queen	**6 Rows**

Tip: Take extra care when putting rows together. Blocks in each row mirror each other. Lay the blocks on a flat surface in sewing order, and check twice before getting behind the sewing machine.

Step 2

For a **baby-size quilt top**, lay out 4 Rows, rotate the bottom 2 Rows 180 degrees, and sew together.

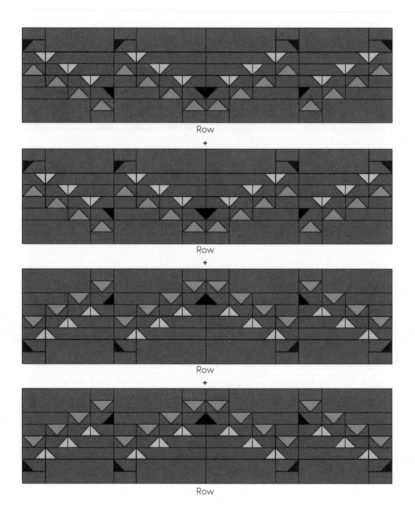

Row

+

Row

+

Row

+

Row

For a **throw- or queen-size quilt top**, lay out 6 Rows, rotate the last 3 Rows 180 degrees to reflect the first 3 Rows, and sew together.

Row

+

Row

+

Row

+

Row

+

Row

+

Row

Step 3

Press the quilt top and backing fabric. Layer the backing fabric, batting, and quilt top. Baste, quilt, and bind.

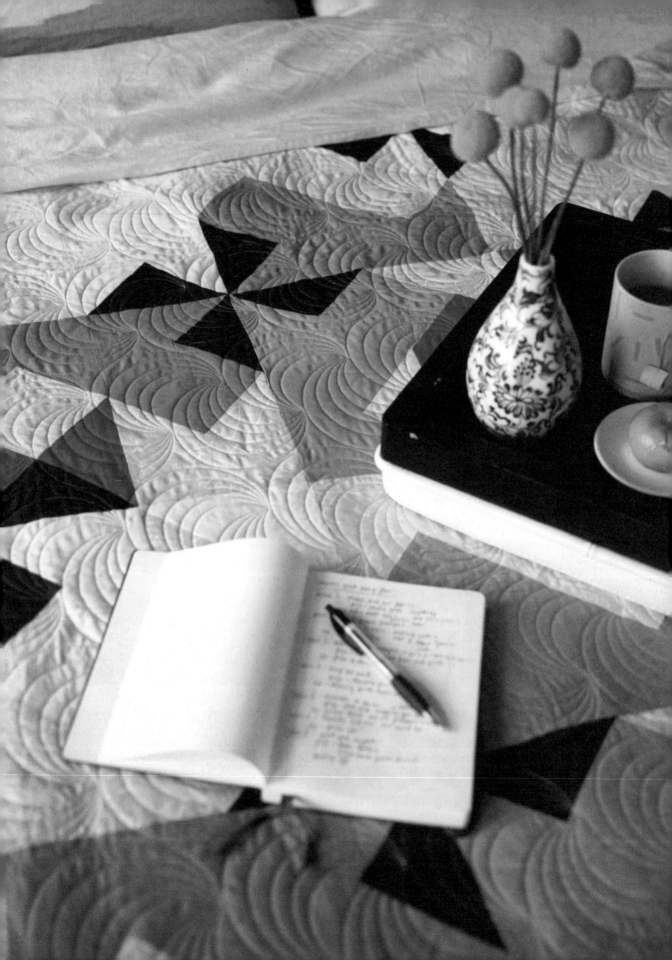

WIND TUNNEL

(Advanced Beginner)

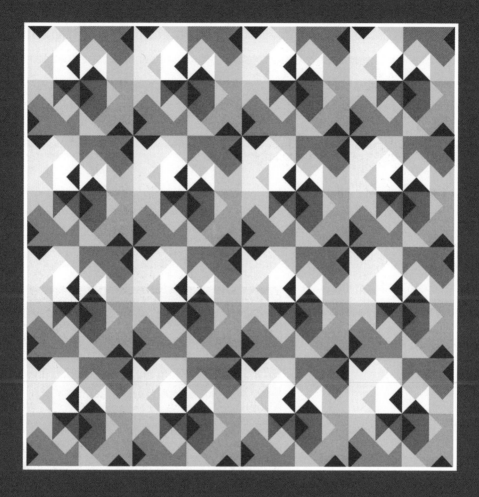

Baby: 48" x 48" (122 cm x 122 cm)

Throw: 72" x 72" (183 cm x 183 cm)

Queen: 96" x 96" (244 cm x 244 cm)

Piecing Methods and Techniques

2-in-1 Half-Square Triangles / Flying Geese /

Hourglass / Spilt-Quarter Square Triangles

The combination of tall city high-rises and gusty wind conditions often develops into the phenomena of wind tunnels. Some streets are windier than others, depending on the direction both you and the wind are traveling. One wrong turn onto another street could lead to gusts so strong you want to hold on tight to everything! It's days like these that make you wish you were wrapped up in a warm quilt with a cup of hot tea.

The Wind Tunnel quilt pattern, inspired by cold, windy days walking through Manhattan, is a modern twist on the traditional Pinwheel quilt block. The darker green and blue triangles shown in the examples illuminate the pinwheel silhouette, and the colorful triangles in the center and on each corner of the block, which almost look like houses in various angles, suggest strong winds powering between the buildings. The pinwheel silhouettes in the design consist of Hourglass, Flying Geese, and Split-Quarter Square Triangle units. In addition to learning and practicing these construction methods, you will also learn how to square up these units before sewing your quilt blocks together. This process can be repetitive and can take a bit of time. However, the results are totally worthwhile.

A Pinwheel block can be constructed in several various ways. A basic Pinwheel block consists of two colors and four Half-Square Triangles sewn together to form a Four-Patch block. The darker colors form the silhouette of the pinwheel, or windmill propellers.

Pinwheel blocks started to make their way into quilts around the early 1800s and were one of the first decorative blocks in quilt design. Quilt blocks were often inspired by what was around quilters at the time, and the names given to blocks were very literal. Pinwheel blocks, also known as Turnstile or Windmill blocks, portrayed the common sights of an American living in the 1800s and early 1900s. Windmills during this period pumped water for livestock, day-to-day tasks, and living.

COLOR INSPIRATION

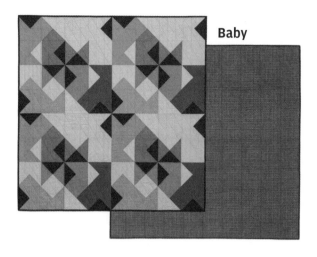

Baby

Fabric A ⬤ Robert Kaufman, Kona Cotton in Light Parfait

Fabric B ⬤ Robert Kaufman, Kona Cotton in Grellow

Fabric C ⬤ Robert Kaufman, Kona Cotton in Breeze

Fabric D ⬤ Robert Kaufman, Kona Cotton in Sienna

Fabric E ⬤ Robert Kaufman, Kona Cotton in Ballerina

Fabric F ⬤ Robert Kaufman, Kona Cotton in Persimmon

Fabric G ⬤ Robert Kaufman, Kona Cotton in Jade Green

Fabric H ⬤ Robert Kaufman, Kona Cotton in Rivera

Backing Fabric Hawthorne Supply Co, Andrea Elias, Terra, Weave in Topaz

Binding Fabric Robert Kaufman, Kona Cotton in Prussian

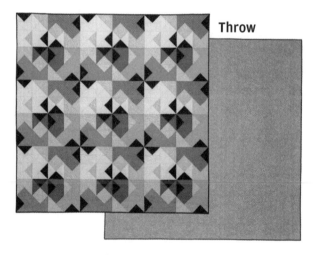

Throw

Fabric A ⬤ Hawthorne Supply Co, Hawthorne Essentials, Star Charts in Sunshine

Fabric B ⬤ Robert Kaufman, Kona Cotton in Oyster

Fabric C ⬤ Robert Kaufman, Kona Cotton in Olive

Fabric D ⬤ Robert Kaufman, Kona Cotton in Candy Pink

Fabric E ⬤ Robert Kaufman, Kona Cotton in Orange

Fabric F ⬤ Robert Kaufman, Kona Cotton in Flame

Fabric G ⬤ Robert Kaufman, Kona Cotton in Sky

Fabric H ⬤ Robert Kaufman, Kona Cotton in Evergreen

Backing Fabric Hawthorne Supply Co, Hawthorne Essentials, Star Charts in Gold

Binding Fabric Robert Kaufman, Kona Cotton in Hunter Green

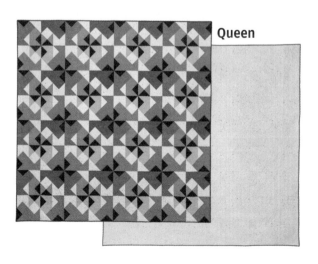

Queen

Fabric A ⬤ Hawthorne Supply Co, Hey Miss Designs, Chi Town, Large Ninety-Fifth Floor in PM

Fabric B ⬤ Robert Kaufman, Kona Cotton in Gold

Fabric C ⬤ Robert Kaufman, Kona Cotton in Blueprint

Fabric D ⬤ Robert Kaufman, Kona Cotton in Marmalade

Fabric E ⬤ Robert Kaufman, Kona Cotton in Pickle

Fabric F ⬤ Robert Kaufman, Kona Cotton in Primrose

Fabric G ⬤ Robert Kaufman, Kona Cotton in Melon

Fabric H ⬤ Robert Kaufman, Kona Cotton in Pepper

Backing Fabric Hawthorne Supply Co, Hey Miss Designs, Chi Town, Large Ninety-Fifth Floor in PM

Binding Fabric Robert Kaufman, Kona Cotton in Pepper

Fabric Requirements

	Baby	Throw	Queen
Fabric A ⬤	1 yard (92 cm)	1⅞ yard (172 cm)	3⅛ yards (286 cm)
Fabric B to E ◖⬤⬤⬤	⅜ yard (35 cm)	⅞ yard (80 cm)	1½ yard (138 cm)
Fabric F to G ◖⬤	½ yard (46 cm)	¾ yard (69 cm)	1⅛ yard (103 cm)
Fabric H ⬤	½ yard (46 cm)	1⅛ yard (103 cm)	1⅝ yards (149 cm)
Backing Fabric	3¼ yard (298 cm)	4½ yard (412 cm)	8¾ yard (801 cm)
Binding Fabric	⅜ yard (35 cm)	⅝ yard (58 cm)	¾ yard (69 cm)

Cutting Directions

	Baby	Throw	Queen
Fabric A ⬤	4 strips, 7⅞" x WOF sub-cut: • 12 squares, 7⅞" x 7⅞" • 4 squares, 7½" x 7½"	6 strips, 7⅞" x WOF sub-cut: • 30 squares, 7⅞" x 7⅞" 2 strips, 7½" x WOF sub-cut: • 9 squares, 7½" x 7½"	10 strips, 7⅞" x WOF sub-cut: • 48 squares, 7⅞" x 7⅞" 4 strips, 7½" x WOF sub-cut: •16 squares, 7½" x 7½"
Fabric B to E ◖⬤⬤⬤	1 strip, 7⅞" x WOF sub-cut: • 2 squares, 7⅞" x 7⅞" • 2 squares, 7½" x 7½" 1 strip, 3⅞" x WOF sub-cut: • 4 squares, 3⅞" x 3⅞" • 4 rectangles, 3½" x 6½"	1 strip, 7⅞" x WOF sub-cut: • 5 squares, 7⅞" x 7⅞" 1 strip, 7½" x WOF sub-cut: • 5 squares, 7½" x 7½" 2 strips, 3⅞" x WOF sub-cut: • 12 squares, 3⅞" x 3⅞" • 5 rectangles, 3½" x 6½" 1 strip, 3½" x WOF sub-cut: • 4 rectangles, 3½" x 6½"	2 strips, 7⅞" x WOF sub-cut: • 8 squares, 7⅞" x 7⅞" • 2 squares, 7½" x 7½" 2 strips, 7½" x WOF sub-cut: • 6 squares, 7½" x 7½" 2 strips, 3⅞" x WOF sub-cut: • 16 squares, 3⅞" x 3⅞" • 3 rectangles, 3½" x 6½" 3 strips, 3½" x WOF sub-cut: • 13 rectangles, 3½" x 6½"

Cutting Directions

Continued...

	Baby	Throw	Queen
Fabric F to G ◑	1 strip, 7⅞" x WOF sub-cut: • 4 squares, 7⅞" x 7⅞" 1 strip, 7½" x WOF sub-cut: • 2 squares, 7½" x 7½"	2 strips, 7⅞" x WOF sub-cut: • 10 squares, 7⅞" x 7⅞" 1 strip, 7½" x WOF sub-cut: • 5 squares, 7½" x 7½"	4 strips, 7⅞" x WOF sub-cut: • 16 squares, 7⅞" x 7⅞" • 4 squares, 7½" x 7½" 1 strip, 7½" x WOF sub-cut: • 4 squares, 7½" x 7½"
Fabric H ●	1 strip, 7⅞" x WOF sub-cut: • 4 squares, 7⅞" x 7⅞" 1 strip, 7¼" x WOF sub-cut: • 4 squares, 7¼" x 7¼"	2 strips, 7⅞" x WOF sub-cut: • 10 squares, 7⅞" x 7⅞" 3 strips, 7¼" x WOF sub-cut: • 12 squares, 7¼" x 7¼"	4 strips, 7⅞" x WOF sub-cut: • 16 squares, 7⅞" x 7⅞" • 4 squares, 7¼" x 7¼" 3 strips, 7¼" x WOF sub-cut: • 12 squares, 7¼" x 7¼"
Binding Fabric	5 strips, 2½" x WOF	8 strips, 2½" x WOF	10 strips, 2½" x WOF

Tip: This pattern uses more fabrics than others in the book, and they may be difficult to differentiate throughout the project. When working with multiple-colored fabrics, cut sample swatches (approximately 1" x 1") before cutting the fabrics. Then tape or sew the swatches onto a piece of paper and label the fabrics. This will come in handy when you are unsure which fabrics you have picked up throughout the project and can help avoid those dreaded seam-ripping moments.

Flying Geese Square Units

Step 1

Draw a diagonal guideline from one corner to the opposite corner on the wrong side of all the Fabrics B to E 3⅞" x 3⅞" squares.

*4 Fabric B 3⅞" x 3⅞" squares are used in this example

Step 2

For all quilt sizes, place 2 Fabric B 3⅞" x 3⅞" squares on 1 Fabric H 7¼" x 7¼" square on opposite corners, with right sides together and diagonal lines lined up, as shown in the diagram.

Step 3

Sew ¼" on both sides of the marked guideline and cut on the drawn line to create two pieces.

Step 4

Press the seams to one side, as shown in the diagram.

Step 5

Place 1 marked Fabric B square from Step 1 on each unstitched corner with the right sides together and the drawn diagonal line running perpendicular to the stitched seam. Sew ¼" on both sides of the marked guideline on both units.

Step 6

Cut on the drawn line, press the seams open, and trim to create **4 Fabric B/H 3½" x 6½" Flying Geese** units.

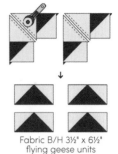

Fabric B/H 3½" x 6½" flying geese units

Step 7

Repeat Steps 2 through 6 with Fabrics B to E 3⅞" x 3⅞" squares and Fabric H 7¼" x 7¼" squares to create a total of:

	Baby	Throw	Queen
Fabric B/H 3½" x 6½" Flying Geese units	4	9*	16
Fabric C/H 3½" x 6½" Flying Geese units	4	9*	16
Fabric D/H 3½" x 6½" Flying Geese units	4	9*	16
Fabric E/H 3½" x 6½" Flying Geese units	4	9*	16

Note: For a throw-size quilt, there will be three extra Flying Geese units for each Fabric (B-E/H).

Step 8

As shown in the diagram, form 1 Fabric B/H Flying Geese Square unit by sewing together 1 Fabric B 3½" x 6½" rectangle to the right of 1 Fabric B/H 3½" x 6½" Flying Geese unit. Press the seam open.

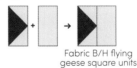

Fabric B/H flying geese square units

Step 9

Repeat Step 8 with the Fabrics B to E and H 3½" x 6½" Flying Geese units and the Fabrics B to E 3½" x 6½" rectangles to create a total of:

	Baby	Throw	Queen
Fabric B/H Flying Geese units	4	9*	16
Fabric C/H Flying Geese units	4	9*	16
Fabric D/H Flying Geese units	4	9*	16
Fabric E/H Flying Geese units	4	9*	16

Press the seams open.

Half-Square Triangle Units

In the following section, we'll use the 2-in-1 method to create Half-Square Triangle units. Then we'll split these units in half to create Quarter-Square Triangle and Split-Quarter Square Triangle units in later sections of the quilt pattern.

Step 1

Draw a diagonal guideline on the wrong side of all Fabrics B to G 7⅞" x 7⅞" squares.

*Fabric B 7⅞" x 7⅞" square used in this example

Step 2

With the right sides together, place 1 marked Fabric B 7⅞" x 7⅞" square on top of 1 Fabric A 7⅞" x 7⅞" square and sew ¼" on both sides of the drawn line.

Step 3

Cut on the drawn line and press the seams open to create **2 Fabric A/B 7½" x 7½" Half-Square Triangle** units.

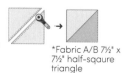

*Fabric A/B 7½" x 7½" half-sqaure triangle

Step 4

Repeat **Steps 2 and 3** with the Fabrics A to H 7⅞" x 7⅞" squares to create a total of:

	Baby	Throw	Queen
Fabric A/B 7½" x 7½" Half-Square Triangle units	4	9*	16
Fabric A/C 7½" x 7½" Half-Square Triangle units	4	9*	16
Fabric A/D 7½" x 7½" Half-Square Triangle units	4	9*	16
Fabric A/E 7½" x 7½" Half-Square Triangle units	4	9*	16
Fabric A/F 7½" x 7½" Half-Square Triangle units	4	9*	16
Fabric A/G 7½" x 7½" Half-Square Triangle units	4	9*	16
Fabric F/H 7½" x 7½" Half-Square Triangle units	4	9*	16
Fabric G/H 7½" x 7½" Half-Square Triangle units	4	9*	16

*Note: For a throw-size quilt, there will be one extra unit of each type of Half-Square Triangle.

Press the seams open.

Step 5

Referring to the diagram, mark a diagonal guide-line on the wrong sides of all Half-Square Triangle units. Cut on the guidelines to create a total of:

 *Fabric A/B 7½" x 7½" half-square triangle used in this example

	Baby	Throw	Queen
Fabric A/B Split Half-Square Triangle units	8	18	32
Fabric A/C Split Half-Square Triangle units	8	18	32
Fabric A/D Split Half-Square Triangle units	8	18	32
Fabric A/E Split Half-Square Triangle units	8	18	32
Fabric A/F Split Half-Square Triangle units	8	18	32
Fabric A/G Split Half-Square Triangle units	8	18	32
Fabric F/H Split Half-Square Triangle units	8	18	32
Fabric G/H Split Half-Square Triangle units	8	18	32

Hourglass Units

To avoid seam-ripping moments, it's important to note the orientation of each Split Half-Square Triangle unit from the previous step before sewing the Hourglass units.

Tip: To avoid confusion, separate the Split Half-Square Triangle units into 16 piles based on color and orientation. Label each pile with sticky notes or a piece of painter's tape.

Step 1

Combine:

- Fabric A/B Split Half-Square Triangle units
- Fabric A/D Split Half-Square Triangle units
- Fabric A/F Split Half-Square Triangle units
- Fabric A/G Split Half-Square Triangle units
- Fabric F/H Split Half-Square Triangle units
- Fabric G/H Split Half-Square Triangle units

to create a total of:

	Baby	Throw	Queen
Fabric A/B/G Hourglass units	4	9	16
Fabric A/D/F Hourglass units	4	9	16
Fabric A/F/H Hourglass units	4	9	16
Fabric A/G/H Hourglass units	4	9	16

Press the seams open.

Step 2

Square up all Hourglass units to 6½" x 6½" squares by matching the intersection of the 3¼" line on the ruler with the center seams of the Hourglass units and the 45-degree mark on the ruler with the diagonal seam line (as shown in blue in the diagram), and trim the top and right edges of the blocks.

45° mark

*Fabric A/B/G hourglass unit used in this example

Step 3

Rotate each Hourglass unit 180 degrees and repeat Step 2 with the remaining two sides.

45° mark

*Fabric A/B/G hourglass unit used in this example

Split-Quarter Square Triangle Units

Use the remaining Split Half-Square Triangle units and the remaining 7½" by 7½" squares to create Split-Quarter Square Triangle units.

Step 1

As shown in the example, mark a diagonal guide-line on the wrong side of:

*Fabric A 7½" x 7½" square used in this example

Baby	4 Fabric A 7½"squares and 2 7½" squares from each of Fabrics B–G
Throw	9 Fabric A 7½" x 7½" squares and 5 7½" squares of Fabrics B-G
Queen	16 Fabric A 7½" squares and 8 7½" squares of Fabrics B-G

Cut on the drawn guidelines to create to a total of:

Fabric A half triangle units

Baby	**8 Fabric A Half-Triangle** units and **4 Half-Triangle** units from each of Fabrics B–G
Throw	**18 Fabric A Half-Triangle** units and **9 Half-Triangle** units from each of Fabrics B–G
Queen	**32 Fabric A Half-Triangle** units and **16 Half-Triangle** units from each of Fabrics B–G

Note: For a throw-size quilt, there will be one extra Half-Triangle each for Fabrics B-G.

Step 2

Combine the Fabrics A-G Half Triangle units with:

- Fabric A/B Split Half-Square Triangle units
- Fabric A/C Split Half-Square Triangle units
- Fabric A/D Split Half-Square Triangle units
- Fabric A/E Split Half-Square Triangle units
- Fabric F/H Split Half-Square Triangle units
- Fabric G/H Split Half-Square Triangle units

to create a total of:

	Baby	Throw	Queen
Fabric A/B Split-Quarter Square Triangle units	4	9	16
Fabric A/C(i) Split-Quarter Square Triangle units	4	9	16
Fabric A/C(ii) Split-Quarter Square Triangle units	4	9	16
Fabric A/D Split-Quarter Square Triangle units	4	9	16
Fabric A/E(i) Split-Quarter Square Triangle units	4	9	16
Fabric A/E(ii) Split-Quarter Square Triangle units	4	9	16
Fabric F/H Split-Quarter Square Triangle units	4	9	16
Fabric G/H Split-Quarter Square Triangle units	4	9	16

Step 3

Square up all the Split-Quarter Square Triangle units to 6½" x 6½" squares by matching the intersection of the 3¼" lines on the ruler with the center seams of the Split-Quarter Square Triangle units **and** the 45-degree mark on the ruler with the diagonal seam line (as shown in blue in the diagram), and trim the top and right edges of the blocks.

45° mark

*Fabric A/B split quarter square triangle unit used in this example

Step 4

Rotate each Split-Quarter Square Triangle unit 180 degrees and repeat Step 3 on the remaining two sides.

45° mark

*Fabric A/B/ split quarter sqaure triangle unit used in this example

Block and Quilt Assembly

Step 1

Combine 1 Fabric B/H Flying Geese Square, 1 Fabric A/B/G Hourglass, 1 Fabric A/C(i) Split-Quarter Square Triangle, and 1 Fabric C/H Flying Geese Square unit, as shown, to create **1 Row 1** unit. Press the seams open. Repeat to create a total of:

Baby	**4 Row 1** units
Throw	**9 Row 1** units
Queen	**16 Row 1** units

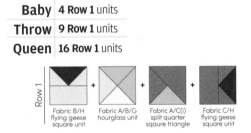

Row 1

Fabric B/H flying geese square unit + Fabric A/B/G hourglass unit + Fabric A/C(i) split quarter sqaure triangle + Fabric C/H flying geese square unit

Step 2

Combine 1 Fabric A/B Split-Quarter Square Triangle, 1 Fabric G/H Split-Quarter Square Triangle, 1 Fabric A/G/H Hourglass, and 1 Fabric A/C(ii) Split-Quarter Square Triangle unit, as shown, to create 1 Row 2 unit. Press the seams open. Repeat to create a total of:

Baby	**4 Row 2** units
Throw	**9 Row 2** units
Queen	**16 Row 2** units

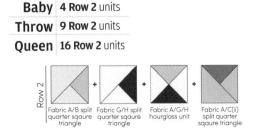

Row 2

Fabric A/B split quarter sqaure triangle + Fabric G/H split quarter sqaure triangle + Fabric A/G/H hourglass unit + Fabric A/C(ii) split quarter sqaure triangle

Quilting Directions

Step 3

Combine 1 Fabric A/E(ii) Split-Quarter Square Triangle, 1 Fabric A/G/H Hourglass, 1 Fabric G/H Split-Quarter Square Triangle, and 1 Fabric A/D Split-Quarter Square Triangle unit to create **1 Row 3** unit. Press the seams open. Repeat to create a total of:

Baby	**4 Row 3** units
Throw	**9 Row 3** units
Queen	**16 Row 3** units

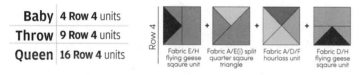

Step 4

Combine 1 Fabric E/H Flying Geese Square, 1 Fabric A/E(i) Split Quarter Square Triangle, 1 Fabric A/D/F Hourglass, and 1 Fabric D/H Flying Geese Square unit, as shown, to create **1 Row 4** unit. Press the seams open. Repeat to create a total of:

Baby	**4 Row 4** units
Throw	**9 Row 4** units
Queen	**16 Row 4** units

Step 5

To create **1 Block** unit, line up the seams and join 1 Row 1, 1 Row 2, 1 Row 3, and 1 Row 4 unit. Press the seams open. Repeat to create a total of:

Baby	**4 Block** units
Throw	**9 Block** units
Queen	**16 Block** units

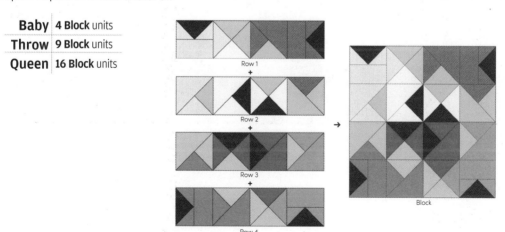

Step 6

To construct the quilt top, refer to the assembly diagram shown and combine:

Baby	2 rows of 2 Block units
Throw	3 rows of 3 Block units
Queen	4 rows of 4 Block units

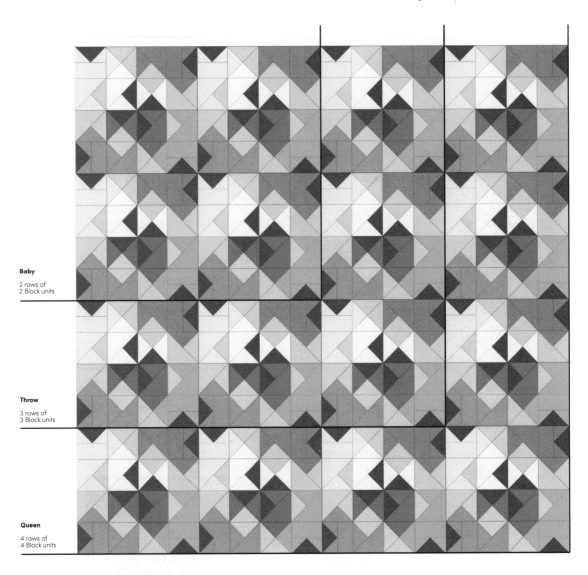

Baby

2 rows of
2 Block units

Throw

3 rows of
3 Block units

Queen

4 rows of
4 Block units

Step 7

Press the quilt top and backing fabric. Layer the backing, binding, and quilt top. Baste, quilt, and bind.

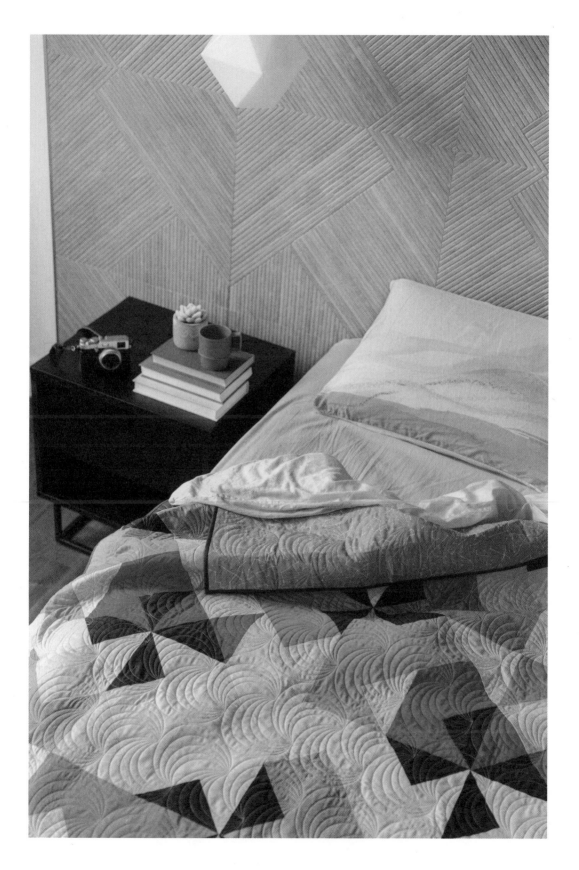

RESOURCES

When I first started my quilting journey, I only ever shopped at my local big-box store and didn't venture out much until I joined the online quilting community. Since then, I have discovered a wide range of resources for all things quilting, and I encourage you to branch out as you grow in your quilting journey too.

The following is a list of recommendations from the quilting community, as well as my favorite online and brick-and-mortar stores for quilting supplies and longarm quilters.

Tools and Notions

JOANN Fabrics and Crafts
www.joann.com

Michaels
www.michaels.com

Fabrics

Cottoneer Fabrics
www.cottoneerfabrics.com

Fabric Bubb
www.fabricbubb.com

Fabricworm
www.fabricworm.com

Fat Quarter Shop
www.fatquartershop.com

Hawthorne Supply Co.
www.hawthornesupplyco.com

Modern Domestic
www.moderndomesticpdx.com

Stash Fabrics
www.stashfabrics.com

Longarm Quilters (U.S. Only)

J. Coterie Quilting
www.j-coterie.com

Knot and Thread Design
www.knotandthreaddesign.com

Prairie Folk Quilt Co.
www.prairiefolk.com

Stitch Mode Quilts
www.stitchmodequilts.com

Threaded Quilting Studio
www.threadedquilting.com

Wild Phil Quilting
www.wildphilquilting.com

REFERENCES

A Brief History of Quilting

Page 5

McCormick Gordon, Maggi. *The Ultimate Quilting Book: Over 1,000 Inspirational Ideas and Practical Tips.* London: Collins & Brown, 1999.

Ehrlich, Laura. *The Complete Idiot's Guide to Quilting, Illustrated*, 2nd ed. Indianapolis: Alpha Books, 2004.

AccuQuilt, the Cutting Experts. *The Evolution of Fabric Cutting: Scissors, Rotary, Rolling Pin. AccuQuilt*, n.d. https://www.accuquilt.com/media/pdf/The-Evolution-of-Fabric-Cutting-ebook.pdf.

Page 6

Smucker, Janneken. *Amish Quilts: Crafting an American Icon.* Baltimore: The Johns Hopkins Press, 2013.

Knauer, Thomas. *Why We Quilt: Contemporary Makers Speak Out; The Power of Art, Activism, Community, and Creativity.* North Adams, MA: Storey Publishing LLC, 2019. E-book.

Shaw, Robert. *American Quilts: The Democratic Art, 1780—2007.* New York: Storey Publishing LLC, 2009.

Deen, Anna. "A Brief History of Quilting in America." FaveQuilts.com. Prime Publishing LLC, accessed May 21, 2020. https://www.favequilts.com/Miscellaneous-Quilt-Projects/A-Brief-History-of-Quilting-in-America.

Page 7

Parsons, Vanessa. "Quilting in America — A Brief History." Textile Arts Center (blog), May 1, 2017. http://textileartscenter.com/blog/quilting-in-america-a-brief-history.

Smucker, Janneken. *Amish Quilts: Crafting an American Icon.* Baltimore: The Johns Hopkins Press, 2013.

International Quilt Museum. "Industrial Revolution." World Quilts: The American Story, accessed May 21, 2020. http://worldquilts.quiltstudy.org/americanstory/business/industrialrevolution.

Purnell, Carolyn. "Quick Piecing: A Short History of Quilting." Apartment Therapy, March 29, 2012. https://www.apartmenttherapy.com/quick-piecing-a-short-history-of-quilting-168357.

International Quilt Museum. "Mail Order." World Quilts: The American Story, accessed May 21, 2020. http://worldquilts.quiltstudy.org/americanstory/business/mailorder.

International Quilt Museum. "The Birth of Modern Quilt Businesses." World Quilts: The American Story, accessed May 21, 2020. http://worldquilts.quiltstudy.org/americanstory/business/birthofmodern.

International Quilt Museum. "Publishing Explosion." World Quilts: The American Story, accessed May 21, 2020. http://worldquilts.quiltstudy.org/americanstory/business/publishingexplosion.

Philibert-Ortega, Gena. "Women During World War II: Knitting & Sewing on the Home Front." GenealogyBank, December 5, 2012. https://blog.genealogybank.com/women-during-world-war-ii-knitting-sewing-on-the-home-front.html.

Page 8
Knauer, Thomas. *Why We Quilt: Contemporary Makers Speak Out; The Power of Art, Activism, Community, and Creativity*. North Adams, MA: Storey Publishing LLC, 2019. E-book.

Keane, Maribeth, and Joyce Millman. "The History of American Quiltmaking: An Interview with Merikay Waldvogel, Part One." Collector's Weekly. Auctions Online USA Ltd., November 24, 2009. https://www.collectorsweekly.com/articles/the-history-of-american-quiltmaking-an-interview-with-merikay-waldvogel-part-one.

Breneman, Judy Anne. "America's Quilting History: World War II & Beyond; Quilting, Alive Beneath the Surface." Womenfolk.com, 2002. http://www.womenfolk.com/quilting_history/midcentury.htm.

International Quilt Museum. "American Bicentennial." World Quilts: The American Story, accessed May 21, 2020. http://worldquilts.quiltstudy.org/americanstory/engagement/bicentennial.

Breneman, Judy Anne. "America's Quilting History: America's Quilt Revival & Bicentennial Quilts; 1960s & 1970s." Womenfolk.com, 2006. http://www.womenfolk.com/quilting_history/bicentennial-quilts.htm.

The Modern Quilt Guild. *Modern Quilts: Designs of the New Century*. Lafayette, CA: C&T Publishing, Inc., 2017.

Hey There!

Alexandrakis, Jessica. *Quilting on the Go*. New York: Potter Craft, 2013. "Quilting in a Digital Age." E-book.

Fall, Cheryl. *Quilting for Dummies*, 2nd ed. Hoboken: Wiley Publishing, Inc., 2006. E-book.

Ricketson, Kathreen. *Little Bits Quilting Bee: 20 Quilts Using Charm Squares, Jelly Rolls, Layer Cakes, and Fat Quarters*. San Francisco: Chronicle Books, 2014. E-book.

International Quilt Museum. "Groups and Guilds." World Quilts: The American Story, accessed February 18, 2020. http://worldquilts.quiltstudy.org/americanstory/creativity/groupsandguilds.

International Quilt Museum. "The Guild Movements." World Quilts: The American Story, accessed February 18, 2020. http://worldquilts.quiltstudy.org/americanstory/creativity/guildmovements.

Streets and Avenues

Dick, Jennifer, and Angela Walters. *Nine-Patch Revolution: 20 Modern Quilting Projects*. Lafayette, CA: C&T Publishing, Inc., 2018. E-book.

Breneman, Judy Anne. "Quilt Patterns through Time: Nine-Patch Quilt Patterns for Babies." Womenfolk.com, 2008. http://www.womenfolk.com/baby_quilts/ninepatchchild.htm.

National Park Service. "Quilt Discovery Experience." Homestead: National Monument of Nebraska, last modified April 14, 2018. https://www.nps.gov/home/planyourvisit/quilt-discovery-experience.htm.

Pattern Observer. "The History of the American Quilt: 19th Century." PatternObserver.com, accessed November 19, 2019. https://patternobserver.com/2012/05/10/the-history-of-the-american-quilt-19th-century

Twin Pole

Various. *The Origin and History of Patchwork Quilt Making in America with Photogenic Reproductions*. United Kingdom: Read Books, Ltd., 2013. E-book.

Quilting in America. "History of Quilts." Historical Quilting, accessed December 16, 2019. https://www.quilting-in-america.com/History-of-Quilts.html.

Cobb, Mary. The Quilt-Block History of Pioneer Days: With Projects Kids Can Make. Minneapolis: Millbrook Press, 1995.

Shaw, Robert. *American Quilts: The Democratic Art, 1780—2007*. New York: Storey Publishing LLC, 2009.

Knauer, Thomas. "The Joy of Quilting." Modern Quilt Guild, March 16, 2017. https://community.themodernquiltguild.com/resources/joy-quilting.

Knauer, Thomas. "Why Modern?" Modern Quilt Guild, January 17, 2017. https://community.themodernquiltguild.com/resources/why-modern.

Boat Pond

OLFA Corporation. "What Sparked the First OLFA Cutter." About OLFA, accessed April 13, 2020. https://olfa.com/craft/about-olfa.

AccuQuilt, the Cutting Experts. The Evolution of Fabric Cutting: Scissors, Rotary, Rolling Pin. AccuQuilt, n.d. https://www.accuquilt.com/media/pdf/The-Evolution-of-Fabric-Cutting-ebook.pdf.

Landmark

American Patchwork & Quilting. "History of Log Cabin Quilts." Allpeoplequilt (blog), accessed January 9, 2020. https://www.allpeoplequilt.com/quilt-patterns/history-of-log-cabin-quilts.

Hall, Jane. "Log Cabin Quilts: Inspirations from the Past." Womenfolk.com, 2004. http://www.womenfolk.com/quilt_pattern_history/logcabin.htm.

Griska, Karen. "Log Cabin Quilts: A Short History." AQS Blog (blog). American Quilter's Society, accessed January 9, 2020. http://www.aqsblog.com/log-cabin-quilts-a-short-history.

Sewing Solutions. "Underground Railroad Quilts." Sewingsolutions.com, accessed January 9, 2020. https://www.sewing-solutions.com/underground-railroad-quilts.html.

Museum Steps

Cox, Patricia, and Maggie McCormick Gordon. *Log Cabin Quilts Unlimited: The Ultimate Creative Guide to the Most Popular and Versatile Pattern*. Chanhassen, MN: Creative Publishing international, 2004. E-book.

Wikipedia, The Free Encyclopedia. "American Civil War." Wikipedia.com, accessed May 26, 2020. https://en.wikipedia.org/wiki/American_Civil_War.

Williams, Suzy. "Everything You Need to Know about the Courthouse Steps Quilt." Suzy Quilts, accessed January 1, 2020. https://suzyquilts.com/courthouse-steps-quilt.

Williams, Suzy. "Super Simple Flying Geese Quilt Tutorial." Suzy Quilts, accessed January 1, 2020. https://suzyquilts.com/flying-geese-quilt-tutorial.

Rush Hour

Knauer, Thomas. *Why We Quilt: Contemporary Makers Speak Out; The Power of Art, Activism, Community, and Creativity*. North Adams, MA: Storey Publishing LLC, 2019. E-book.

Various. *The Romance of the Patchwork Quilt in America in Three Parts: History and Quilt Patches — Quilts, Antique and Modern — Quilting and Quilting Designs*. United Kingdom: Read Books Ltd., 2013. E-book.

Chinatown

Deen, Anna. "All About the Snowball Quilt Block." FaveQuilts.com. Prime Publishing LLC, accessed March 26, 2020. https://www.favequilts.com/Block-Patterns/All-About-the-Snowball-Quilt-Block.

Sisk, Carrie. "BLOCK Friday: Snowball Quilt Patterns & Quilt Blocks; Fons & Porter." Quilting Daily blog. Golden Peak Media, July 1, 2016. https://www.quiltingdaily.com/block-friday-snowball-quilt-patterns-quilt-blocks-fons-porter.

Marston, Gwen. *Twenty Little Amish Quilts: With Full-Size Templates*. Mineola, NY: Dover Publications, 1993.

Crosstown Buzz

Mitchell, Angela. "8 Incredible Flying Geese Patterns: Your Quilting Will Soar!" Bluprint, June 3, 2014. https://www.mybluprint.com/article/flying-geese-quilt-patterns.

Quilting in America. "Flying Geese." Resources, Quilt Blocks, accessed December 12, 2019. https://www.quilting-in-america.com/flying-geese.html.

Really Good Stuff. "Underground Railroad Quilt Guide," accessed December 12, 2019. http://www.novamil.org/sites/novamil.org/files/freedom_quilt.pdf.

Carolina Country. "Follow the Flying Geese." Carolina Country, February 2003. https://www.carolinacountry.com/carolina-stories/follow-the-flying-geese.

Williams, Suzy. "Super Simple Flying Geese Quilt Tutorial." Suzy Quilts, accessed January 1, 2020. https://suzyquilts.com/flying-geese-quilt-tutorial.

Wind Tunnel

Debra's Custom Machine Quilting & Gifts. "History of the Pinwheel Quilt Block." Cool Information, March 9, 2018. https://debrascustommachinequilting.com/cool-information/f/history-of-the-pinwheel-quilt-block.

Delaware Quilts. "Block of the Month: Pinwheel." DelawareQuilts.com, last modified July 2014. http://delawarequilts.com/BOMs/Pinwheel/index.html.

National Park Service. "Quilt Discovery Experience." Homestead: National Monument of Nebraska, last modified April 14, 2018.

ABOUT THE AUTHOR

Wendy is an Aussie modern quilter and pattern designer based in New York City. The founder of @the.weekendquilter, she aims to bring a timeless and fresh perspective to one of the oldest forms of needlework with her bold and distinct modern quilt designs.

ACKNOWLEDGMENTS

I'm so grateful for all the people who have contributed to creating my first book, *Urban Quilting*. I'd like to start off by saying thanks to my two older sisters. Wynne, if you did not turn our parents' dining room into a sewing room and make those awesome quilts for our family and friends, I would not know what quilting is and this book would not have ever existed. Thank you for introducing me to the world of quilting and for showing me the different possibilities and joy it can bring to life. Vincci, if it wasn't for your time and patience in showing me how to use Adobe Photoshop when you were busy with your architecture school projects back in 2004, these illustrated diagrams throughout the book would not have been achievable. Thank you to you both for being my lifelong creative mentors and, of course, thanks mum and dad for passing on your creative genes.

To my husband, Brian, thank you for being so accepting and supportive in my new journey and obsession with quilting. Although I don't listen to them more than half the time, your second opinion on design choices still means a lot to me. I am so lucky to have you as my sounding board every step of the way and for pouring those glasses of wine to keep me sane.

I am especially appreciative of the quilting community and their generosity. Shout out to my pattern testers, a.k.a. Team Hawk Eyes—Raye Bednorz, Wynne Bell, Elizabeth Bolten, Anna Brown, Claire Brown, Julie Burton, Sarah Campbell, Amanda Carye, Holly Clarke, Bay Corbishley, Shannon Fraser, Julie Gehman, Sarah Gerth van den Berg, Arianne Lott, Amanda McCabe, Donna McLeod, Hannah Prigge, Laurel Ryan, Lorna Slessor, Jodie Tang, and Catalina Urias. Thank you so much for your time and efforts in putting together my designs, providing feedback on improvements and corrections, as well as spreading the word and sharing photos of your beautiful *Urban Quilting* makes with the community. You ladies are all amazing and inspiring. And to all my quilt friends near and far, thank you for your support, for being so creative, and for continuously pushing the boundaries and influencing and shaping the future of quilting. Don't ever stop creating and passing on the creative legacy of quilting.

To Lindsay and Charlie Prezzano and the team at Hawthorne Supply Co., and Kristina and Evan Green at Fabric Bubb, thank you for your service to the quilting community, and for your time and efforts in fulfilling my fabric orders so promptly. To Sarah Campbell at Stitch Mode Quilts, thank you for going above and beyond in providing design suggestions on the quilting pantographs, and for your quick turnarounds and taking off the pressure of quilting up the larger quilts. Thank you to Laura Henneberry and Gar Liu from PreQuilt for introducing me to the world of quilt pattern writing, as well as upgrading my PreQuilt account to help me visualize my designs, and making the designing process for *Urban Quilting* easier and faster.

Thanks, Rachel Kuzma, for taking on the challenge to photograph all my quilts. Your photos play such an integral role in bringing my quilts to life and communicating that quilts are timeless and can be integrated into the modern home. Nhu Le, thanks for introducing me to Rachel Kuzma and allowing us to use your beautiful apartment for photos.

A massive thanks to the team at Blue Star Press for making this all possible. Thank you to Brenna Licalzi for reaching out and presenting me with this once-in-a-lifetime opportunity to write a quilting book and continue to share the art of quiltmaking with generations to come. Never in my wildest dreams would I have ever imagined writing a book. Thank you to Lindsay Wilkes-Edrington and Clare Whitehead for making the time once every other week to jump on a call, and for making sure we were on track in the delivery of the book and your second opinions on the quilt designs; Stephanie Carbajal and Lindsay Conner for making sense of the copy, diagrams, and testers' feedback; Peter Licalzi for sharing your wisdom and expertise in the look and feel of the book; Rhoda Wong for the hours spent laying out each page, and everyone else on the Blue Star Press team who helped bring my book to life.

And finally, YOU! Thank you for bringing *Urban Quilting* into your life. It brings me great honor to know that I have somehow been a part of your quilting journey. I hope that my designs will enhance and bring joy to your space. I hope they will mark and celebrate special milestones in your life, and that you will be able to connect and share quilting with others for many years to come.